The

THE LOGIC OF THE LURE

John Paul Ricco

THE UNIVERSITY OF CHICAGO PRESS
CHICAGO AND LONDON

JOHN PAUL RICCO is assistant professor of art history at Texas Tech University. He has curated several contemporary art exhibitions on gender, sexuality, and AIDS.

The University of Chicago Press, Chicago 60637
The University of Chicago Press, Ltd., London
© 2002 by The University of Chicago
All rights reserved. Published 2002
Printed in the United States of America
11 10 09 08 07 06 05 04 03 02 1 2 3 4 5
ISBN: 0-226-71100-5 (cloth)
ISBN: 0-226-71101-3 (paper)

Library of Congress Cataloging-in-Publication Data
Ricco, John Paul.
 The logic of the lure / John Paul Ricco.
 p. cm.
 Includes bibliographical references and index.
 ISBN: 0-226-71100-5 (alk. paper) —
 ISBN: 0-226-71101-3 (pbk. : alk. paper)
 1. Homosexuality and art. 2. Homosexuality and architecture.
3. Homosexuality—Philosophy. I. Title.
N72.H64 R53 2002
709′.04′9—dc21

 2002003841

⊗ The paper used in this publication meets the minimum requirements of
the American National Standard for Information Sciences—Permanence of
Paper for Printed Library Materials, ANSI Z39.48-1992.

Contents

ILLUSTRATIONS

The Logic of the Lure
and the New Pornography

William Haver

...

Fragmentary, anonymous, promiscuous, perverse, always in flight from the rigor mortis of academic art history and the flat line of gay and lesbian or queer studies, *The Logic of the Lure* belongs essentially to the instauration (at once renewal and founding: the reiteration) of the New Pornography. The work of instauration that founds no institution but utterly exhausts itself in the infinite repetition of its singular happening is a work for which it will always be impossible to establish a pedigree by way of introduction; the work of the New Porn is at once immemorially archaic, always yet to come, and yet nothing other than the impossibility (for knowledge) of: here, now, this. To read the work of the New Porn, to read *The Logic of the Lure,* is not only to read the work of the stranger (for "John Paul Ricco" is only one of the innumerable names of anonymous singularity), but to read as the stranger one becomes in pornographic invention—in other words: seriously to give oneself to the risks that art, fucking, imagination, love, and thinking are.

What can be said of *The Logic of the Lure* and the New Porn of which it is one articulation? What is specifically pornographic about the New Porn, and what makes Ricco one of the New Pornographers? What rules (albeit rules that are constantly and necessarily being rewritten) for pornographic invention might we imagine govern *The Logic of the Lure?*

1. Do not imagine that the pornography upon which you are engaged will ever authorize any possible explanation, interpretation, or knowledge of the world; you have riskier, more interesting work to do. Pornographic invention is neither an alternative form of knowledge,

nor does it replace knowledge. Rather, it is the irreducible supplement of knowing; pornographic invention engages what the aspiration of explanation, interpretation, and knowledge can only dismiss as accidental, transitional at best. Ricco's text provokes a relation to art's work quite other than explanation, interpretation, or knowledge; his commentary is itself of, rather than about, art's work.

2. Abandon the assumption that the pornographic enterprise is reducible to questions of representation, correspondence, adequation, or judgment; what is specifically pornographic in porn is precisely what in the act of presentation exceeds representation, for porn is not merely a portrait of pleasure, but presents itself as *in itself* pleasurable; provoke pleasure and enjoyment instead of teaching appreciation, and thereby free art's work from every possibility for a moralistic pedagogy.

3. Address yourself, therefore, to what of your readers exceeds knowing, judging, or desiring subjectivity, for it is neither epistemological, moral, nor desiring subjects who experience the unbearable pleasure of the fuck. Offer them not objects that would confirm them in the comfortable neuroses of their subjectivities, but the singular risk of the fetish, withdrawn from the very possibility of intelligibility and meaning. Honor thereby the ontological stammering upon which art's work opens, thus recalling to your readers what of life, beyond all reason, is consecrated to pleasure, *bios apolaustikos*.*

4. In addressing yourself to what is most obscene and perverse in your readers—that is, in addressing yourself to the indestructible supplement of interpretation, knowledge, judgment, or desire, in addressing yourself to the chaos of the passions and affects, in addressing yourself to thinking—you thereby abandon the respectable comforts of the seductive transcendence promised in nostalgia and prolepsis. Choose non-transcendence, the destitution of John Greyson's Patient Zero in *Zero Patience*, Luke in Gregg Araki's *The Living End*, the unrepentant faggot of Diamanda Galás's *Plague Mass*, the cast of Samuel Delany's *The Mad Man*, Isabelle Stengers and Didier Gille's "utter fool," all members of a "race" that in affirming its non-transcendence "is not the one that claims to be pure but rather an oppressed, bastard, lower, anarchical, nomadic, and irremediably minor

*Aristotle, *Nicomachean Ethics*, 1.5.1095b.

race—the very ones Kant excluded from the paths of the new Critique," as Deleuze and Guattari have it: the whore, the hustler, the bad queer, the junkie, the Lumpenproletariat, the mad, the stranger.*

5. And thereby abandon any project that would reduce the political (as such) to any geography of location or cartography of position, whether literal or metaphorical. Abandon the putatively neutral white cube of the museum for the labyrinth and the corridor; desert the boulevard for the alleys; forsake the park's lawns for the shrubbery; leave the stadium for the deserted warehouse. Or, better yet, transform the white cube into a labyrinth, architecture into something not simply anti-architectural, but undecidedly contingent, something at once both and neither architecture or anti-architecture. Above all, transform location or position, always already a point in space fixed in a possible cartography or geography, into place, the "here, now" of Whitehead's prehension, or Deleuze and Guattari's plane of imma-
nence, or the place of the stranger's pleasure—all of which specify an engagement of thinking with its impossibility precisely in an absolute resistance to any attempt to reduce place to location.† "Here, now" is the place of the simultaneity of deterritorialization/reterritorialization, the place of fragmentation, anonymity, promiscuity, utter strangeness, unknowable difference, and an obscene perverse pleasure subject to no possible calculus. The New Porn never forgets that this untenable place of absolute risk is at once infinitely hospitable and entirely uninhabitable; "here, now" is nevertheless the New Porn's only place, for it is here, and here alone, that the political ("in itself and as such") *happens*.

Were *The Logic of the Lure*, or the New Porn of which it is an important articulation, to become canonical; were this text to become a model, these rules to become a protocol, and the New Porn to become an aca-

*John Greyson, *Zero Patience* (film, 1993); Gregg Araki, *The Living End* (film, 1993); Diamanda Galás, *Plague Mass* (Mute Records, 1991); Samuel R. Delany, *The Mad Man* (New York: Masquerade Books, 1994); Isabelle Stengers and Didier Gille, "Body Fluids," trans. Paul Foss, in Isabelle Stengers, *Power and Invention: Situating Science*, trans. Paul Bains (Minneapolis: University of Minnesota Press, 1997), 233–38; Gilles Deleuze and Félix Guattari, *What Is Philosophy?* trans. Hugh Tomlinson and Graham Burchell (New York: Columbia University Press, 1994), 109.

†Alfred North Whitehead, *Process and Reality*, corrected ed., ed. David Ray Griffin and Donald W. Sherburne (New York: Free Press, 1978), 219–80; Deleuze and Guattari, *What Is Philosophy?* 35–60.

demic fashion; were this work to achieve even a certain limited intellectual hegemony, then the passions, pleasures, and exigencies of this writing, as well as all the engagements of the New Porn, will have been betrayed. There is little chance that writing of such uncompromising rigor will achieve that kind of success, perhaps; but it would be no less disastrous were this work to be accommodated within any liberal multiculturalism as a voice of the subaltern; what is at stake in this writing is beyond adjudication. As art's work, as the pure interruption that thinking necessarily is, this work can only be the sovereign object of a certain misunderstanding. And it is precisely as such that it is most intensely pornographic.

Should you risk this reading, exposing yourself to pornographic invention, and allowing this work finally to withdraw from interpretation and meaning into the essential anonymous singularity of the fetish and the event of art's work, you will have risked the invention, on the other side of reading, of an unimaginable extremity.

To all those anonymous others

There is no pathology of pleasure, no "abnormal" pleasure. It is an event "outside of the subject" or on the edge of the subject, within something that is neither body nor soul, which is neither inside nor outside, in short a notion which is neither ascribed nor ascribable.

—Michel Foucault, "Le Gai Savoir II"

Let us imagine others which [*sic*] diverge infinitely. No meeting point, and nowhere for them to be recorded: They often had no echo but that of their condemnation. We have to grasp them in the force of the movement that separates them; we have to rediscover the instantaneous and startling wake they left when they plunged into an obscurity where "the story is no longer told" and where all "fame" is lost.

—Michel Foucault, cover note to *Herculine Barbin, dite Alexina B.*

What if we neither began nor ended
with identity? What if the abandonment of this hermeneutic/progres-
sivist trajectory forced a relinquishing of (re)productive forms of doing
culture, say as sociological mapping, anthropological description, and art
historical representation? Which is to ask, along with William Haver:
what if we stopped looking for either a method or an object for our re-
search and theorizing?[1] What if we were no longer impressed by per-
manence, longevity, and a certain museological artifactuality rendered as
evidence? What if we began to recognize the false comforts of situated-
ness and the adverse effects of territorialization? What if, in our queer
theorization of globalization, we neither strove for a singular totality (a
"Queer Planet") nor a pluralistic string of places? What if then, in our in-
vestigations of sex and space, we did not rely upon visual-based modes of
knowledge production that are intended to generate statistical mappings
and models of community (i.e. presupposed zones of identity)? What if
we were to think sex and space beyond positivizing logics of reification,
commodification, and privatization? In the end, what if we were to sub-
stitute something like a cruising ground for an epistemological ground?

The Logic of the Lure takes the risks inherent in these hypotheticals in
order to think and write the visuality and spatiality of anonymous, itiner-
ant, erotic, and uncertain forms of sociality (e.g. cruising); loss, passing,
and the disappearing of people, places, and practices (in the AIDS pan-
demic); site-specific yet mobile installation art practices; and "illicit" ped-
agogical practices and forms of theoretical production (counter-publics).

Each of these axes is marked by an attenuation of relations between the social and the visual, and it is in this slender gap that the defiance or refusal of those certainties listed above occurs, a defiance or refusal that is perverse and traitorous, a singular multiplicity that is . . . queer. It is perverse in the double sense of *imperfectly* naming *improper* singularities (encounters, proximities). A singular multiplicity renders the interrelations between spatiality, sociality, and historicity as a series of indefinite articles and indeterminate things: a here that is wherever; a whom that is whomever; a what that is whatever; a whence that is whenever. The terms that are theorized here (i.e. being-with-out, waiting, disappeared, imperceptible, hypnagogic) elicit the non-relational social bond that is materialized as nothing more or less than a wink, a nod, a discarded snapshot, a handwritten note on a scrap of paper, or two drinking glasses stacked together and left on a counter. Such betrayals of identity, intersubjectivity, property, and hence even the slightest degree of epistemological certainty, defy representational logics and, I argue, are worthy of being thought precisely because of this defiance. This work concerns persistence in the midst of abandonment, impoverishment, exhaustion, and negligence. In its articulation of this persistence, this writing is itself the persistence of thought in those very instances at which thought becomes nearly impossible. It is this persistence that is at once erotic and ethical (and inextricably so). It is an attraction-unto-negligence that operates through, and that is, the full force of what I am calling the logic of the lure.

It is in this way that this work is not about texts, images, or objects, but *events,* here understood as the force or potentiality of spatiality, visuality, and sociality as an indeterminate, undefinable taking place, a happening that happens outside of the evidentiary. The sheer fact of this taking place is absolutely material in its force if not in its form, or in a form that is its force: the formless unworking of the work, "art's work" as opposed to any work of art.[2] Therefore, what I have written is in no way an interpretation of examples of essential production and their consolidation as something that one might refer to as queer. Since the material force of the event is beyond both ignorance and knowledge, my work is not even so much a theoretics as it is a poetics/erotics, a giving oneself over to the ecstasy of uncertainty, interminability, insatiability, and inconsolability. Such a relinquishing or abandoning of epistemological certitude (and also of willful ignorance for that matter) is the exposure to

the Outside (the full force of a radical exteriority that undoes all inside-outside dialectical structures), and an incessant interruption of disciplinary boundaries. Undisciplined, this work proceeds by way of a promiscuous methodology, which should be taken to mean that it is without method just as much as it is without proper object(s). This is not, nor does it aspire to be art history, queer space theory, or any other number of imaginable fields of inquiry. It is as if I am an art historian for whom art history is never a possibility, an art historian who insists on remaining within the space of writing, refusing art history, or more precisely to exist where it is nearly impossible to exist in art history, in the other art history, the Outside of art history, the one that cannot be thought or known or written. This then, would be the incessant interruption of the art historical impossible, a potentiality of art history as the coming or un-becoming art history. It is here, in this atopic or vertiginous place that is all interval, meanwhile, aside and amidst that one runs the risk of practicing "invention to the brink of intelligibility,"[3] no easy feat and one that I cannot attest to fully accomplishing.[4]

Each of the four chapters below includes an epilogue that poses writing as a question, partially puts into question the writing that constitutes the principal text of the chapter, and has been prompted by the writing that has just preceded it. A Bartleby-inspired preference not-to write follows chapter one, a disappeared writing is attempted following chapter two, a friendship in writing follows chapter three, and writing across counter-publics is part of chapter four. These epilogues do not function as moments of textual closure but rather as interruptions, a parenthetical undoing of writing that attests to the ways in which the promiscuous methodology described above, and deployed throughout the book, makes for an impossible writing. And yet, and perhaps most important, these epilogues mark the persistence or a remaining within this impossibility, and thereby affirm that what remains is this persistence and incessance. It is this that is utterly material. These epilogues expose the book to the Outside and make of it a singular multiplicity. Of course, this is an Outside that has never been farther away from the book than the writing itself, the place where the touch or sensation of the Outside is felt, right then and there—whenever, wherever. This refers "not to something said but to the sayable that remains unsaid in it,"[5] the potential force of enun-

ciation, of that which is incessantly coming in the slender gap that is the attenuation of the spatial, the visual, and the social. Not a queer space, nation, or planet but community that is queer to the extent that it is unbecoming. Or, as Jean-Luc Nancy suggests,

> Perhaps we should not seek a word or a concept for it, but rather recognize in the thought of community a theoretical excess (or more precisely, an excess in relation to the theoretical) that would oblige us to adopt another praxis of discourse and community. . . . Which means here that only a discourse of community, exhausting itself, can indicate to the community the sovereignty of its sharing. . . . An ethics and politics of discourse and writing are evidently implied here.[6]

Such an ethics and politics of discourse and writing is one of the principal concerns of this book, for it is here that what we do stands the greatest chance of mattering. But only to the extent that this ethics and this politics exists prior to, or in the wake of, identities—be these spatial, visual or social. Without a proper (or even an improper) name, concept, method, and set of protocols, this would be the promiscuous ethics and insurgent politics of those who remain anonymous, itinerant, imperceptible, and illicit.

I began this work nearly a decade ago, originally inspired by walking down a narrow corridor on the uppermost floor of the Limelight nightclub in Manhattan, and into a small, rather quiet, dark, and nearly stifling-hot room packed full of men and boys, pants around their ankles, hands groping crotches, t-shirts pulled behind necks, kissing, sucking, jacking, licking. I instantly realized that I had entered a space of erotic, ethical, and perhaps political potential unlike any other, in its refusal of so many codes, protocols, laws, and imperatives. That night I experienced, as if for the first time, the pure pleasure of the force of the existential in all of its singular multiplicity, as though the "what if?" of some philosophical hypothetical erotic fantasy had been answered, not finally, or even for the first time, but simply prior to coming.

ACKNOWLEDGMENTS

....................................

This project was initially inspired xxiii
by a resurgence of anonymous sex spaces and practices in Manhattan
around 1992, and had its textual origins as a paper for a graduate semi-
nar at Princeton University's School of Architecture. Over the ensuing
nine years, various parts of the project have been heard and read by
many. Some are as anonymous now as they were then.

The following public forums offered an opportunity to present earlier
versions of this project: College Art Association Conference; the Society
for Architectural Historians Conference; the Sawyer Seminar on Sexual
Identities and Identity Politics, Chicago Humanities Institute, University
of Chicago; University of California–Berkeley Summer Research Semi-
nar; Society for the Humanities, Cornell University; Gay and Lesbian
Studies Workshop, University of Chicago; Visual Culture Colloquium,
Cornell University; Hamilton College; Randolph Street Gallery, Chicago;
and Gallery 400, Chicago.

I am grateful to the organizers of these events for their support, and
to the audiences for their critical response to my work.

For the financial support that enabled me to pursue this work under
conditions that otherwise would have been much more difficult, I wish
to thank the Mellon Foundation; Berkeley Summer Research Seminars;
Society for the Humanities, Cornell University; School of Criticism and
Theory, Cornell University; the Texas Tech University Office of the Pres-
ident; and the TTU Faculty Research Enhancement Grant.

Discussion with the following individuals greatly informed my think-

ing on issues related to this project: Leo Bersani, Kathy Biddick, Michael Blackie, Jane Blocker, Joel Burgess, Tom Burr, Michael Camille, Richard Carrazza, Richard Cornwall, Francisco Fernández de Alba, Scott Herring, Hannah Higgins, Trevor Hope, Matt Johnston, Matts Leiderstam, Glenn Ligon, Joung Yoon Lym, Jürgen Mayer H., Stuart Michaels, Maria Miranda, Aaron Moore, Norie Neumark, Dawn Odell, Scott O'Hara, Elizabeth Povinelli, Linda Seidel, Dorian Stuber, Matthew Suttor, Henry Urbach, Jeffrey Walkowiak, Janet Wolff, and Joe Wolin.

I am fortunate to count the following people as friends, and wish to thank each of them for the intellectual intensity and challenge that they have shared over the years. Phoebe Lloyd, Carolyn Tate, and Rick Dingus, in the School of Art at Texas Tech University, for being colleagues in the fullest sense of the word. Eleanor Kaufman, for nine months of companionship and her prodigious bestowal of absolute hospitality. Doug Mitchell, my editor at the University of Chicago Press who, at each step along the way towards turning whatever I began with into a book, has been the deftest of guides. Doug Ischar, who has been one of the closest of friends, co-conspirators, and mentors, and W.J.T. Mitchell, who made my graduate studies what I had hoped they would be. I especially wish to thank William Haver for his absolutely prescient thinking and writing, his friendship, and his generous words as foreword to this book. It is here that I follow his lead, and can only hope to aspire to the rigor of thought that is uniquely his. Finally, I wish to thank Rick West for his support and unwavering confidence, which sustained me throughout each phase of this project.

An earlier version of chapter two appeared as the artist's book publication to accompany the exhibition *disappeared,* Randolph Street Gallery, Chicago, 1996. Earlier versions of sections of chapter three appeared as "Matts Leiderstam: Insinuating Nestings," in *Come Closer: Scandinavian Art in the '90s and Its Predecessors,* Liechtensteinische Staatliche Kunstsammlung, Vaduz, Liechtenstein, 1998; and as "Parenthetically Yours," in *Doug Ischar: User,* Institute of Visual Arts (*inova*), University of Wisconsin–Milwaukee, 2001.

THE LOGIC OF THE LURE

CHAPTER ONE

Minor

......................................

The middle: the only place where one can begin, as I shall, here and now. A here and now that in its singularity is not properly designated by *the* middle, but more so as *a* middle or simply as *middle,* thereby marking the impropriety of every singularity, every here and now. A middle, then, that is in the midst of the middle, a *now here* that is at the same time *nowhere* but elsewhere.[1]

In an attempt to address the specificity of queer forms and forces of sociality and spatiality as "absolute destitutions of empirical singularities"[2] one can neither begin nor end with the architectural (or any other predicate for that matter). Rather, one must remain someplace other than where "a rational space or an adequate place"[3] remains; the singular multiplicity of spatiality, itself, some-place like, *wherever.*

The relation to wherever is the specificity of *relationality* itself, such that the ontology of existence is defined as relational (being as being-with). And yet this is a relation that is not a relation "to" or "with" something, someplace, or someone.[4] The form and force of relationality that I am interested in is a relation *with-out* rapport, a relation literally marked by the "simultaneously conjunctive, disjunctive, and undecidable" hyphenation between *with* and *out.*[5] It is precisely the double refusal of neither being-with (a relation) nor being-without (a non-relation) but rather *being-with-out* (a non-relational relation). It is what Blanchot refers to as a relation of the third, which Derrida in turn defines as

not the third as the condition for the symbolic and the law, but the third as destructuring structuration of the social bond, as social disconnection (*déliaison*) and even as the disconnection of the interruption, of the "without rapport" that can constitute a rapport to the other in its alleged normality.[6]

The Blanchotian/Derridean third, in its sociality-spatiality, is what I take to be the specificity of relationality. It is *a midst* (amidst) without being *a between* (mediation), since it refuses the logic that insists on a choice between either *a one* or *an other*, or even that which is argued to lie between the two. Rather, one might begin to understand how relationality lies both before and after the subject, identity, the social, the architectural, etc.—in other words, to begin to think relationality as something other than either grounding or transcendence: conditions for the symbolic and the law.[7]

The "out" of *being-with-out* (a non-relational relation), is what Blanchot and Foucault refer to as the *Outside*.[8] With every inside-outside opposition there comes something, something that is outside the closure that is this coupling, something that is not a thing at all (at least not necessarily). This is the Outside that not only remains outside of every inside, but outside of every outside. The Outside might be understood as that which exists prior to and stands in the wake of every inside-outside opposition. It is what remains before and after all is said and done. Being-in-relation-with-the-Outside is a way of thinking the relationality that is being, as *being-with-out*.

The *topoi* of the Outside may be what Foucault meant when he spoke of *heterotopias*, or *other spaces*.[9] Heterotopias are radically other spaces, and like the Outside, cannot be said to be outside *of* anything; they are solely or solitarily outside. As the refusal of the inside-outside dialectic, nothing comes in from, or out of, the Outside, except for *coming*, which comes as the Outside. The Outside is the outside to come, the coming outside, "the coming of what does not come, of what would come without an arrival, outside of Being and as though adrift," or amidst.[10] As coming, the Outside is a relation without a context, a future without futurity (an end). The Outside is simply outside, simply coming.

The spatiality of the Outside as the defiance of emplacement is something like relationality itself, whereby we can now understand the latter as the rapport with-the-outside, or simply the rapport with-out. A rapport with-out (as opposed to the negative relation of being without rapport) is

a folding of space, which occurs at the limit and in the midst of it all; a *perplication* that "introduce[s] a creative distantiation into the midst of things." [11] It is a social-spatial folding that is at the same time the attenuation or stretching of social and spatial fabrics. It is indeterminate or virtual—which is to say it bears the indeterminacy and virtuality of all singularities—and necessarily will remain so here, throughout this text. Nonetheless, it need not be reduced or elevated to the level of either universalizing or minoritizing abstraction, both of which would posit it as an object of inquiry and interpretation.[12] Rather, it is a form and force of social-spatial folding that in its double refusals and evacuations of contents might be taken as perverse, if not—perforce—as queer. During an interview in 1981, Foucault spoke of this social-spatial form and force as the *slantwise position* of the homosexual.

> Homosexuality is a historic occasion to reopen affective and relational virtualities, not so much through the intrinsic qualities of the homosexual but because of the "slantwise" position of the latter, as it were, the diagonal lines he can lay out in the social fabric allow these virtualities to come to light.[13]

5

Note that Foucault is speaking not of homosexual content, identity, or perhaps even specific acts, but of a relational logic that is indeterminate, one that neither begins nor ends with homosexuality, but through which one might come to relate socially and spatially other-wise, and perhaps actualize other-spaces. And yet a passing through homosexuality that in turn may be a relinquishing of homosexuality (as determinable object, position, and agency), which in the end might not be such a bad thing. Foucault's slantwise or *anamorphic* trajectory, like Deleuze's *fold,* and Rajchman's *perplications,* are ways one might begin to understand a relation to the Outside, as a force of experimentation (a coming) and a form of implication (an insinuating).

> We can invent the other peoples that we are already or may become as singular beings only if our being and being-together are indeterminate—not identifiable, given, recognizable in space and time—in other words, if our future remains unknown and our past indeterminate.[14]

This suggests, in the here and now, an ethics and a politics articulated through a future-anterior logic of pasts to come and futures that have been. This is indeed untimely, yet it is a temporal interruption that folds

across futures and pasts, and thereby strives neither towards revolutionary ends nor nostalgic origins. It is what it might mean to give oneself over, without expectation, objective, or certainty; and to act ethically yet without a project, and to engage in political practice without a program.[15] Spatially, it defines an ethics and politics that puts one neither within oneself nor outside of oneself, but rather, beside oneself.

Defining a *self* as *being-beside-itself* is to define a self relationally, which is to say as other than a self, without being the Other of a Self (neither one nor the other). Being beside oneself is the relation that is the relation to the Outside, such that a self can no longer be posited prior to a relation with the Outside into which the self may or may not move. Rather, the very definition of the self, its ontology, is this relation to the Outside.[16] The self's ontology is hereby re-inflected as a topology: whoever as wherever.

To the extent that distinctions between figure or body, and ground or space, allow one to speak of the architectonic, the foldings or implications that I have been unfolding and explicating in their refolding and complication of these distinctions place the architectonic beside itself. Architecture beside itself is what one might call minor architecture—architecture that is neither the inside of architecture nor the outside of architecture, but architecture outside architecture—the architectural Outside.[17] Minor architecture is prior to and in the wake of architecture. It is less a form than a force, one that folds across architecture: "the force of an Outside that is not merely the outside of the inside, but the outside that is inside, the insidious inside."[18] Minor architecture's insidiousness, its insinuation and intense implication (which is, at the same time, not an instantiation) is a hollowing out of major architecture, an evacuating of the latter's recognizable content (i.e. signification), verifiable substantiality (i.e. monumentality), and determinate status (i.e. positive type). In writing an "architecture from the outside," Elizabeth Grosz has asked, "Can architecture be thought, no longer as a whole, a complex unity, but as a set of and site for becomings of all kinds?"[19]

Along with Deleuze's notions of the *virtual* one might say that minor architecture is virtual architecture, to the extent that it is "real without being actual, ideal without being abstract."[20] In its imperceptible, nonverifiable, and indeterminate force, which is to say, in its virtuality, minor architecture is the architectural *informe*. Descriptions of it may be only useful as a means of tricking the enemy (e.g. the police, bashers, etc.) into thinking that it knows where and what minor architecture *is*.

As the architectural *informe,* minor architecture is an undoing of architecture, although less in terms of a deconstruction than of a withdrawing of the architectural from itself, something like an architectural *ascesis* or *unworking* of architecture, in the midst of architecture. It is the coming of—without approach to—architecture, a coming of architecture *without becoming* architecture. It is a relation to architecture that is poetic, erotic, perhaps perversely poetic or poetically perverse.

> Simply a coming without the "be"; a coming without the identity relation
> of the "to be"; a coming to the surface of the present tense presence; super-
> ficiality in all its glory . . . bent and re-designed in the instant coming of its
> come, by self-immolation, self-exhibitionism, self-abuse . . . [21]

Minor architecture is rather *unbecoming* architecture.

In terms of visuality, minor architecture is neither visible nor invisible, but imperceptible. It is itinerant architecture (not necessarily "architecture of movement" or "mobile architecture") that refuses territoriality and ownership, as it operates through a deterritorializing spatial logic. It is neither here nor there, but elsewhere, wherever. This conjunctural relationality or infinite substitutability—of not only wherever, but whoever, whatever, and whenever—effects an architecture of promiscuous spatiality, sociality, and sexuality. No place is safe any longer, and therefore none is more enjoyable.

As unbecoming architecture, minor architecture is also necessarily the forgetting of architecture, and of what architecture forgets (what remains after the architectural). This is its virtuality and its critical capacity: neither to be architectural, nor to not-be architectural, but—as though in terms of Bartleby the Scrivener's neutrality—simply to prefer not-to.[22] Which might be to say that it is an architecture of abandon and abandonment that is often actualized as abandoned and nondescript folds in the urban fabric—an architecture without qualities, truly unbecoming. Manhattan's West Village piers and after-hours meatpacking district, the trailer trucks parked and empty on New York's West Side, what we think we see in Stephen Barker's penumbral *Nightswimming* photographs, Matts Leiderstam's public park/cruising ground installations, Doug Ischar's visual-spatial-aural foldings (figures 1–5)—for instance if not for example.[23]

These then are sites where architecture is betrayed by forms of sociality, sexuality, and spatiality that betray architecture, including what-

7

ever it is we might designate by the term minor. For it is virtually (if not actually) only once "the head . . . bursts through the roof or the ceiling" that one realizes not that the body is gigantic, but that the architecture is minor.[24] However, such a designation at the moment of its realization (its historicity) is no longer relevant, since the limit has at the very same moment become a point of departure.[25] What is implicated here is what remains after the architectural: the Outside, poetics, erotics, and for all of these, the forces of attraction, uncertainty, and itinerancy.

In his essay "Maurice Blanchot: The Thought from Outside," Michel Foucault points to the

> role that houses, hallways, doors, and rooms play in almost all of Blanchot's narratives: placeless places, beckoning thresholds, closed, forbidden spaces . . . hallways fanned by doors that open rooms for unbearable encounters . . . corridors leading to more corridors where the night resounds, beyond sleep. . . .[26]

This architecture of corridors, insomnia, and endless wandering would seem—at first glance—to be a description of minor architecture. And yet it is not, since it alludes to the recuperative capacity of architecture to provide shelter and to create spaces of enclosure/disclosure (even if these were nothing more than underground passageways). For as Blanchot reminds us, there are others who

> neglect even to construct the burrow, for fear that by protecting them this shelter will protect in them that which they must surrender, would bolster their presence too much and thus avert the approach of that point of uncertainty toward which they slip.[27]

The itinerant path described by Blanchot as "the approach of that point of uncertainty" is the trajectory towards the Outside (neither of the outside nor from the outside)—*of coming at the point of departure.* This trajectory, insofar as it slips toward wherever, whatever, whoever, whenever, will always be the betrayal of architecture, identity, the social, etc. For if there is a trajectory towards the outside, it is one that is obliterated in its wake, leaving no visible signs of its movement or path. It is an indeterminate cross-folding of spatiality and sociality, the attraction of uncertainty through itinerancy that is (for instance if not for example) the cruising of a cruising ground, and more accurately, the incessant with-

drawal from grounding that is cruising; an *ungrounding* that is not the *Abgrund* (abyss).

Although a cruising ground may be geographically located it is none-theless not delimited or circumscribed from the outside, but operates through an exteriorizing logic by which it is constantly departing from and approaching towards its indefinite limit. A cruising ground is a placeless place; about which it is impossible "to say where," since it is the spatiality of (that is) *wherever,* at once *now here* and *nowhere, any* place rather than, or before it is, *some* place. Such a groundless ground may have customary paths (a circuit of movement), although these are lines of diversion, iterance, and abandonment, and therefore never culminate as a contour, border, or other such device for the circumscription or de-limitation of space (i.e. as a phenomenological ground). The movement that is cruising may be from point to point, although always as a spatial proximics rather than a spatial convergence, since it is a movement to-wards a point, and another, and still another, only to leave each of them behind. The exteriorizing spatial logic of the cruising ground always ren-ders each point as a point of departure. Cruising is an "ungrounded movement that is no longer bound to move from one fixed point to an-other [something other than a spatial punctuation through points of con-tact] but rather traces its own unbounded space through the trajectories or paths that it takes."[28]

Blanchot's *others* are those who, in their incessant itinerancy, cease-lessly approach that point of uncertainty, and thereby remain as indeter-minately anonymous and unbecoming as the placeless places through which they pass. They too are without qualities or content: infamous (*in-fâme*) any-bodies-whomever of formless (*informe*) any-places-whatever. "No one hears tell of these. They leave no account of their journey, they have no name, they are anonymous in the anonymous crowd because they do not distinguish themselves, because they have entered into the realm of the indistinct."[29] This anybody is the approach towards the Out-side, nothing more or less than the trajectory of an anonymous, itinerant erotic sociality; a *trajectivity* that is not yet and no longer a subjectivity.

It is a becoming-space-of-self that is a non-suicidal unbecoming of self, literally (or laterally), of being beside oneself. Through this spatial-ization, this moving beyond oneself, *homomorphic* relations fold, unfold, and refold across human/inhuman, animate/inanimate, and corporeal/

9

spatial forms, and thereby effectively undermine attempts to make such distinctions between sameness and difference. Through a relationality predicated upon inaccurate replications of forms in space (again, a question of topology rather than typology), one is left with a sense of incomparable sameness and unrecognizable difference. Beyond recognition and comparison, this *phagocytosis* operates through a principle of the similar, "not similar to something" (a relation) "but just *similar*"—and yet not the same (the identical)—but a non-relational relation. It is in this way that "each repetition engenders a version of the same without any presumption of identity." [30] One might think of this in terms of the capacities of certain insects to mimetically become a part of their surroundings, a phenomenon discussed by the French sociologist Roger Caillois in his influential essay "Mimicry and Legendary Psychasthenia" (*Minotaure*, 1935).[31] Following Caillois' lead, Elizabeth Grosz has more recently described how "[t]he mimicking insect lives its camouflaged existence as not quite itself, as another." [32] For my purposes, it is the deterritorialized self who finds itself saying, "I know where I am, but I do not feel as though I'm at the spot where I find myself" (Caillois, 30). This is the voice of the one who is standing apart from me, he who is beside himself, the one who "breaks the boundary of his skin and occupies the other side of his senses. He tries to look at himself from any point whatever in space. He feels himself becoming space, dark space where things cannot be put" (ibid.).

Just as much as we might speak of a fear of the dark, we must also acknowledge the attraction of the dark. The nearly palpable uncertainty and obscurity of indefinite darkness that "touches the individual directly, envelops him, penetrates him, and even passes through him" (ibid.) is often what lures one into the dark. One is attracted to the dark to the extent that one cannot be put in one's place there. This becoming-space is not only the dissolution of phenomenological distinctions; it is also a "depersonalization by assimilation to space" (ibid.). *Phagocytosis,* as an intensified becoming-space of self, which is to say, as a way of moving beyond oneself, is a becoming-disappeared through what we might refer to as a *spatialized ascesis*. This spatial unworking renders identity, subjectivity, and sociability unbecoming. It is attraction-unto-negligence, "the inertia of the élan vital, so to speak" (ibid., 32). In other words, it is the logic of the lure. My sense is that this is the logic of erotic relationality, and perhaps even the erotics of relationality.

Foucault's meditation, in "The Thought from Outside," on the inextricable relations between attraction and negligence, is the strongest thinking on this complexity, of which I am aware. I take it to be, and will attempt to explicate it as, the logic of the lure.

Attraction is the pure relation to the infinite Outside. It does not imply or necessarily operate through will, desire, or other interiorized forces. At the same time, it does not rely upon an exteriorizing force, that is, something *from* outside. Therefore, attraction is something other than intersubjectivity, communication, a relationship, or intimacy. Less a form than a force of relationality, attraction is being-with that is also and at the same time being-with-out. It is an infinite unfolding of surfaces, textures, spaces, and forms that solicits a coming without arrival. It is neither a subject, nor a name, nor another person that serves as the source of this attraction, nor any other such "positive communication or presence" (Foucault, "Outside," 27); it is the interminable, insatiable intensity of erotic uncertainty, and its unmappable itinerancy: wherever, whenever, whoever. It is "the indifference that greets him as if he were not there, a silence too insistent to be resisted and too ambiguous to be deciphered and definitively interpreted—nothing to offer but a woman's gesture in a window, a door left ajar, the smile of a guard before a forbidden threshold, a gaze condemned to death" (ibid., 28).

As the social-spatial force of the Outside, attraction is no more and no less than whatever lures you to walk through just one more time, to linger a few minutes longer, to go back again and again, just as you were about to leave, or quit, each and every time. In being attracted, one is then "outside the outside, which is never figured, only incessantly hinted at" (ibid., 29) by a towel left on a hook, a discarded note, a foot under a partition, inescapable lingering, a wink, a turning around, "aimless movement" (ibid.).

Infinitely non-reciprocal, attraction only finds reciprocity in negligence. The intensity of attraction, its attractiveness if you will, is an unavoidable negligence. "Whoever believes he is attracted finds himself profoundly neglected."[33] This negligence occurs precisely when you are attracted and absolutely disregard your surroundings, and forget where you are. Obviously this is risky, yet it is precisely the risk of being attracted by attraction—the uncertainty and indeterminacy of this attraction-unto-negligence—that is erotic.

As a coming at the point of departure, attraction is an unbecoming

relationality, a leaving, a disappearing, and even a betraying of identity and sociability. As a form of erotics, attraction is what remains beyond "the two readymade formulas of the pure sexual encounter and the lovers' fusion of identities."[34] In other words, this is erotics as something more (or less) than fucking or intimacy. What is it that remains in relation to the Outside, that which remains in remaining with-Out, a remaining with-Out that is an incessant coming, a coming without end?

Waiting. Interminable waiting in the midst of incessant coming.

Waiting is without expectation and yet because it awaits nothing, it is insatiable. For since any arrival or other form of gratification would be its end, waiting must ceaselessly betray itself by "withdrawing everything that is awaited."[35] Yet this withdrawal also makes waiting inconsolable, since it only finds consolation in its insatiability, its fulfillment in its disappointment. Therefore and perhaps contrary to one's sense of things, waiting is most impatient: all the time in the world—the time that it awaits—is all the time that it does and does not have, the *untimeliness* of waiting.[36] So waiting is also itinerant, since, in waiting for what never comes, in the coming of waiting, waiting is always and only moving or departing, never arriving. It is the irremediable relation to the Outside, and its attention (or attraction) is so intense that it is its forgetting (or negligence). For "waiting gives attention while withdrawing everything that is awaited."[37] It is in forgetting that the wait remains waiting, which is to say, it—waiting—is what remains in forgetting. Waiting forgetfully attests to the sense that something remains in forgetting. Waiting, as what remains in its forgetting or fleeing, is a relation with-Out (i.e. without content) that is a withdrawing from either here or there, inside or outside, visible or hidden.

> "Where do they wait? Here or outside?"—"Here, which keeps them outside."—"In the place where they speak or the place about which they speak?"—"The force of waiting, maintained in its truth, is to lead, wherever one is waiting, to the place of waiting."— "In secret, without a secret?" —"In secret in sight of everyone."[38]

The movement of waiting-forgetting is the movement of attraction-unto-negligence: neither staying nor leaving but remaining—insatiably, inconsolably—with-Out. Neither *with* nor *alone,* neither fully integrated into a social whole (e.g. community, intimate couple, or even the quick fuck) nor absolutely alone (since, as with every form of solitude, "we can-

not be alone to experience" it),[39] the one who waits is absolutely beside himself.

> He had always suspected it: if he waited, it is because he was not alone, removed from his solitude so as to be dispersed in the solitude of waiting. Always alone to wait and always separated from himself by waiting that did not leave him alone.[40]

Is this not enough for sociality to exist, and if it is enough, is this *enough* sociality, such that it need not be taken as lacking or, for that matter (unlikely yet possible), as abundance? Further, what kind of sociality —anonymous, imperceptible, uncertain, itinerant—would this be, and would it have an "aesthetic, ethical, or ontological value"?[41] What might value mean in this instance?

That which remains prior to identity, knowledge, judgment, in a word, content, is *irreparable*. The irreparable is the *there is (il y a)* and *it gives (es gibt)* of whatever—that which is without "admiration, reflection, comparison,"[42] as well as without denigration, projection, or differentiation. This is what Maurice Blanchot encountered one night, in reading his friend Georges Bataille's story *Madame Edwarda*. The irreparability of the writing that Blanchot was reading "overwhelmed to the point of silence" (Blanchot, "After the Fact," 62). After the fact of this writing and this reading, there was nothing more to say, except perhaps the fact of that very nothing more (or less), of that very irreparability. For Blanchot, this "most minimal of books," pseudonymous if not anonymous, and "read by just a few people" (ibid.), was quite simply, enough. It was irreparable even though it "was destined to sink clandestinely into the ruins of each of us (author, reader)—with no traces left of this remarkable event" (ibid., 62–63), perhaps although not exclusively due to the historical circumstances ("all this happened during the worst days of the Occupation," ibid.). In fact, if future events that could not have been expected did not occur, we might have been left without knowledge of this irreparable moment. However, "as we know, things turned out differently," since Bataille decided to write a sequel, and Blanchot was therefore somewhat provoked to add comments to that which he had only known as defying commentary (ibid., 63). Nonetheless, something remains of that irreparable moment, even in the wake of the author's proper name, book reviews, and "the full-scale commentaries it has inspired" (ibid.). And this irreparable something is attested to by Blanchot as "the

13

nakedness of the word 'writing,' a word no less powerful than the fever-
ish revelation of what for one night, and forever after that, was 'Madame
Edwarda'" (ibid.).

The erotics of this encounter are as inescapable as I would argue erot-
ics to be irreparable, if only one were to leave it, as is. To leave the erotic
as is would mean that a blow job would be nothing more, although cer-
tainly nothing less, than a blow job. The pure intensity of a blow job, that
is, a blow job unencumbered by either sexual profundity or social mo-
rality, is simply the fact that "it gives" (*es gibt*). *Head,* is the *it gives* of the
blow job.

Unfortunately, the uncertainty that is the non-conditioning condition
of the irreparable often provokes an insistence of attention that is epis-
temological and discursive. This is a form of attention that wishes to turn
the uncertain into the certain, the unrecoverable into the recoverable,
rather than give the uncertain the inattentive attention that it gives, and
the unrecoverable the negligence that it needs. These shifts in status, or
more accurately a shift from being *without* a status to being *with* a status,
may mark the regulatory translation of promiscuous erotic perversity
into the normalizing discourse of sexuality.

In his story *The Last Man,* Blanchot gives voice to this struggle
over uncertainty and the resistance to simply leave sociality in all of its
indeterminacy.

> He gave me the feeling of eternity, of a person who would need no justifi-
> cation. . . . The moment we met, I was lost to myself, but I also lost much
> more, and the surprising thing is that I struggle, that I can still struggle to
> get it back. Where does that come from? Where does that come from in
> that space where I am, where he has brought me, I constantly go back near
> the point where everything could start up again as though with a new be-
> ginning? For this, it would be enough to . . . He says it would be enough if,
> in fact, I stopped struggling.[43]

This is a struggle over subjects (subjectification), meanings (signifi-
cation), and ownership (property, possession of/by proper selves), at the
expense of non-defensive, non-paranoid forms of relationality that would
be forms or forces of belonging, without belonging *to, with,* or *for.* This
pure belonging—without vindication, reparation, recognition or verifica-
tion—is exactly what the State, society—State-society—cannot tolerate,

"a threat the State cannot come to terms with."[44] In his preface to Renaud Camus' tales of one-night stands, *Tricks,* Roland Barthes makes this very argument:

> [W]hat society will not tolerate is that I should be . . . nothing, or to be more exact, that the something that I am should be openly expressed as provisional, revocable, insignificant, inessential, in a word: irrelevant. Just say "I am," and you will be socially saved.[45]

The erotic, as this irrelevance of being, is a force that makes subject-hood, identity, citizenship, and sociability, unbecoming. This is what Leo Bersani means when he asks after the "kind of social cohesion and political expression [that] might develop from the knowing ignorance that brings two strangers' bodies together."[46] My sense is that it would be a social-sexual ethics without pre-determined—and perhaps with indeterminate—content, parameters, and valuations. It would be an erotic ethics, in distinction from merely an ethics of erotics, and something other than, yet perhaps alongside, sexuality.

An erotic ethics would not allow for either positive or negative affirmations, since it would neither seek to avow nor disavow its forms and forces, but would rather insist on their unavowability. The relationality of this erotic ethics is what William Haver has referred to as "an essentially *perverse* nonpositive affirmation; it is this nonpositive affirmation of our impossible commonality (and community in its *perversity*) that is here being designated by the term 'queer.'"[47]

It is based upon this notion of ethics that I take issue with Michael Warner's recent elaboration of an ethics of queer life.[48] In his book, *The Trouble with Normal*—an extremely necessary intervention against the ongoing mainstreaming of contemporary queer culture—Warner argues for a disruption of what he calls the "politics of shame." The politics of shame polices sexuality yet does so not through repression but by articulating hierarchies of shameful sex. To the extent that sex is rendered shameful, identities associated with sex are stigmatized to greater or lesser degree. As Warner observes, over the course of the past decade (but with a genealogy extending back to at least the 1950s) mainstream gay and lesbian politics has fought for the recognition and de-stigmatization of gay and lesbian identities, by disassociating these identities from sexual acts. The endeavor to disassociate identities from acts, although

15

untenable, has effectively intensified the politics of shame while attempting to destigmatize identities. This effect underscores the inextricable relations between sexual identities and sexual acts, and Warner's analyses of recent debates between the two attests to their inextricable relations (i.e. U.S. military policy on gays and lesbians).

A shift in emphasis (politically, theoretically) from identities to acts is considered to be one of the most critical interventions of queer theory in discourses of sexuality. Yet I wonder whether the choice between identities and acts as objects of inquiry and sites of contest has not in fact limited the work that queer theory may be capable of doing. More specifically, the question may be not only whether there might be ways to think relationality other than through the sexual, but also, whether in doing so, one might need to think in terms other than those of identities or acts. Are identities and acts the only things with which we have to work in thinking about relationality, or are there other things, perhaps less circumscribed by discourses of sexuality, that remain before or after identities and acts? If something does in fact remain, is it enough for an ethics and/or a politics to exist?

In terms of stigma and shame, identity and act, Warner states that "to have a politics of one without the other is to doom oneself to incoherence and weakness" (Warner, 31). Perhaps a politics without verifiable identities and acts (even those that are stigmatized and shameful) may be incoherent (although I am not completely convinced of this), but what of an ethics without verifiable identities and acts? Such an ethics would not be a complete denial of identities and acts (how would such a denial ever be possible?), but would be an interruption in the discursive protocols that make identities and acts verifiable. This then, would be an ethics without sexual content, what I am calling an erotic ethics: without a positive, epistemological ground, and therefore without a struggle for recognition (even a shameful recognition).

Warner's ethics of queer life is predicated upon owning up to the shame that is ascribed to sex acts, a scripting that often identifies these acts as queer. Furthermore, Warner argues that we should not only embrace this shame, but also dignify it. The problem that I have with this argument is not simply in its reversal of terms, nor in the specific status that is being avowed, but that a status (if not exactly an identity) is being avowed in the first place. Where does such an avowal leave one, ethically and politically? It seems to leave Warner defining an ethics of queer life

that undermines the very qualities that he finds most promising, including the non-hierarchical potential of his version of ethics.

For in Warner's ethics, shame is disavowed or divested of its negativity by being subversively repositioned, and is positively avowed by being dignified through its defiant repetition of shame. Therefore, shame is something to fight over, and the dignifying of shame is the way in which queers ought to fight. However, it is my sense that unless one is willing to neither own nor disown something like shame, one will always find oneself struggling over subjecthood, signification, and ownership—in a word, over content. I would argue that when it comes to shame, one should not even dignify it, but simply act as if one couldn't care less. It would be a matter of evacuating sex of any possible profundity, even making profoundly shameful sex impossible, or at least less than desirable.

Instead, Warner's definition of an ethics of queer life based upon shame is an ethics that maintains logics of evaluation, hierarchy, and unification. At one point he writes, "I call its [queer culture's] way of life an ethic not only because it is understood as a *better* kind of self-relation, but because it is the premise of the *special* kind of sociability that *holds queer culture together*" (Warner, 35). A bit further, he states that, "[a]t its best, this ethic cuts against every form of hierarchy you could bring into the room," and yet in the sentence prior he relies upon a sense of hierarchy, telling us that "you stand to learn most from the people you think are *beneath* you" (ibid.). This may be an inversion of hierarchies, but it is a matter of hierarchies nonetheless.

Obviously the move to dignify shame is only possible through a hierarchical logic of elevation and reduction, such that shame is raised to a dignified level, and/or dignity is lowered several notches to the depths of shame. Inevitably, the result is a hierarchical structuring of shame itself, a hierarchy that is separate from its denigration by the "good, normal, natural." Once shame becomes a substantial position that one must occupy and the basis for criteria of evaluation, it leads to notions of greater or lesser degrees, more and less authentic forms of shame. This is what allows Warner to argue for the political radicality of shame, as when he writes, "Those closest to the stigmaphile world will express the most radical political defiance" (Warner, 43). In other words, this would be a politics and perhaps an ethics in which would be heard: you're so wonderfully shameful whereas you, over there, you're not nearly shameful enough. Warner's ethics of queer life in shame is nothing more than a counter to

what he calls a "hierarchy of respectability" (Warner, 49). Rather than the ladder of normal respectability, this is the slide of unrespectable shame; nonetheless, they still constitute a single game of shoots and ladders.

Although Warner's sense as to the attachments between stigma and identities, shame and acts, is undoubtedly accurate, to think an ethics in these terms is to remain within, in David Halperin's words, the "normalizing apparatus of sexuality,"[49] since identities and acts are the constitutive elements of any discourse of sexuality. This is what Foucault's work on sexuality has been able to teach us. Yet it was also what provoked him, following the publication of the first volume of *The History of Sexuality*, to think beyond identities (categories of individuals) and acts (sexual practices), towards rather unspecified—and perhaps unspecifiable—forms of relationality and modes of pleasure. Persistently indeterminate and therefore largely unrecoverable, these are the forms and forces that Barthes, in the passage quoted above, referred to as insignificant and irrelevant, yet not necessarily inconsequential. Quite the contrary, since in their unworking of sexuality, in the evacuation of its content, they have the potential to make identities and acts irrelevant. As Halperin reminds us, Foucualt's later work was an "effort to denaturalize, dematerialize, and derealize sexuality so as to prevent it from serving as the positive grounding for a theory of sexuality, to prevent it from answering to 'the functional requirements of a discourse that must produce its truth'" (Halperin, 110).

It is in these terms that Foucault can be said not to have written a theory of sexuality, since any such theory would posit sexuality as a substantiality and would therefore be a theory *of* something. Rather, Foucault's work on sexuality was a critical investigation into the ways in which something like sexuality comes to be substantialized, again and again. Most importantly, Foucault seemed to have undertaken this work convinced that there were forms and forces of attraction and negligence that defy the discursive closure of sexuality, those things that, in Halperin's words, "modern sexual discourse and practice include but largely ignore, underplay, or pass quickly over" (94). However it is not a matter of incorporating or recuperating them, but of figuring out how they may remain uncertain, anonymous, and indeterminate, prior to and in the wake of acts and identities. The latter may be verifiable gatherings of the former,[50] but even in this process, something continues to come in the midst of the coming into being of identities and acts, something that

remains unverifiable yet undeniable—the Outside of sexuality—erotics. This would not be a mode of territoriality in which claims are made to a position of substantial content, but rather what Halperin refers to as a "desubstantialization of sexuality" (111). Such an evacuation or hollowing out of sexuality's content would be a deterritorialization of acts, identities, positions, sites, and statuses.

Erotic relationality, as the force of attraction and negligence, might begin to suggest an ethics without content in which, for once, we might find ourselves in relation with-out (and without) the desire or need for either positive or negative affirmation, or some imagined in-between, such as ambivalence or irony.[51] "As indeterminate spatial bodies, we are thus something else than calculating individuals, members of communities, or even cheerful participants in a nice 'civil society.' "[52] This *something else* is the non-relational relation to the Outside, to whoever, whatever, wherever, and whenever, a relation that in its promiscuous erotic perversity can only be non-positively affirmed (which is not to define it negatively) as the logic of the lure.

The waiting attracted by the uncertainty and indeterminacy of attraction—of being attracted by attraction—is not only erotic relationality's negligence or forgetting, but also the negligence or forgetting of the law. For like the placeless place of erotics, the law is neither interior nor exterior (as either consciousness or codification) but is the contradictory relation of all dialectics without being dialectical itself. It is the Outside that envelops conduct and into which it is always receding without ever reaching definitive closure. In other words, the law necessarily and inevitably fails, and in this failure finds its power.[53]

To the extent that the law, in its solicitude, relies upon a negligence or forgetting of the law (which is to say that it attracts in its uncertainty and indeterminacy), it can often be mistaken for the attraction-unto-attraction that is the relationality of erotics. To put it more simply, the non-erotic logic of the law may at times, perhaps quite often, resemble the erotic logic of the lure. Thanks to this homology, law enforcement agencies entrap men who, in being attracted to the law's solicitous negligence, mistake the logic of the law for the logic of the lure, and are then arrested for soliciting sex from a "stranger" (a police officer) in a "public" park, restroom, etc. As a resemblance to an outside that is at the same time embedded within the law, this homology may locate the first and last homologic: the logic and law of resemblance.

So how does one elude the logic of the law without abandoning the logic of the lure? Neither by obeying or abiding by the law, nor by disobeying or transgressing it, but by intensifying its logic of attraction and forgetting, something like *awaiting* the law. Awaiting the law would mean never *not* waiting for it (which would surely guarantee the arrival of the law), but awaiting the law in the sense that it is always on its way, never stopping, always coming. Awaiting the law would be a relation to the Outside of the law, to the law *without arrest*. It is in this way that queer erotic itinerancy eludes the territoriality of the law's circulation as campaigns against public lewdness, pressures of propriety, inscriptions of stigma, and the politics of shame.

It is important to note that the criminality of queer erotic itinerancy is beyond merely a transgression of the law, since that would place it back within the space of the law, as in the form of punishment "which would be the law finally placed under restraint."[54] Rather, it is the approach of erotics that is as intense as the law's perpetual receding, "the endurance of a movement that will never end and would never promise itself the reward of rest" (Foucault, "Outside," 56). The "approach of forgetting and the distance of the wait" (ibid., 24) is the *when* and the *where* in which queer erotics awaits the law that never comes. Because queer erotic relationality is insatiable, it is always coming, never arriving, and is therefore always further from where it was and where it wants to be. It is a past without a history, a future without futurity (something other than the not-yet-present), an untimely relation without a context, historicity as the impossibility of historicization. This is what Barthes may have had in mind when he wrote of "the encounter of a glance, a gaze, an idea, an image, ephemeral and forceful association . . . a faithless benevolence: a way of not getting stuck in desire, though without evading it; all in all, a kind of wisdom."[55]

Queer erotic relationality suggests an ethics that is outside of or, more accurately, beside a "system of interdictions."[56] It is motivated by the idea, expressed by Foucault during a series of conversations at UC-Berkeley on the "genealogy of ethics," "that ethics can be a very strong structure of existence, without any relation with the juridical per se, with an authoritarian system, with a disciplinary structure."[57] This ethical withdrawal from normative structures may be one way of understanding Foucault's notion of ethics as an aesthetics that would be the practice of

ascesis. Inspired by the ancient Greek notion of a rigorously experimental and creative self-fashioning, *ascesis*—as a mode of ethical conduct—would be less a mode of being than of becoming through a relinquishing or refusing of what today we often call our "baggage." Think of it as a becoming of self that is an unbecoming of self, an *art of living* that is an *art of leaving.* One would no longer be the subject of the law but would be a subject unto the Outside, beyond even the status of an outlaw. By withdrawing the *self* from *oneself, anyone* refuses the imperative to be *someone.* In the unbecoming of self, one remains anonymous, an incapability of being named that is not simply the limit of nominalism, which would be what Blanchot has referred to as bureaucratic anonymity, but simply the anonymity of anyone (which is not to say everyone).[58]

In this chapter, I have tried to give a sense of the ways in which ontology as unbecoming is a mode of spatialization through which the self is always a straying from itself, always beside itself. This is not simply an ethical relation to oneself or to an other, but the way of tracing ethical relationality itself, as that being-within-an-outside, of being with-out, a moving beyond without being a transcendence, a becoming that is unbecoming—*ascesis.* In turn, this attenuation is not a reduction or a suicidal renunciation of self, but rather an intense desubjectification, in which notions of individuality in the form of a subject, of intersubjectivity in the form of intimacy, and of collectivity in the form of community are rendered impossible. This is "the community of those who have nothing in common."[59]

Such an intense desubjectification renders one neither famous nor unknown, but infamous (*infâme*). These are the ones—precisely *whoever*—that Deleuze described, in his admiring remarks on Foucault's essay "The Life of Infamous Men," as "insignificant, obscure, simple men, who are spotlighted only for a moment by police reports or complaints."[60] They are no one in particular, "'anybodies' before being turned into 'somebodies.'"[61] Their deterritorialized movement is a sidestepping of emplacement: neither outside nor inside, neither here nor there, but elsewhere, in a place that is something other than "an experienced place-in-space."[62] These anonymous no ones, in their irreducibility and iterability—which is to say in their singularity and multiplicity—are neither individual nor universal, but exist as the specificity that takes-place in multiplicity. A specificity that is not an identity, prop-

erty, concept, genre, or class, but rather a specificity that is always already relational.

Infamous anonymity is also formless: "less than a form, a kind of stubborn, amorphous anonymity—that divests interiority of its identity, hollows it out, divides it into non-coincident twin figures, divests it of its unmediated right to say I, and pits against its discourse a speech that is indissociably echo and denial."[63] As an aesthetics of life, this divesting of interiority, identity, and subjectivity—in a word this ascetic form of being-beside-oneself—is a relation to the Outside, and this I would argue is the place of ethics.

Being beside oneself is "suddenly to feel grow within oneself a desert at the other end of which (but this immeasurable distance is also as thin as a line) gleams a language without an assignable subject, a godless law, a personal pronoun without a person, an eyeless and expressionless face, an other that is the same" (Foucault, 48). Because it is a relationality without a bond (a non-relational relation), being beside oneself is as much unworkable as it is unbecoming. Becoming-disappeared, finding a way Outside, is what the State, law, civil society (perhaps even queer theory) cannot tolerate, and what architecture forbids. "Institutional codes [including the architectonic] can't validate these relations with multiple intensities, variable colors, imperceptible movements, and changing forms."[64] These are forces of relationality that remain attractively unverifiable and audaciously negligent, incessant refusals in a world of positive and negative affirmations, which can only be known at those moments when they come in contact with power-knowledge. It is there and then, in the glare of epistemology, that they come to be identified, situated, and rendered visible as social identities and subjects within a State-based bureaucracy.

> In order that something of this should come across even to us, it was nevertheless necessary that a beam of light should, at least for a moment, illuminate them. A light which comes from somewhere else. What rescues them from darkness of night where they would, and still should perhaps, have been able to remain, is an encounter with power; without this collision, doubtless there would no longer be a single word to recall their fleeting passage.[65]

We might imagine that the sudden glare of light that Foucault speaks of in this passage might be coming from the headlights of a squad car as

the police show up at a late-night cruising ground. Only now can those who have side-stepped regimes of identification become known as infamous, for up until now they existed within-the-outside, an "immeasurable distance [that] is also as thin as a line,"[66] the attenuated path of becoming-disappeared.

...

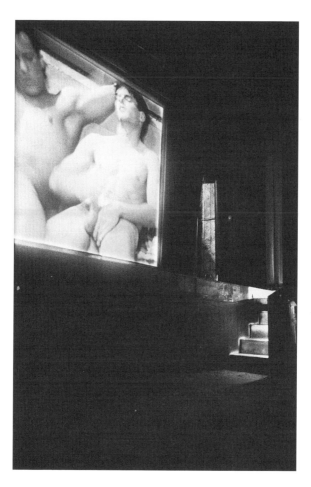

1. Stephen Barker, *Untitled* [neg. 11-33] (1994), gelatin-silver selenium-toned print; from the series *Nightswimming* (1993–94), New York City. © 1999 Stephen Barker.

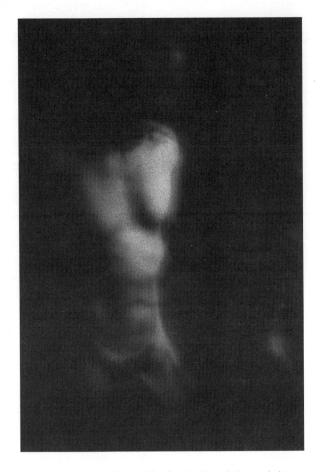

2. Stephen Barker, *Untitled* [neg. 9-19] (1994), gelatin-silver selenium-toned print; from the series *Nightswimming*. © 1999 Stephen Barker.

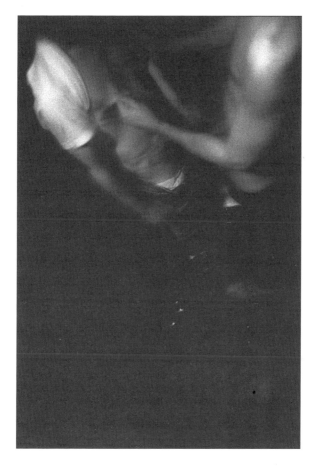

3. Stephen Barker, *Untitled* [neg. 46-28] (1994), gelatin-silver selenium-toned print;
from the series *Nightswimming*. © 1999 Stephen Barker.

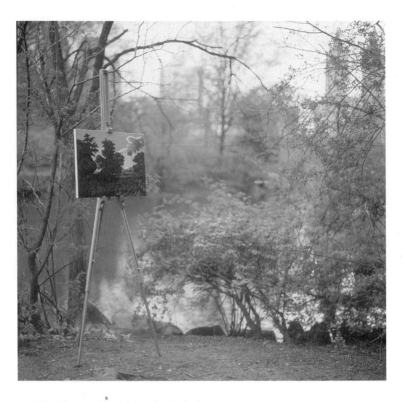

4. Matts Leiderstam, *Returned, The Rambles* (1997), oil
on canvas and an easel. Courtesy of Matts Leiderstam.

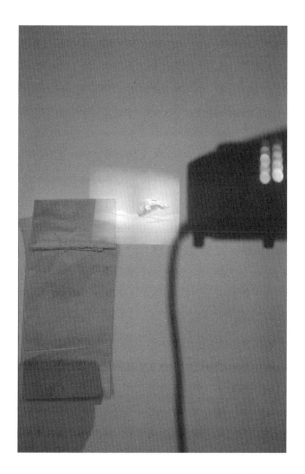

5. Doug Ischar, *Mock* (1995), mixed media; from the installation *Wake* (1994–96). Courtesy of Doug Ischar.

. .

To the extent that this writing you have been reading does not leave these infamous men alone, and "illuminates" forms of itinerancy and imperceptibility that maintain an anonymity through the logic of the lure, it runs the risk of implicating itself within these very same protocols of power-knowledge. In consideration of the ethical and political questions that are raised in writing an ethics and politics of queer erotic relationality, I have deliberately avoided the taxonomic desire to identify, categorize, historicize, and map persons, places, and prac-

tices. For this has been the exclusive project of the recently recognized discourse of "queer space," and I not only do not wish to participate in this discourse, I do not even think that such a thing as "queer space," can be posited in the first place. To do so is to rid queer sociality of its capacity to interrupt these very epistemological imperatives.

Rather, I have attempted to write in an anonymous voice something that might begin to approach "a non-communicative, incomprehensible audibility; an erotic, sensuous palpability; an ontological stammering."[67] To have done so is to have done nothing in my writing other than to leave my subject (that is, *whatever*) as is, and to remain loyal to its irreparability by necessarily betraying discourse (especially "queer space" discourse). Anonymous writing exists at the limits of discourse, as self-effacing writing and as a becoming-disappeared in writing. No doubt this is a difficult task to maintain, and the reason why Foucault, in writing of this anonymity in writing, admitted a "rather shaky hand." In the well-known final paragraph of the Introduction to his *Archaeology of Knowledge,* we read of a difficult yet pleasurable and persistent writing that is a form of itinerancy through which one can approach the Outside of discourse and become anonymous amongst other nameless strangers and perhaps become-disappeared.

> What, do you imagine that I would take so much trouble and so much pleasure in writing, do you think that I would keep so persistently to my task, if I were not preparing—with a rather shaky hand—a labyrinth into which I can venture, in which I can move my discourse, opening up underground passages, forcing it to go far from itself, finding overhangs that reduce and deform its itinerary, in which I can lose myself and appear at last to eyes that I will never have to meet again. I am no doubt not the only one who writes in order to have no face. Do not ask who I am and do not ask me to remain the same: leave it to our bureaucrats and our police to see that our papers are in order. At least spare us their morality when we write.[68]

We might imagine this to be the voice of Bartleby the Scrivener, Herman Melville's infamous writer who *preferred not to.*[69] As we might recall, Bartleby—employed as a copyist in a lawyer's office—never said, "I will not," but always said, "I would prefer not." The form of this refusal is what the lawyer in the story refers to as a "point blank refusal," and no description could be more accurate. For Bartleby's preference not to, although obviously not an expression of wanting, is not exactly an expression of the com-

plete lack thereof either. Instead, Bartleby's refusal effects an evacuation of content, including any negative residue, and what is so disarming about it is that it is utterly without intention or objective. His speaking is an absolute withdrawal, being neither with speech nor without, but the withdrawal from both, a passage toward the limit of language. The only thing that he says, and practically the only words that he speaks are, "I would prefer not to." This not-wanting-to-speak, in its saying, understandably perplexes the lawyer, and as speech at odds with itself—as speech folded in on itself—may be a definition of perplexity itself.[70]

Bartleby's refusal is an interruption of speech and of the positive and negative affirmations through which it operates. He neither does prefer nor does he not prefer, but rather "would prefer not to," and in this exact sense his refusal is a non-positive affirmation. To prefer the logic of neither/nor is to prefer neutrality, and to prefer neutrality is to exist in an ethical relation to *whatever*. A man of preferences, including the preference not to, is a man without assumptions (including moral assumptions). Bartleby's incessant writing, all the while preferring not to, leads to a form of worklessness, in which at first he would prefer to do nothing else, and eventually would prefer not to do *that* either. So he gives up copying, yet for much of the narrative remains at his desk, behind a high green folding screen in a corner of a mid-nineteenth-century lawyer's office on Wall Street—a minor architecture which, like this chapter, is written through a minor writing.

Disappeared

The normative logic of relationality offers the choice between either being-with (a relation in the positive sense of the term) or being-without (a relation in the negative sense). Spatially, it delineates and regulates the differences between inside and outside, such that being-with is a relation of interiority and a process of interiorization, while being-without is a relation/process of exteriority/exteriorization. A further conflation arises across the registers of the social and the political, as relationality is consolidated in forms of bonding or union (being-with) and as it faces its dissolution through loss (being-without). In their delineation of limits and borders between the proper and the improper, discourses, rituals, and rhetorics work towards the institutionalization of social relations of union and loss. These institutions of the indivisible (Derrida) represent the positive and negative affirmation of the social, and it is through such inclusionary-exclusionary forces that the social can be said to exist.

This testimony to the existence of the social as structuring/de-structuring bond often takes the discursive form of a narrative, a story that is told about the social, and through which the social is constituted as narrative, for instance through stories of union and loss. Paradigmatically, these narratives take the form of marriage plots and mourning rituals, and in both instances social boundaries are enforced, social identities are validated, and the rewards of sociability are bestowed (or withheld). These are some of the ways in which one becomes a social being, which is to say, a member of a universalized *we*.

As queer theorizations of narrative, D. A. Miller's analysis of the marriage plot and Paul Morrison's analysis of mourning rituals have outlined the normalizing functions of these narrative genres, and have demonstrated the specific ways in which they consolidate heteronormative and homophobic forms of sociality.[1] For Miller (and those of us who are also not of the marrying kind), the marriage plot is a (the?) preeminent device in the social exclusion of anti- or non-normative sexualities, a social plot as much as it is a story of the social. In turn, Morrison unsparingly ascertains the ways in which mourning—as a narratological relation between the dead and the living—in the time of AIDS effectively disappears gay male subjects from both sides of the social divide.

To register what this often sounds like, I have quoted at length from two stories, both of which happen to occur in a church. The first is an encounter with a wedding, the second is an attendance at a funeral. These are stories about not being in stories, stories about having been disappeared through stories, of no longer being granted the status of social subject, which is to say, someone with a story. The first anecdote is Roland Barthes' as reiterated by D. A. Miller, and the second is Simon Watney's as quoted by Douglas Crimp. In the chiasmic relation between the two stories (as the rice is thrown and the black station wagon arrives), one can begin to discern the homophobic and the AIDS-phobic effects of narrative, as narrative records stories of union and loss, marriage and mourning: two forms of queer bashing that equally resound with the words "till death do us part." In the course of this chapter I will further elaborate the ways in which becoming-disappeared, as the unworking of visual representation, can be an effective tactic for refusing such regulatory regimes of social identity; for now, I simply wish to note the silencing force of the social symbolic itself.

An incident from Barthes's life, recounted by him as though it had befallen someone else, offers me a reason why I always cry at weddings: "Walking through the Church of Saint Sulpice and happening to witness the end of a wedding, he has the feeling of exclusion. Now why this faltering, produced under the effect of the silliest of spectacles: ceremonial, religious, conjugal, and petit bourgeois (it was not a large wedding)? Chance has produced that rare moment in which the whole Symbolic accumulates and forces the body to yield. He had received in a single gust all those divisions

of which he is object, as if suddenly, it was the very being of exclusion with which he had been bludgeoned, dense and hard."[2]

In the opening pages of *Policing Desire*, Simon Watney recounts a funeral service similar to those many of us have experienced, an event that made him decide "then and there" that he would write his book on AIDS. "[Bruno's] funeral took place in an ancient Norman church on the outskirts of London. No mention was made of AIDS. Bruno had died, bravely, of an unspecified disease. In the congregation of some forty people there were two other gay men besides myself, both of whom had been his lover. They had been far closer to Bruno than anyone else present, except his parents. Yet their grief had to be contained within the confines of manly acceptability. The irony of the difference between the suffocating life of the suburbs where we found ourselves, and the knowledge of the world in which Bruno had actually lived, as a magnificently affirmative and life-enhancing gay man, was all but unbearable."[3]

The unbearable exclusion effected by these two narratives, the alienating violence of these scenes, is highlighted by the fact that these two accounts are recounted secondhand. This is especially made evident by Barthes, as he re-casts himself from the status of a narrating *I* into a narrativized *he*. Barthes uses the third-person singular male pronoun to refer to himself, in recounting an incident that he, Barthes, had experienced. By doing so, Barthes is able to accentuate the ways in which the ostensible narrator of such a story is transformed into an object and thereby occluded in its subjectivity by narration. As the one who is telling the story of an encounter with the social symbolic, Barthes is no longer capable of saying *I* but is instead rendered as an alienated *he*. As discussed above, the social symbolic operates through a series of dialectical distinctions ("all those divisions"): subject-object, same-different, visible-invisible, with or without, inside-outside, etc. By narrating a firsthand encounter with the social symbolic in the form of a secondhand account, Barthes is able to register the way in which he is positioned, by the social symbolic, as the second term in each of these couplings.

In turn, the unbearable distress that Simon Watney experienced at his friend's funeral was not simply predicated upon the homo- and AIDS-phobic rhetoric of the mourning ritual, but more specifically upon the way in which it—perhaps like every mourning ritual—was capable

of denying or withholding Bruno's death, and in doing so, rendered Watney (and others) equally invisible.

Derrida, through his reading of Heidegger's existential interpretation of being-toward-death, in which one's only relation to death is to the death of the other, enables us to understand how mourning that death "institutes my relation to myself and constitutes the egoity of the ego."[4] With this in mind, one can understand the deprivation of Bruno's death through mourning as equally the deprivation of Watney's life in mourning. In that Norman church, it was as though no one had died even though for some, it felt as though Bruno was not the only one deceased. Denied the ability to speak, to maintain a sense of self, perhaps to say "my death" in the encounter with Bruno's, Watney decides then and there that he will rectify this silencing and alienation by writing *Policing Desire*, "his book on AIDS," in which the anecdote, quoted above, originally appeared.

Yet by insisting on the differences between "suffocating" suburban normativity and the "magnificently affirmative" life of a gay man in London, Watney participates in the social logic of positive and negative affirmations in an attempt to fill the void left by Bruno's funeral. It seems that there remains the hope of rewriting the funeral narrative of mourning so as to authenticate the grief of Bruno's gay friends. Rather than allow the encounter to approach the limits of truth in which death and the social are rendered inaccessible, Watney intimates the substitution of one symbolic truth for another.

Barthes, on the other hand, approaches the point at which such counter-negotiations are impossible at any point in time, since he recognizes that the social symbolic has put him in his place, that place of "final alienation: that of his language: [where] he could not assume his distress in the very code of distress, i.e., express it."[5] Therefore, only the impossibility of expression can be spoken, the inexpressibility of a moment that can only be expressed through the withdrawal or refusal of language, discourse, of finding (or accepting) a place within the story. This ethical withdrawal of the self from normative structures, this refusal of being someone, must not be confused with the objectifying modes by which the social symbolic casts those who are not granted subjectivity into the status of outcasts. Rather, this would be what Blanchot has defined as an absolute, categorical, and irreducible refusal.[6] A force of refusal that is

the uncompromising and non-negotiable de-subjectifying force of an unsociable sociality in which sociability itself is refused. As Blanchot emphasizes, this is not simply the refusal of the worst but also of what might appear to be reasonable or felicitous, the refusal of an acceptable refusal, not even the best of the worst, so to speak. In other words, this is a refusal that is without resolution, agreement, or conciliation. The fact "that we will not hear of . . . "; the refusal that is that very fact; perhaps something like the difference between crying at and never attending weddings and funerals.

Nonetheless, while avoiding a victim status one need not deny the very real forms of violence that exist at these moments of social regulation and legitimatization. To do so would be to perpetuate the effects of invisibility and ignorance by which they gain their power. For although one might not want to confuse or conflate various forms of violence, at the same time it seems necessary not to ignore or diminish the ways in which representational strategies function within discourses of AIDS and homophobia. One such example is the pervasive narrative logic that inscribes AIDS as the life-story of gay male sexuality, per se. In this story, ends are transposed onto beginnings as a means of identification and explanation. "The cultural function of AIDS has been to stabilize, through a specifically narrative or novelistic logic, the truth of gay identity as death or death wish."[7] In other words, through the narration of gay male lives in AIDS, gay men do not die of AIDS they are AIDS. By mourning the life of a gay man who has died of AIDS, one runs the risk of condemning this death to a retrospective narrative logic through which homophobic prophecies are considered fulfilled. And if it is not a matter of the fulfillment of homophobia, then it is often the reconstitution of the family in the wake of a gay son's death (which nonetheless may be the same thing).

This has been most famously represented in Jonathan Demme's 1993 film *Philadelphia*. The family of Andrew Becker (the main character who dies of AIDS, portrayed by Tom Hanks) is twice shown gathered together in a family-reunion-like scenario. The first instance is the celebration of his parents' wedding anniversary at the family's suburban Philadelphia home. On this occasion, Becker announces (with his lover, portrayed by Antonio Banderas, at his side and an infant niece in his arms) that he is going to sue his former law firm on the grounds that they terminated his position of employment due to the fact that he has AIDS. The second instance occurs at the end of the film, immediately after his funeral, in his

downtown Philadelphia loft apartment. In this scene, the family is re-united and watches old home movies of Andrew as a little boy. Demme deploys the retrospective force of narrative so as to represent Andrew's life, even as a little boy, as inscribed by AIDS. As a means of explanatory hindsight, AIDS becomes the way to re-view these family films projected at the end of Demme's film (and thereby to review Demme's film as well). Unable to avoid the retro-teleo-logic of narrative, film viewers find them-selves in the implied perspective of Andrew's family, which seems to be saying: look, here is little Andrew who will one day grow up and be a gay man who will die of AIDS.

It is in this way that the social symbolic takes the impossible historic-ity of AIDS and narrates it, as an identity that "others" possess, even those others who are supposedly our own. The distantiating effects of such reification is part of an attempt to find a place outside of AIDS, a place, albeit impossible, in which one is no longer affected by AIDS. It is to deny the fact that "in the time of AIDS, we all live and die 'in AIDS' (as one is said to live and die 'in religion'), whether or not we die 'of AIDS.'"[8]

35

Resistance to this narrative historicization calls for an incessant vigi-lance and an ever more uncompromising refusal of these very social log-ics. It is to prefer not to be identified, domesticated, and narrativized, and instead to remain in relation *with-out* these predications. This is a sub-junctive (rather than a subjective) temporality, in which the temporal logic of narrative, in its retro-teleology, is effectively disrupted. The subjunctive is the temporality of a past that would have come and a future that would have been. This is a folding of historical time that makes it impossible to speak from beginnings and towards ends, or to transpose ends back onto beginnings and find explanations in this sense of inevitability.

Surely such refusals and withdrawals cannot be tolerated by normaliz-ing logics of relationality that demand either being-with or being-without, and have no use for those who refuse sociability and indeterminately exist as being-with-out. Therefore, the latter always run the risk of being ensnared by subjectivizing discourses, if only to be identified as illicit, perverse, illegitimate, mad, suicidal, etc. It is through these attributions that such "others" are disappeared into bureaucratic anonymity and in-teriorized in social institutions (i.e. prison, asylum, and military). This is in fact the very way in which so-called "others" become "others."

Therefore as a means of resistance it cannot be a matter of overcom-ing or transcending but rather of intensifying these very forces of disap-

pearing, and in ways that attest to the inevitable difficulty if not the impossibility of such intensification. This is the need not simply to occasionally refuse, or to do so in ways that are acceptable, but to refuse incessantly and in ways that are irrecoverable. Rather than taking these social discourses, rituals, and rhetorics as occasions for assimilation (to reconfigure narrative so as to make room for those excluded) or reform (to reinterpret these forms so as to excavate gay presence that, it might be argued, has otherwise gone unnoticed), it is a matter of forcing a crisis of signification and representation, by persistently evacuating the social of verifiable content. It is the ethical-political reasoning that "what is called AIDS is, for consciousness and for thought, a necessarily impossible object. As such, and in itself, AIDS is radically unthinkable, resisting objectification, interpretation, the understanding, meaning, and the aspiration to transcendental subjectivity absolutely; AIDS belongs to that to which every teratology, phenomenology, or hermeneutic is necessarily and forever inadequate."[9]

The time of AIDS is, as Haver and others have argued, the time in which all of us undeniably live even though the specificity that is its historicity is continuously occluded by modes of recuperative reification, for instance through processes of narrative historicization. Living in the time of AIDS is not only an existential condition for the ontological leaving that I theorized in chapter one, but also a condition for living as an interminable relinquishing or losing.[10] Like the woman who, according to Hélène Cixous, does not mourn, one finds it impossible to either work through loss (mourning, so as to live without loss) or to remain in loss (melancholia or living with loss).[11] Rather than either this negative or positive affirmation of loss, one might approach the difficult if not impossible relation to absolute loss, which would be loss as the losing of every predicate whether positive or negative. It would be a matter of living as losing. "When you've mourned, it's all over after a year, there's no more suffering. Woman, though, does not mourn, does not resign herself to loss. She basically takes up the challenge of loss in order to go on living: she lives it, gives it life, is capable of unsparing loss. She does not hold onto loss, she loses without holding onto loss."[12]

To be capable of unsparing loss would be to bear the capacity of losing everything, including loss, not to hold onto loss but to lose it, to let go of loss, even. Loss that is not spared is what we might mean when we speak of unsparing loss. Such an impossible relation necessarily would be ir-

recoverable, non-negotiable, and without mediation. This would be a non-redemptive relation to loss that would exist without surrogates, scapegoats, and other dissimulating figures that, in their figuration, would amount to the betrayal of loss. Instead, Cixous describes a sense of loyalty to loss, and thereby suggests an ethical-political relation to AIDS in its interminability, a place that leaves one at a loss, the placeless place of historicity and ethics. For without this, as Derrida writes, "there will never be any event, decision, responsibility, ethics, or politics." [13]

Being-unto-death, as an (the) existential predicament, is all the more exacerbated by and materialized as the irresolvability that is AIDS. The historicity of AIDS is the time of the immemorial and imminent, the not yet and the no longer, prior to and in the wake of, at once. This time, arguably the time of survival, effects an irrecusable "retrospective anticipation that introduces the untimely moment and the posthumous in the most alive of the present living thing, the rearview mirror of a waiting-for-death [s'attendre-à-la mort] at every moment." [14] This is what it might mean to think one's place in the time of AIDS as being at the limit in the midst of it all, an unavoidable blind spot or *aporia,* conditioned by the untimeliness of AIDS. For here and now, this midst and this limit define the place of historicity in the time of AIDS, and as such, the exigency of a double refusal neither to perpetually mourn nor to willfully forget but to live loss as the confluence of dying, testifying, and surviving. To do so requires an evacuation of the comparative "as" from the expression "living as losing," since one would need to articulate that relation to loss that is the withdrawal of distinctions between self and other, and before and after, that otherwise would be preserved if one were to think this relation as something other than the losing of relations that it is. [15]

A poetics of perverse becoming therefore may be necessary in order to approach the incessance of this interminability. Carl Phillips writes this in his poem *Cortège,* a portion of which reads as follows:

> One is for now certain he is
> one of those poems that stop only;
> they do not end. [16]

The end that does not come is not an end as yet unfinished or still incomplete, as though to suggest that at some future point in time an end will be reached—the end to come. Rather it is a question of unbecoming beginnings (something like the anarchic) that preclude any ends from

ever taking place. This of course makes narrative and other stories with beginnings and ends, including artists' bio-narratives, impossible.[17]

For instance, although Derek Jarman's film *Blue* (1993)—which I shall treat (perhaps impossibly) as a paradigmatic example of a disappeared aesthetics—is unquestionably his last, the rhetorical logic of historiciza-tion (in the related forms of artist's bio-narrative, life work, and aesthetic judgment) has defined it as late.[18] However, in the time of AIDS, in which one can speak of pasts that might have been if only one's future was not prematurely contracted into one's present, differences between pasts and futures are no longer reliable. It is not so much that time has been nul-lified, as that it has been infinitely and inexhaustibly arrested, and ren-dered untimely. The time of AIDS, its historicity or present-ness, is "a present without end and yet impossible as a present," a future without futurity. For Blanchot, this is the non-redemptive time of suffering, in which time is now without recourse, event, project, and possibility, some-thing like the Outside of time, "a time neither abiding nor granting the simplicity of a dwelling place," the unhomely of the untimely.

Consequently, the notion of lifetime has been destroyed, along with the bio-narrative coherence that would have served as its record. In the time of premature deaths, in the time of AIDS, a dying before one's time—an enfolded temporality that finds expression through the future anterior—robs one of the time of life and of death. AIDS is not the "ul-timate metaphor for lateness,"[19] but the mortal reality of prematurity. Therefore, the notion of lateness no longer applies, and so to rely upon the historicizing logic that gives it meaning is to obscure the force of the uncertainty or historicity of AIDS. "The worst of the illness is the un-certainty," as Jarman said of AIDS. "I've played this scenario back and forth each hour of the day for the last six years."[20]

Conversely, scriptings of early, middle, and late stages of a life or ca-reer can be confounded by the ways in which the absolute singularity yet iterability of historicity (something like survival) can be precisely the re-currence that makes a difference. This is what Jarman visualized and en-acted in much of his cultural production and activism, and most potently in *Blue*. As he said during an interview, "I've written my epitaph about six times now, apparently. Every single film is scotched up as my last. Surely they'll stop on that business, especially if I get another run together."[21]

To be at/as a loss is to be beside oneself: a subtractive ontology that always places one neither with nor without, but elsewhere (with-out).

Neither an active nor a reactive relation, to be at a loss is to be in a non-relational relation which can only be non-positively affirmed. In terms of visuality it is neither a matter of visibility nor invisibility but something like imperceptibility. Linguistically, its temporality is registered as a subjunctive form of the past participle ("would have"), that marks the fact of always already being *within* as one moves towards being *with-out*. Its space is the place of implication, which in turn, and again, would be what it means to be at the limit in the midst of it all.

This folded space, for instance, was the place through which Foucault passed, in his inaugural lecture at the Collège de France in 1970. This was yet another moment in which he attempted to express a desire for anonymity, by making this particularly auspicious beginning unbecoming.

> I would really like to have slipped imperceptibly into this lecture, as into all the others I shall be delivering, perhaps over the years ahead. I would have preferred to be enveloped in words, borne way beyond all possible beginnings. At the moment of speaking, I would like to have perceived a nameless voice, long preceding me, leaving me merely to enmesh myself in it, taking up its cadence, and to lodge myself, when no one was looking, in its interstices as if it had paused an instant, in suspense, to beckon me. There would have been no beginnings; instead speech would proceed from me, while I stood in its path—a slender gap—the point of its possible disappearance.[22]

Foucault's becoming anonymous and imperceptible in the midst of discourse suggests a way to think the conjuncture of the middle and the limit (*aporia*) that is not the "double bind" or impasse by which it is commonly understood. For the double bind is understood to be the conjunction of being-with and being-without, rather than the double refusal of both, which would be an oblique or slantwise trajectory towards elsewhere. "To be enveloped in words" is to be insidiously insinuated in discourse, always already prior to ("speech would proceed from me") and in the wake of ("perhaps over the years ahead") a future without futurity. Visually, this placeless place is the blind spot, "the point of . . . possible disappearance," and its spatial extension is the attenuated path ("a slender gap") of becoming-disappeared. It is the *way* for slipping through discourse, without ever imagining a place outside of discourse (transcendence), or a moment when such deterritorialization is no longer neces-

sary. In its refusal, it bears the subjunctive of Foucault's "would have," a non-positive affirmation.

This is the step (*pas*) of the "not" (*pas*) that is not taken, for to do so would be to move towards definitive finality, to step into the negative position of "will not," a path that is nearly always a dead end, as in suicide. Rather, one might think in terms of a side-stepping, a "coming without *pas*" (step/not), a coming to pass, that is more a form of trespass or traversal than transgression. So "not even the *non-pas*, the not-step, but rather the deprivation of the *pas* (the privative form that would be a kind of *a-pas*)," something like becoming-disappeared.[23] Becoming-disappeared then, is a non-suicidal "dying to no end,"[24] to the extent that it is incessant rather than final in its refusal, and unlike suicide, remains true to disappearance by not making it visible.[25]

The blind spot's obliquity, which is the path of becoming-disappeared, is that trajectory that runs alongside vision while remaining just out of view. In its double refusal and in broad daylight, it approaches the limits of the visible without being invisible—a double *blind* as opposed to a double *bind*. It thereby disrupts the discourse of the visual by effectively making vision and representation impossible. *A disappeared aesthetics visualizes this impossibility (this disaster or crisis) of vision and representation, in its very impossibility.*

In the time of AIDS, a disappeared aesthetics may be the only way to ethically relate to the historicity and sociality of AIDS; to avoid sparing loss as has occurred in the history of symbolizing, narrativizing, and putting a face to AIDS.

Surely it is undeniable that the history of AIDS and representation has largely been a history of symbolizing, narrativizing, and victimizing the conditions and effects that we attempt to name—and necessarily fail to name—when we say AIDS.[26] These strategies to seize control of AIDS through representation have thus amounted to the normalization and de-politicization of AIDS, effects that have been well documented and criticized by others. Also noted, but much less so, has been the work of a small number of artists, theorists, and activists that has approached the very unrepresentability of AIDS. Weary of ideological battles over what constitutes positive and negative forms of representing AIDS, these are practitioners who have understood that such battles are futile, and that the problem is not simply the question of representational content, but

the question of representation itself. Or, more specifically, the metaphorical, narratological, and recuperative logics of representation.

In order to avoid these logics, art's work must be redefined as "tak-[ing] up the challenge of loss in order to go on living" (Cixous). It will do this by visualizing loss as just that, a difficult if not impossible task of being loyal to loss by not recuperating it through artistic practice. Art's work then, would be an unworking (*désoeuvrement*) of the artifactuality of the work of art (*oeuvre*)—a disappeared aesthetics.[27]

In terms of visuality, disappeared aesthetics is neither a matter of the visible nor the invisible, but of the imperceptible. In terms of aesthetic judgment, disappeared aesthetics is neither a matter of the good nor the bad, but of the neutral. And in terms of verification, including that of knowledge, disappeared aesthetics is neither a matter of that which is avowable nor disavowable, but of that which is unavowable. It is in these ways that one might understand disappeared aesthetics as a refusal of either/or logics, a non-dialectical double refusal that is "no-longer-being" and "not-yet-being," at once.[28] At the same time, it will be important to note that in its double refusal, disappeared aesthetics does not occupy some conceptual middle ground but is a side-stepping of such differences, for instance, between the visible and the invisible. A disappeared aesthetics non-positively affirms that visuality is something other than merely the difference between the visible and the invisible. It is "what turns away from everything visible and everything invisible," and this Orphic turning away, in turning its back on the visible and the invisible, is a betrayal, a "double infidelity."[29]

A disappeared aesthetics is precisely that aesthetics which cannot not visualize, and which persistently and defiantly approaches its potentiality to not visualize, to forget, to be rendered blind. In this way, it materializes visuality itself, as the pure potential of visuality, that is, its potentiality to visualize and to not-visualize. It is an attenuation of the visual and, simultaneously, a persistence of the visual in the midst of imperceptibility. It is "an incapacity to stop seeing what is not there to be seen,"[30] something like a visual ascesis, the worklessness or unworking of visuality. To re-write Heidegger, one might say that a disappeared aesthetics is not the impossibility of being-able-to, but the "possibility of being-able-no-longer-to" visualize.[31] The possibility of impossibility that is the aporetics of a disappeared aesthetics consists, "not in showing the

invisible, but in showing the extent to which the invisibility of the visible is invisible."[32]

This poses the potential that there might be a view or a seeing beyond viewing, a seeing-unto-blindness, and a form of visuality that would also be the impossibility of not seeing, something like the pure potentiality of vision and thought. Aristotle drew a comparison to a writing tablet (*grammateion*) on which nothing is written,[33] and Derek Jarman—in what was to be his final film—saw it, while suffering the blinding effects of cytomegalovirus (CMV), as a monochromatic blue. In either case (and a few others that will be discussed below), it is not a matter of ceasing to write, think, or visualize (which would be to operate in a space of negativity within the written, the cognitive, and the visual), but rather, as Herman Melville's Bartleby the Scrivener says, to "prefer not to."[34] Therefore this aesthetics, as a tactic of becoming-disappeared, eludes logics of positivity and negativity, by doubly refusing visibility and invisibility. A disappeared aesthetics visualizes nothing but a potentiality or a preference to not-visualize, and thereby points to the ethical-political dimensions of visuality itself.

A disappeared aesthetics disappears aesthetics, making it difficult to determine artifactuality, authorial presence, even form and content—those things that constitute aesthetic and art historical discourse. Therefore, a disappeared aesthetics must not be confused with what has been called an aesthetics of disappearance, since the latter, with all the force of the partitive, is a recuperation rather than an evacuation or hollowing out of that which allows for aesthetics. This "of" marks the insistence of determinative contents or qualities, and their visualization as that which has been disappeared—an aestheticizing of disappearance. In other words, a disappeared aesthetics, unlike an aesthetics of disappearance, is not an aesthetics "of" anything, although it is also not an aesthetics of nothing, for it is much more irrecoverable than even that. As Gerald Bruns might say, this is the Nothing that lies outside of negation, a nothing without identity, an interruption of the visual that marks the disappearing of the visual without ever arriving at invisibility.[35]

In its never-ending relation with the Outside, a disappeared aesthetics operates through the logic of the lure, and thereby affirms the sense that art is never an end in itself, but a mode of relationality. Understood in this way, art, in its critical capacity, is never located in an object (work of art) or in a set of aesthetic criteria, but instead along the path of their

deterritorialization, "toward the realms of the asignifying, asubjective, and faceless." [36]

Derek Jarman, Tom Burr, and Jürgen Mayer H. are three artists who have traced and necessarily erased this path of becoming-disappeared (what Derrida refers to as an "aporetography"),[37] and thereby have attested to the aporetics of representation, visual-based epistemologies, and AIDS. In what follows, I do not treat the work of these artists as exemplary within a field of artistic practice that has attempted to seize control of AIDS, or along a scale of aesthetic judgment that might seek to evaluate the degree to which their work achieves closure (epistemological, phenomenological, etc.) in regard to AIDS. The critical force of these projects lies in a resistance to such imperatives and criteria, and in an uncompromising confrontation with the ethical-political stakes of positing an object or image in order to represent AIDS. Yet perhaps even the word *project* is inappropriate, since it implies positing or projecting something (an iconic surrogate, empty symbol, or endless commentary) behind which one might find shelter or security. "Not that, alas or fortunately, the solutions have been given, but because one could no longer even find a problem that would constitute itself and that one would keep in front of oneself, as a presentable object or project, as a protective representative, or a prosthetic substitute, as some kind of border still to cross or behind which to protect oneself." [38]

"I shall haunt anyone who ever makes a panel for me." This threat appears in *Derek Jarman's Garden,* the artist's last book.[39] The "panel" is, of course, a reference to the Names Project AIDS Memorial Quilt, which is composed of thousands of handmade panels each dedicated to the memory of someone who has died of AIDS. The AIDS Quilt has been much criticized for being a "presentable project" that can serve as a "prosthetic substitute" (Derrida) for loss caused by AIDS. Jarman more than once contributed to this critique, which for him was broadly construed as an ethical-political question of representing AIDS and memorializing the losses that it has caused.[40] On the same page of the garden book and following an allusion to *The Garden,* a film that he made about AIDS, Jarman writes, "AIDS was too vast a subject to film." We might assume that at the time when he wrote this (1993), Jarman still believed that AIDS was incapable of being represented in film. It is my sense that his

76-minute, monochromatic film *Blue,* made during the same year, is a filmic statement in support of this conviction. Suffering from CMV, a virus—associated with AIDS—that among other things causes a retinal infection and, without the sort of treatments developed only very recently, leads to blindness, Derek Jarman persisted in his work as an artist and in *Blue* created one of the most uncompromising visualizations of blindness and the limits of visual representation in the time of AIDS.

Blue is Jarman's *adieu,* it is the way (the path, the placeless place) in which he says and sees *adieu,* precisely where saying and seeing, speech and vision fail him and us—where speech and vision bid their adieu. *Blue* is rendered nearly homologous with adieu, and sounds a prayer for what is, yet cannot be seen, spoken, filmed: death, the Outside, AIDS. "In the pandemonium of the image / I present you with the universal Blue / Blue an open door to soul / An infinite possibility / Becoming tangible."[41] Throughout the film Jarman tries to get us, as viewers, to see something that in its infinite possibility is imperceptible and yet, throughout the film, is incessantly becoming tangible. The notion of approaching without ever fully materializing that which is imperceptible is crucial to understanding Jarman's meditation on blue as the singular multiplicity or intensity (as color, mood, form, etc.) that it is.

The film opens with the following supplication:

You say to the boy open your eyes
When he opens his eyes and sees the light
You make him cry out. Saying
O Blue come forth
O Blue ascend
O Blue come in

This calling may be the voice of an unidentified witness who recounts the exchange between an equally anonymous "you" and "the boy," in which the one who solicits the boy to open his eyes and see the light is quoted throughout ("open your eyes"). Yet the final three lines may also be understood as having been spoken by the boy, a little boy blue perhaps, the one who cries out for Blue, saying, "O Blue come forth / O Blue ascend / O Blue come in."

Multiple and indeterminable subjects (witness, boy, and the one beside the boy) are folded into a sup-*pli*-cating prayer of vision and light that invokes *Blue* by calling it forth. The opening of the film is an introduc-

tion to blue that in its "absence of determinable properties, of concrete predicates, of empirical visibility," betrays every introduction and every beginning, as well as every form of recognition.[42] One is less introduced than one is exposed to blue, "[b]efore the name or noun, before the verb, from the depths of the call or of the silent salutation . . . [w]ithout a name or noun, without a verb, so close to silence."[43] Adieu.

The "becoming tangible" of blue is the becoming-disappeared of visual representation, identity, visual-based epistemologies, and sight if not vision. *Blue* affirms Deleuze's sense of becoming-imperceptible through color[44] as it projects a monochromatic Yves Klein–like blue onto the film screen, making it the surface of an imageless visualization of loss.

Jarman treats his attenuation of sight to-the-point-of-blindness as irreparable, that is, as a condition that even if it could be repaired, need not be corrected. Jarman loses his sight without in any way attempting to restore his sight. One might go a bit further and say that this loss of sight is inconsolable, similar to the ways in which I earlier had discussed conditions of unsparing loss. Perhaps one of the reasons why Jarman is capable of unsparingly losing his sight is due to a distinction that he makes between sight and vision, when he asks, "If I lose my sight will my vision be halved?" This calculus suggests that vision is at least twice as great as sight, in which vision is a mode of perceiving that is neither a matter of seeing, nor a mode of representing.

It is in this way that Jarman forces us to think towards a persistence of vision in the midst of blindness. Such a persistence of vision in the midst of blindness "is not the index of something that is missing, but the insistence of something that refuses to disappear." Jarman presents us with the potentiality of not not-seeing, and thereby foregrounds vision and visuality as questions, perhaps the only questions worth asking of vision and visuality, especially in the midst of countless persons, places, and practices becoming-disappeared. For it is only to the extent that we define our work to be the problematization of the hegemony of visual-based epistemologies, which is to say, to think the limits of visual representation and such discourses as art history, that our work will become a mode of critical practice.

Blue presents us with forms of vision and visuality that are prior to and in the wake of seeing and the visible, yet also as something other than merely blindness and the invisible (the negative of seeing and the visible). Rather than define blindness in terms of a loss of sight, or recu-

perate it through the notion of a mystical insightful blindness, we might locate blindness as an inaugural or originary moment, a prior blindness that exists before seeing, and which makes seeing possible: "the invisible from which the visible streams."[45] Redefined as inaugural to visuality rather than its accidental or circumstantial negation, blindness then could only be understood as a loss if one was no longer able to operate in the visual. By demonstrating, through a persistence of vision-in-blindness, that one is still operating in the visual even while losing one's sight, Jarman's film offers yet another sense in which this visuality is inconsolable, since it is something that cannot be lost.

Blue is a lure. It solicits a visual fascination that in its intensity summons us to the Outside of the visual, and more specifically to the Outside of cinematic perception. In leaving us there (nowhere), it forces us to reckon with the incapacity of visual representation to register this aporetography, and to face the threat that we may not be rescued from this possible disappearance. *Blue* lures us to "go toward the appeal of eyes that see beyond what there is to see: 'eyes world-blind,' 'eyes submerged by words, unto blindness'; eyes that look (or have their place) 'in the fissure of dying.'"[46]

Visually attracted and visually neglected, and visually attracted by this very negligence of visuality, we are where nothing is in sight, an unbecoming (interrupted) vision in which nothing comes of sight except the coming of sight. Viewing this film implicates our vision and confronts us with the ethical-political dimensions of a visual ascesis, of "thinking blind, becoming blind." This is a blinding that takes our sight *away* (elsewhere), an incessant approach towards the limits of sight, the place or perspective of no one, here projected as a no image. Like Bersani and Dutoit's estimation of the status of Nazism in Alain Resnais' film *Night and Fog*, we might measure the significance of Jarman's intervention based upon an ethical refusal to posit an object in an attempt to represent AIDS. "By which we do not mean that it puts into question the existence of the death camps and the mass murders [deaths caused by AIDS and global genocidal neglect], but rather that it suggests that wanting any documentary knowledge of Nazism [AIDS] may be a way of refusing to confront our implication in it."[47]

Blue is the film that one has never seen before, and not simply because one has not seen Jarman's last film. Perhaps it is the film that we have not wanted to see or that we have not been allowed to see or, that we

have been incapable of seeing, and are still incapable of seeing, even after multiple screenings. One might say that it is a film that prefers not to be a film, or it is the film prior to film, the one that demonstrates film's potentiality to not-be, by not not-being. It effects an interruption that momentarily reveals the cinematic, in the not yet and no longer that is the cinematic's singularity. There may exist no other film that interrupts in a more thorough and sustained way what Bersani and Dutoit have referred to as the myth of film, namely, "the simple but radical proposition that the world can be seen."[48] For instance, in the screening of the film, a light is projected that seemingly illuminates nothing, and although one can hear what might be referred to as its soundtrack, one is never free from the sense that a visual accompaniment to the audio has gone missing. Conversely, it is one of the only films in which you can look away without missing anything.

Blue undoes the filmic by leaving or moving beyond it. It presents us with what remains in the wake of the filmic, something like the Outside of film. And yet this step that is taken, this movement of art that is an approach towards the limits of art, takes place across the surface of the film's projection. The sounds of the film: street noises, AIDS activist chants, everyday conversations, household sounds, bicycle bells, church bells, and more, fold the outside and the inside across the surface of the monochromatic blue film screen. "It is as if a cacophony of sounds has supplanted the pandemonium of images," and it is the screen, as fold, that "allows us to hear the geography that runs outside of architecture, silently."[49] In *Blue,* the geography that runs outside of architecture and across the screen of projection does so imperceptibly, rather than silently. In its effects, it is not unlike the way Jarman describes a nighttime walk along the beach: "I walk down to the beach with that slight insecurity you feel when you can hear the sea but not see it."[50]

A geography "that runs outside of architecture," a geography that can be heard and not seen, is a form of spatiality that defies the pictorial logic of landscape. It is geography becoming imperceptible through color, a spatiality that is nothing more or less than a chromatic surface, a surfaciality that literally under-mines the facial, as well as landscape, bionarrative and every other figural mode of representation.

An "empty sky-blue afterimage," "Blue transcends the solemn geography of human limits," in which transcendence is a refusal of the imaging or picturing of geography (landscape), and therefore not only an

empty sky-blue afterimage, but the empty-after-image that is the blue (of the) sky.

> I have walked behind the sky.
> For what are you seeking?
> The fathomless blue of Bliss.

> To be an astronaut of the void, leave the comfortable house that imprisons you with reassurance.[51]

Sky, as the indeterminate nominative that it is (since the sky is no one's place), anonymously names the anonymous infinity of spatiality. As (perhaps) the (most) pure Outside, it opens onto or is the spacing for relationality (of the "to"), and therefore is well beyond landscape and architecture; something other than the picturesque sublime or a sheltering sky. The sky is the groundless ground that enables us to take place, or as Hölderlin writes in his poem "In Lovely Blueness," to dwell.[52] The distance (or what Heidegger in his lecture on Hölderlin's poem refers to as the "dimension") between earth and sky is what calls for measure and what allows us to take measure of our taking place.[53] The sky, in its disconnecting hyphenation, offers evidence as to the fact of life's finitude and of our non-relational relation to the unknown, the Outside, the unasked question via the forces of attraction and negligence.

To further specify (and perhaps to further withdraw God or the divine from the sky), this is sky not as intermediary but as immediacy or amidst (a midst), an immediacy that is as immediate as the sky might be said to be. "The pure void of bottomless light, the pure spacing, above our heads, of air and light (Ether); the spacing that outlines, rather than being outlined by the earth" (as in geography and landscape).[54] It is the surface of whatever is, and Jarman's "empty sky-blue afterimage" renders it no less tangible than the blue of the sky. This tangibility is the sky's surfaciality: a "fathomless blue of bliss" (Jarman) and an undermining of grounding that surfaces as "the wild night fucking you on the floor of Heaven" (intensification of surfacing). How might one go about registering this?

Poetically. At least this is the answer offered by Hölderlin's "In Lovely Blueness" and Heidegger's reading of that poem, which together are the occasion for (or inauguration of) the question in the first place. It might

be said that Jarman shared this same sense of the poetic as the measure of life's finitude, of dwelling, of spatiality made tangible by the sky. In what were to be the last years of his life, his small house on the Dungeness coast of England, his elaborate garden and the book that documents it, and his film *Blue,* constitute a three-fold response to that which is without response (i.e. death, erotics).

In the middle of his last book, *Derek Jarman's Garden,* there is a poem, the first line of which—"under this blue sky"—locates the poem, the book, and the garden. Jarman's stony Dungeness garden became a blind man's world, as blind as "the stone in the air" of Paul Celan's "Flower."

> The stone.
> The stone in the air, which I followed.
> Your eye, as blind as the stone.
> …
> Flower—a blind man's word.[55]

To stare at the sky, as a gardener might do, is to be caught up in the visual fascination of staring at nothing, and to find this blindness of sorts to be irreparable—simply enough. Or, if not to stare at the sky, then to stare at what the sky makes possible: "I can look at one plant for an hour, this brings me great peace. I stand motionless and stare."[56]

To stand motionless and stare is an undoing or unworking of poesis and aesthesis, an attenuation of speech, sight—of movement—that approaches the limits of knowledge in any of its auditory and visual forms. This immobile staring-unto-blindness visualizes the potential to not not-visualize, a persistence of vision in the wake of blindness. It is the nothing that we think we see when we stare at the sky, and Jarman's vision, materialized as *Blue,* is the measure and manifestation of this attenuation. *Blue* is a visualization of the impossibility to visualize, the "infinite possibility" (or potentiality) of this impossibility, *becoming* tangible (without ever *being* tangible). Again, the tangibility of Jarman's *Blue* might be as tangible as the sky. It non-positively affirms "the invisible from which the visible streams,"[57] in its withdrawing of geography, redemption, image, and finality, to a fathomless blue from which "light's luminosity continues to withdraw to it as its very appearance."[58] "Blue [and *Blue*] is darkness made visible."[59]

This is the poetic measure of imperceptibility, "a near nothing," that

as a disappeared aesthetics is "as evident as the invisible is evident, withdrawn into the visible *as* its visibility."[60] Like Orpheus's ability to see Eurydice only by turning away from her, Jarman attests to the necessary withdrawal of vision in any attempt to perceive AIDS as that, which, like Eurydice, is imperceptible. It is an attempt to glimpse the impossibility of seeing, to try to see the unseeing of sight. It is in this way that *Blue* is a ruining and betraying of the work of art and the interminable and inexhaustible work of sustaining this movement of impossibility that is the exigency of AIDS. A sustaining that is here an interrupting, and an interrupting that is un-circumscribable and therefore cannot be so easily reduced to a mere interruption. For there is a work (and there have been so many works) to the extent that AIDS is ignored, and yet the look towards AIDS—in all of its impossibility—is what must happen in order to take the work beyond "what assures it." Therefore the work must be forgotten in order to turn towards AIDS, a turning towards that is at the same, and necessarily so, a turning away, a betrayal that is an ethical necessity (as Genet might put it). In this way, the work as artifact is lost, and in this losing and turning away, it non-positively affirms the exigency of AIDS. "Thus it is only in that look that the work can surpass itself, be united with its origin, and consecrated in its impossibility."[61] *Blue allows us to see AIDS by eclipsing or attenuating our vision.*

This attenuation is also the relationality of an anonymous visuality, the indifference of a blank stare. This attenuation of the visual and the social, an attention that is inattention, is erotic. "All our memories—the wild night fucking you on the floor of Heaven—all our memories are wasted."

> The smell of him
> Dead good looking
> In beauty's summer
> His blue jeans
> Around his ankles
> Bliss in my ghostly eye
> Kiss me
> On the lips
> On the eyes
> Our name will be forgotten
> In time

No one will remember our work

Our life will pass like the traces of a cloud

…

I place a delphinium, Blue, upon your grave.[62]

There seems to be an objectless remainder, here at the end of *Blue*, something that lingers on, after speech, writing, and sight. For after all of the attempts visually to represent AIDS, and after all that has been said about AIDS, it still remains ill seen and ill said. One can never see it, and when one says it, one says nothing. What we hear and see in *Blue* is the voice of that which will always be over-heard and the vision of that which will always be over-looked.

Smell, like Celan's "Flower," may be yet another one of the blind man's words, the word that does not return to speech or writing let alone to sight, but wanders or waifs beyond all of these senses and their supports.[63] Like the flowers that close Jarman's garden book, and the delphinium that is placed at the end of *Blue*, perhaps these are the few words that remain after unsparing loss, the words that are more incessantly persistent than any final word could ever be. These would be the words dedicated to the friend who did not save my life, voiced by the body of this death. These are the words that continue to go without saying, by the vision that continues to go without seeing. Blind man's words. Flower, Blue, Adieu.

Approximation of a Chicago Style Blue Movie House (Bijou) was an installation created by Tom Burr for *disappeared*, an exhibition that I curated at the Randolph Street Gallery, Chicago (1996) (figure 6). Just as the conception of the exhibition was inspired by Derek Jarman's film *Blue*, so too was Burr's installation conceived in relation to this film, and the prominent place that it was accorded in the gallery.

Jarman's film was projected onto a screen—cinematic in scale—that was suspended from the ceiling and positioned just inside the entrance to the gallery (figure 7). A narrow corridor-like space was thus created between the back of the screen and the inner wall of the gallery's façade, and as they entered the gallery, visitors had the option of either walking behind or around the film screen (figure 8). In this way, one entered and moved through the exhibition along paths similar to those determined by the spatial layout of many independent movie houses, gay bars, porn

51

theaters, and sex clubs—trajectories of and through minor architectures. One had the unavoidable experience of entering from behind the screen, and perhaps the even more unexpected option of occupying this space, which was neither inside nor outside but alongside the space of exhibition.

As an installation artist and writer, Tom Burr has had a long-standing interest in the relations between cinema, anonymous forms of sociality and sexuality, minor architectures, and a history of minimal sculpture and site-specific art practices. Each of these concerns is evident in the title of his project for *disappeared*. It is in the double-inflection of canonical architectural history ("Chicago Style") and minor architecture ("Blue Movie House") that Burr's project functions as a critical approximation. As the last word of the work's title, "Bijou" introduces what seems to be a degree of specificity that is at the same time withheld by its parenthetical bracketing. It signifies a specificity that approaches and yet defers identification, and in this way may be understood as a singular multiplicity. "Bijou" is, at once, a porn theater/strip joint in Chicago, a francophilic genericism, and an identity without a proper address. Burr reconfigures or suggests other ways of folding the map of Chicago's architectural history by attending to those architectures and histories that will never be granted the status of the architectural or the historical, and allowing them to remain as remainders—disappeared, anonymous, minor architectures.

The becoming-cinematic of the gallery space through the presentation of *Blue* was further inflected by Burr's installation of two sets of wooden risers, partitions, and theater seats, reminiscent of porn theaters and sex clubs. The physical proximity of Jarman and Burr's work effected a series of monochromatic approximations (or was it an approximating monochromatics?) that suggested social-political relations between Jarman's film (*Blue*), porno theaters (blue movie houses), pornographic films (blue movies), and legal regulations of pornography (blue laws).

Working in a non-mimetic and image-less mode similar to that used by Jarman in *Blue*, Burr's project set out neither to represent nor reproduce a minor architecture, but to furnish—via a critical inflection of terms, materials, and histories—forms of attenuated visuality and anonymous architecture that are increasingly becoming-disappeared by the collaborative forces of urban real estate markets and campaigns against sex. As has been noted of one of Burr's earlier yet related projects, "while

most artists exploring issues around pornography fixate on its imagery, Burr banished erotic images from his show . . . instead of reproducing the architecture of sex, Burr abstracted its shapes and materials."[64] Burr's project operates through and is able to present anonymous sociality and sexuality precisely because of this evacuation of imagery from the scene of the social and the sexual. For as Bersani and Dutoit have argued, "to identify images is to originate an identity in opposition to them."[65] This is enticingly provocative since it implies that to relate socially yet without the mediation of imagery is to relate in a way that is non-oppositional. Anonymous in their visuality and spatiality, Jarman's *Blue* and Burr's installations attest to forms of sociality that do not require an object to either identify with or against in order to be viable. These can also be strategic forms of sociality, since in their image-less anonymity they may be able to circumvent becoming identifiable targets of and for opposition.

As drawn by Bersani and Dutoit, the distinction between the relational logics of the cinematic and the pornographic is, in part, a distinction between a non-erotic sadistic movement and an erotic sadistic movement, respectively. By deterritorializing the cinematic and the pornographic, Jarman and Burr materialize what might be referred to as an erotic, non-sadistic movement, a non-appropriating relational logic that is constitutive of neither the cinematic nor the pornographic, but of the obscene.

According to Bersani and Dutoit, the relationality that is constituted in and through the cinematic is based upon a fiction, one that attempts to maintain a distinction between the viewing subject and the object viewed. The distance between supposedly allows the former to go untouched and assures that it is not implicated in the movement towards the latter, a movement that is appropriating or sadistic.

> Here is an appropriation of objects in which the subject remains untouched—an ideal aptly figured by the protective darkness surrounding the unseen spectator in the moviehouse. Thus the aesthetic medium of film would almost miraculously realize the analytic fantasy of a nonerotic sadism, the sadism of an affectless mastery of the world.[66]

A key word in their analysis is "almost," since it qualifies this fiction of non-implicated viewing as difficult and perhaps even impossible to maintain. For although theoretically the cinematic establishes an all-seeing unseen position of viewing, this distinction is inevitably blurred. Once a viewing subject is touched through its viewing by the object being

viewed, the relationality shifts from a non-erotic to an erotic form of appropriation. This erotic blurring of distinctions constitutes a process of identification that is, at once, ambivalent (a confluence of love and hate) and erotic, and precisely erotic to the extent that it is ambivalent. Stimulated (touched) by the object viewed, the viewing subject, in a desire for self-recognition, mis-recognizes itself in the object viewed, is therefore torn or split, and in the interest of self-preservation, attempts to appropriate the object lest it dissolve the identity of the subject. Of course this process of identification (from having to being), like all others, is never completely mastered, and as Bersani and Dutoit argue, it is in this very failure or "loss of the appropriated identity" that identification is sexualized. This process of ambivalent, erotic, and un-masterful appropriation is what might go by the name "pornotropic."

To summarize, the difference then between the sadistic movement of cinematic relationality and the sadistic movement of the pornotropic is that the latter by definition incites an appropriating *identification* with the object, image, or body projected or viewed, and thereby explicitly implicates the viewer in its viewing. Yet the question remains, the one that has motivated Bersani and Dutoit's collaborations over nearly the past decade, namely: "[I]s there a nonsadistic type of movement?"[67] The first chapter of this book has argued that such a non-appropriating movement does indeed exist in a spatiality of anonymous sociality and sexuality, but what about in terms of visuality?

To the extent that Jarman and Burr make it impossible to identify with an object, image, character, body, or camera (and engage in a process of identification), their anonymous visualizations defy the appropriating logics of cinematic *and* pornotropic visuality. An empty sky-blue afterimage and the evacuated furnishings of minor architecture leave very little that may be appropriated.

Burr's neo-minimalist installation practice, as a mode of *furnishing*, distinguishes itself from its historical antecedents in its *itinerancy* or *movement (meuble*—movable *adj.;* furniture *n.*), beyond the subject-object dynamics of recognition and epistemological conquest and control. Instead, it effects an uncertainty that is its relation to the Outside, such as the uncertainty that is experienced as waiting, in which waiting is an opening towards or an exposure to the Outside (of being-with-out). To furnish space, which is neither to give nor to take space, but to occupy it itinerantly (without a property-yielding mastery or authority), is yet an-

other way of waiting. The incessant withdrawal from arrival, presence, property, and a self—this de-situating spatiality that is waiting—is also a giving over to space, a becoming-space (phagocytosis) that is a furnishing of space. As noted in the previous chapter, this spatial folding, as a way of spatially defining being as being-with-out, is the place of implication and the only place in which ethics might be addressed. To be in the world then, would be a matter of always already being implicated and to feel the immediacy of this implication, a waiting for a touch that is the touch of waiting (the logic of the lure). The "instant of eroticism" are a few words from Levinas that we might invoke here in order to name this touching waiting, in which the distance between self and other is withdrawn—not from its uncertainty, but as its uncertainty, the very uncertainty that is the relation to the Outside.[68]

One way of undertaking art's work would be through a furnishing of space, or what is more commonly referred to as installation art. Certainly, the differences between Derek Jarman's *Blue* and Tom Burr's *Approximation of a Chicago Style Blue Movie House (Bijou)* are too numerous to mention, and yet in the exhibition *disappeared* and in a proximity that was not simply spatial, they might be said to have worked together. As discussed above, Burr's project was inaugurated by the other's decision (viz. Jarman's, although perhaps my own, as curator) in him. In this way, an ethical relation (the stranger-in-me) was opened up through art's work, and thereby affirmed the sense that it is always the response that begins or initiates, that the only possible beginning is by responding, and therefore that responding is never the way to end.[69] The non-dialectical (or non-relational) relation that was materialized between Jarman and Burr in *disappeared* is in their response to a third that is called by their responses, a calling that can only be heard from the promise of a response that is their work.

So their work is neither passive nor reactive but implicated, since the third does not wait but interrupts incessantly. This ethical relationality in art's work—a non-relational relation—is a form of separation without negation or exclusion, but rather the unbinding bond of being together-apart. Together-apart, Jarman and Burr furnished space as neither cinematic nor pornographic, but as ob-scene: prior to, and the Outside of, the scene of representational appropriation and identification. Spatially, this is a form of itinerancy, a cruising that is not a territorializing or partitioning of space, but a furnishing or better yet a folding of partitions.

This is the place that replaces subjects and objects with guests and hosts, through a substitutional logic that in the indeterminate switching between the latter two cancels out the former. This is also the place, albeit an uncanny place, where hosts and guests welcome and are welcomed—the place of hospitality. Finally, it is the ethical relationality of the stranger of me—a form of relationality that is not alienation but something much more strangely familiar: a touching of the Outside in the unhomely of the blue movie house.

Through this attenuation of sight, sound, and even smell, one is led perhaps to touch, and still in the spirit of a certain promiscuous hospitality, to German architect Jürgen Mayer's *Housewarming*. In the version of *Housewarming* created for the exhibition *disappeared,* the project consisted of a series of temperature-sensitive surfaces painted directly onto the walls of the gallery, and printed as the pages of a *Guest Book* (a limited edition artist's book) (figures 9 and 10).

Enticed by the words "touch me" minutely affixed to the surface of some of the rectangles of temperature-sensitive wall paintings, one was led to make physical contact with the work. Each conjuncture of painted wall surface, physical force, room temperature, and body heat was registered without remains, by the disappearing and reappearing of painted surface and handprint. As a hand, set of lips, side of face, whatever, was pressed against the red painted wall, the heat of these body parts caused the red color to temporarily disappear, leaving in its place, again only temporarily, the trace of the body part as a white silhouette on the wall (figure 11). These surfaces came to be referred to as hot spots which, like all haecceities, are always in flux in their degrees of intensity, rather than in terms of a state of composition. Degrees of intensity, such as heat and color, are physical realities not in the sense of intrinsic qualities but rather in terms of affective capacities amongst mobile relations. It is only in their accidental and fleeting conjuncture that they may be said to function, that is, to exist at all. Such promiscuous properties undermine the very conditions that make sense as property, and thereby register, in becoming-disappeared, the kinds of counter-communal sociality that exist as the Outside of the familial, the domestic, the social.

Mayer's *Housewarming* is the unbecoming inauguration of the familial, the domestic, and the social that is celebrated in a housewarming. Putting into question by undoing a sense of property, it approaches most closely the law of hospitality. For as Derrida reminds us, the host is the

first to be welcomed in his/her home, and therefore the host is a guest received in his/her home by an always prior host. In other words, the host arrives at the place where the guest arrives, not earlier or later but rather always not early enough and always a moment too late. The hot spots are surfaces across which seemingly apparitional hand- and body-prints of innumerable guests and hosts are glimpsed as ghosts that haunt the architecture of the familial, the domestic, and the social. Here, the walls do not speak or hear, but are the unhomely touch of the Outside that is hospitality.

The law of hospitality then, recasts the home-as-dwelling in terms of flight, passage, or wandering, and therefore as nothing more than a refuge (a temporary one) along a path of endless itinerancy. It is this endless itinerancy that makes hospitality an opening beyond, an infinite unconditionality (without predicates); an exposure to the Outside that is at the same time a form of ethicity itself. It is an interruption of the self by the self as other: the other of me, the stranger, the newcomer, he/she who is without name, address—the trick, the fuckbuddy. Rather than think this interruption as a moment of defensive paranoia, it must be understood as the very specificity of what it means to be at home in the world. It is that which allows for an extension outward and always with a sense of potential departure and abandonment. Reciprocity is no longer an issue, since this hospitable relationality is without expectations, without (pre)determinative content—it is unconditional. You can be certain that gifts are not exchanged at Jürgen Mayer's *Housewarming*.

The companion to the hot spots is the *Guest Book*. Typically, a guest book serves as an archive for the signatory record of the presence of each person who has come, and then, gone. In fact, it is at the moment of departure and in the space of the threshold that the *Guest Book* exists, as it is inscribed with the residual traces of guests. This is the case regardless of whether it is signed upon arrival or when leaving, since it is precisely this arrival at the point of departure that defines the spatiality and sociality of hospitality. And yet in its preservation of the remains of guests, it betrays the very law of hospitality that it is meant to serve as record, logos, book. For if to be a guest in a book means that one goes in writing, then any guest book recuperates this necessary departure and reclaims it as text or book. Therefore to remain loyal to the law of hospitality, a guest book must refuse the status of text or book, and make way (passage) for any guest in writing, a writing that is the trace of the unwriting

of writing, an undoing of book and guest. This is exactly what occurs in Mayer's *Guest Book*.

Printed with a dense pattern of illegible typographical characters, the pages of this guest book appear to be already inscribed. Formally, they replicate data protection patterns that are customarily printed in the place of the signatory line on each copy of a signed form, check, or other such document. These patterns, a kind of textual noise, serve as data camouflage, and in their everyday use might go largely unnoticed. They are the blind spots of anonymity that are embedded in the authenticating and abjectifying logics of modern print culture. Yet in this guest book, these patterns are no longer residual and disposable byproducts, but rather the very surfaces on which signatures are to be written. Because of this, they make for an illegible writing and an undecipherable reading, as all inscriptions are lost amidst the equally illegible pattern printed on every page. These pages then make it difficult to look back and to remember by reading guests that have come and gone in writing. Flipping through the pages of this guest book, it appears as though there is nothing to read, as though there have never been any guests or as though there have been more guests than it will ever be possible to count. In either case, this is a book that seems to be saying (and in this way approaches the limits of the book): don't read me.

This guest book remains true to the logic of hospitality (a logic of arriving at the point of departure), as it is neither a book of mourning nor melancholia (of recuperating loss), nor for that matter a book of the dead. Rather it is the most proper guest book, the guest book of the ones who remain disappeared, and more precisely, of those who remain by becoming-disappeared through a form of ghost writing.

Yet Mayer further intensifies this becoming-disappeared in writing (which is also the refusal of reading) by printing the pattern of these pages with temperature-sensitive ink similar in its effects to the paint used for the hot spots on the gallery walls. To touch a page in the book by placing fingers and hands upon its surface is to cause the printed pattern to temporarily fade away and thereby to reveal, rather unexpectedly, the signature(s) of guests. In this way, the undoing of writing in writing is in turn undone by the touch of the Outside. This effects what Derrida refers to as the "absolute arrivant," the one who is not even a guest of a host who is not yet a host, the unexpected guest who arrives where one was awaiting arrival yet without waiting, without expecting.[70] It is here

58

that both guests and hosts are without proper name or address, and remain anonymous strangers to each other, and thereby affirm the unconditional or non-relational relation of hospitality. These are instances that cannot go by the name of dates, and if they must, they are dates neither remembered nor forgotten but that remain perverse or ob-scene.

...

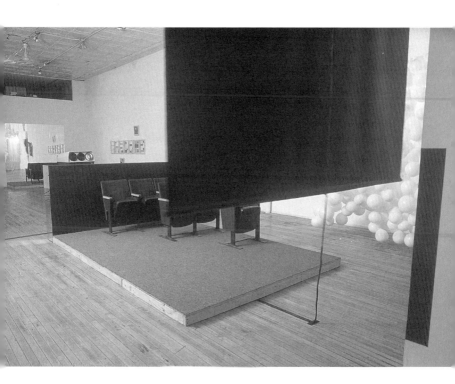

6. Installation view of the exhibition *disappeared*
(1996), Randolph Street Gallery, Chicago; featuring
Tom Burr's *Approximation of a Chicago Style Blue
Movie House (Bijou)* (1996), mixed media. Photo by
author.

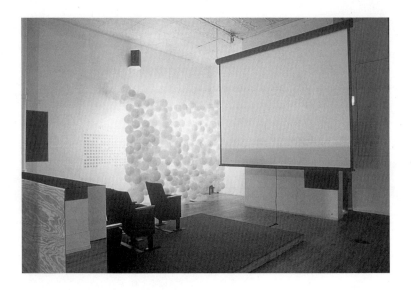

7. Installation view of the exhibition *disappeared;*
featuring Derek Jarman's film *Blue* (1993). Photo by
author.

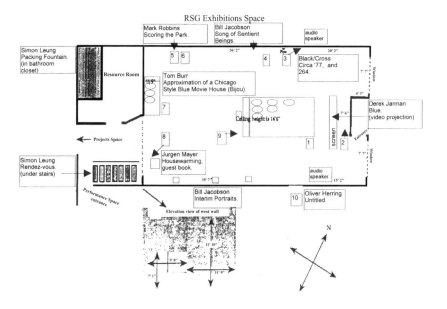

RSG Exhibitions Space

Mark Robbins
Scoring the Park.

Bill Jacobson
Song of Sentient
Beings.

audio
speaker

Simon Leung
Packing Fountain.
(in bathroom
closet)

Resource Room

5 6

4 3

36' 2"

20' 2"

Black/Cross
Circa '77, and
264.

7' 7"

Window

Tom Burr
Approximation of a Chicago
Style Blue Movie House (Bijou).

119"

7

Ceiling height is 14'6"

4' 3"

Derek Jarman
Blue.
(video projection)

7' 6"

screen

Entrance

1 2

7' 7"

Window

Projects Space

8

9

Jurgen Mayer
Housewarming,
guest book.

Simon Leung
Rendez-vous.
(under stairs)

audio
speaker

Performance Space
entrance

39' 7"

15' 2"

Bill Jacobson
Interim Portraits.

10 Oliver Herring
Untitled.

Elevation view of west wall

11' 10"

9' 8"

7' 1"

11' 9"

N

8. Gallery installation plan for the exhibition
disappeared. Photo by author.

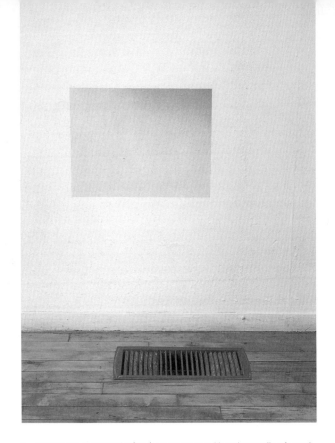

9. Jürgen Mayer, *Housewarming* (1996), temperature-sensitive paint on wall; as featured in the exhibition *disappeared*. Courtesy of Jürgen Mayer H.

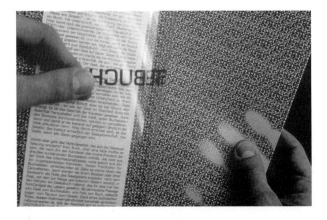

10. Jürgen Mayer, *Housewarming* (1996), *Guest Book*, temperature-sensitive pages printed with data-protection pattern; as featured in the exhibition *disappeared*. Courtesy of Jürgen Mayer H.

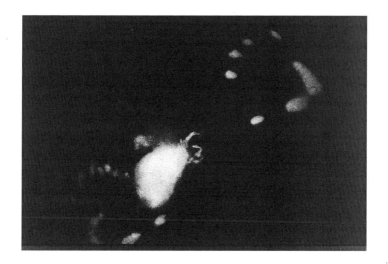

11. Jürgen Mayer, *Housewarming* (1996), tempera-
ture-sensitive paint on wall, showing evidence of
hands and a face in prior contact with surface; as
featured in the exhibition *disappeared*. Courtesy of
Jürgen Mayer H.

..

This perverse or obscene potentiality
of a disappeared aesthetics to not-visualize is redressed or recuperated by
art's historiography, whether in the form of historical, theoretical or critical
discourse. To write towards disappearance, as the guests in Mayer's guest
book do, and as I have attempted to do here, is to betray historiography. It
is to see, as Maurice Blanchot writes, "without the very words that signify
sight."[71] As a question of writing then, writing towards disappearance is
neither writing nor not writing, but rather a wanting-not-to-write in writing.
In re-deploying the excessivity and uncertainty of disappeared tactics in
one's writing, one is no longer simply threatened with being put out of
work, as much as one is cast into a state of workless interminability. For as
Ann Smock has noted, "To *see* something *disappear*: again, this is an expe-
rience which cannot actually start. Nor, therefore, can it ever come to an
end."[72] What Smock says for seeing, we might say for writing. Writing to-
wards disappearance then, would be an incessant writing, one that nec-
essarily never ends up with an object, positive presence, or negative as-
sumption. Yet perhaps this writing towards disappearance is, in fact,

nothing more than the specificity of writing itself, writing's own betrayal, in writing.

This is how Blanchot—one of the most insightful thinkers and writers on the question of writing—has come to understand writing. In earlier and later collections of essays, such as *The Space of Literature* and *The Infinite Conversation,* and in more recent books including *The Writing of the Disaster,* Blanchot has written some of the most sustained thinking on the question of writing.[73] In these works and others, he articulates the relationship between writer, book, and work. He argues that the writer belongs to the book, but that the book belongs to the work. Therefore in relation to the book as work, that is, in the writing that is published and read, the writer is disappeared. In Blanchot's words, from an essay titled "After the Fact,"

> . . . if the written work produces and substantiates the writer, once created it bears witness only to his dissolution, his disappearance, his defection and, to express it more brutally, his death, which itself can never be definitely verified: for it is a death that can never produce any verification.
>
> Thus, before the work, the writer does not exist; after the work, he is no longer there: which means that his existence is open to question—and we call him an "author"! It would be more correct to call him an "actor," the ephemeral character who is born and dies each evening in order to make himself extravagantly seen, killed by the performance that makes him visible—that is, without anything of his own or hiding anything in some secret place.[74]

The specificity of writing's space and time—writing's spatiality and temporality—is already becoming and yet always interrupted in its becoming. This "not yet" and "no longer" is not the path of the writer, but rather the writer is this path—the path that is writing toward disappearance. In its always interrupted becoming, writing is always unbecoming or an unworking of writing (unwriting that is not simply erasure). No sooner is one becoming a writer than one is unbecoming, that is to say, is no longer a writer. To be a writer, then, is an impossibility; and no one can be a writer. This impossibility in turn points to the insatiability of writing, and to its necessary incessance. As Maurice Blanchot affirms, one writes only to the extent that one has already written, and does so precisely because of this un-remarkable originary mark of writing.[75]

Writing's insatiability and necessary incessance also attests to the fini-

tude of the work, of a future with death, a future without futurity. This is the very reason why Blanchot was led to re-define the writer as an actor. The finitude of the work is such that the work may be said to have a future without futurity, a never-ending ending, something other than a simple negation of writing, something like writing's incessant becoming-disappeared, its wanting-not-to-be-written in writing.

For disappearance is what never happens and what always occurs yet never enough. Disappearance keeps on disappearing without ever completely becoming-disappeared. If the potential that it poses, if its threat would simply disappear, if only becoming-disappeared could become being-disappeared, we might find contentment; but *disappearance refuses to disappear.*

Disappearance, then, is not an event, yet it makes every event possible. It, disappearance itself, cannot be experienced, and yet this impossibility is what we might mean, what we might try to approach, when we speak or write of experience itself. Disappearance, in writing, is the force of writing, the unworking of writing, its enabling disruption; writing's interrupted becoming.[76] It is what is de-scribed in writing—what unwrites writing—and therefore that which cannot be described by writing. It is in this way that one can speak of the impossibility of writing ever being able to touch itself. Think of it as the blind spot in writing, the blindness of every writer in writing.

To avoid betraying this betrayal that is writing, one must write out of the failure of writing. If disappeared tactics are a betrayal of ontologies, and writing towards disappearance is a betrayal of historiography, then is it possible to write on—without betraying—the betrayal that is this writing towards disappearance? In other words, can one sustain writing at the limits of writing, which would mean writing without sovereignty, mastery, or authority, and outside of discourse, including historical, theoretical, and critical forms?

This would be giving oneself over to an exhausting of writing—a becoming exhausted in writing. Yet the question remains as to what it is that might remain, once writing is exhausted. What is left after (or is it before?) objects, forms, referents, positivities and negativities?

Perhaps what remains is the very incessance of writing itself. This would not simply be the repetitive reproduction of anything, including writing, especially in its mimetic pretension, but of writing at the point of its attenuation, the becoming of writing that is the unbecoming of writing. It would be

what it might mean to write the silence that is language's enabling disruption, the ceaseless interruption of speech, of neither saying nor not saying, but of wanting-not-to-say. A wanting-not-to-say, as emphasized by Blanchot in the passage quoted earlier, that is not reducible to the subjectivity of the writer or to any kind of secreting or hiding in writing. Rather, it would be something like an unavoidable stuttering in writing, a stuttering that would not be taken as either a positive or a negative trait, but as the very path of writing's interrupted becoming.

For if disappeared aesthetics is the betrayal of determinative content, dialectical logics, and teleology, then the indeterminacy that is disappeared aesthetics' potentiality must be written in equally indeterminate ways. It would be to do to writing, in writing, what Jarman did to film, in *Blue*. It would be a matter of seeing the blindness in sight, of speaking the muteness in speech, of writing the erasure in the written. It is this that is materialist, materialist in terms of the event of matter, not as an "inert substratum of a form" but as the very process of materialization in its pure potentiality.[77] It is the non-mimetic disappeared writing that is registered by the word "toward" in the expression "writing toward disappearance." A path toward disappearance that is the writing of every written, the writing that never gets there, the impossible writing.

I should like to say that it is the writing written by the ones without secrets, subjectivity, a proper place, and a discourse, those who are neither visible nor invisible, avowed nor disavowed: anonymous, errant, traitorous, promiscuous. But that is more than I can say of the ones who would dare not speak, especially here, of such writing.

Wink

> I am forever unfolding between two folds, and if to perceive
> means to unfold, then I am forever perceiving within the folds.
>
> —Gilles Deleuze, *The Fold: Leibniz and the Baroque*

..

The spatiality of the fold is neither a 67
matter of an inside nor an outside but of an incessant folding of the two
across a plane of immanence, the latter becoming the surface of these
foldings, "the not-external outside and the not-internal inside" of what-
ever.[1] If to perceive is to unfold, and if unfolding always occurs between
two folds, then a pure event of perception—as the impossibility of sight
seeing itself seeing—is indeed, as Deleuze states, nowhere else but for-
ever within the folds. A pure event of perception, or what we might re-
fer to as visuality itself, can only be defined as a folding, unfolding, and
refolding of perception across surfaces that are themselves constituted
through foldings, unfoldings, and refoldings. Hence Deleuze's use of the
word "forever," as a way to register the inescapable incessance of pure in-
flection or folding, as such and as that which never stops happening.

A pure event of perception, as a matter of folds, is the seeing that
sight cannot see, a blindness that is the condition of all sight as well as
its limit. This enabling interruption, as the potentiality of visuality (to see
and to not-see), is a lure that draws out perception by incessantly with-
drawing vision and the visual.[2] Just as the Stoics' sense of a pure event
of language found its point of reference "not to something said but as the
sayable that remains unsaid in it,"[3] so too might we locate a pure event
of perception in the seeable that remains unseen in it. This is the inces-
sant exposure of perception to the Outside, something like the unbecom-
ing of perception or (simply) unbecoming perception.[4] This is a state, or
perhaps less a state than a *sense* of visual fascination, conditioned by this

very withdrawal and attenuation of the visual. It is a form of visuality that is fascinating to the extent that it is incessantly being withdrawn and attenuated. It is the blank stare, understood as a visually inattentive attention that is a manner of waiting not *for* sight but simply, and barely, *in* sight, that is, between and within folds.

These are the folds "of agitated sleepers who twist and turn on their mattresses,"[5] or perhaps more specifically, the one who is caught between sleep and wakefulness: the insomniac. In what follows, the insomniac will not be limited to (although must certainly include) the one who suffers from the well-known sleeping disorder. Here insomnia and the insomniac will also stand for a folding of a series of economies (including the visual), and thereby register their potentially uninterrupted interruption.

In his essays "The Outside, The Night," and "Sleep, Night," Maurice Blanchot writes on the ways in which work—as the labor of the day—is drawn by night, a withdrawal that is "the job of the day."[6] For it is in the night of sleep and dreams and even ghosts and apparitions—what Blanchot refers to as "the first night"—that day finds its beginning and its end, each and every night, and in this way can be said to exist.[7] Sleep, as structure of the first night, is a task of preservation, a habitual means of domestication and of gathering oneself together before the next workday.

But what if this economy is interrupted, which is to say, what if one cannot sleep and thereby is unable to reassure oneself of a day to come, of a tomorrow? According to Blanchot, one then approaches the "other night," the night that lies outside of both day and (the first) night, in a state that is neither habitual nor inhabitual but rather, unbecoming. The other night is the Outside of day and night, the place of the insomniac, of being "already almost asleep."[8] This is the night without rest, the ceaseless night, a spatiality-temporality that is the interruption of space and time, an interruption that is incessant and therefore one might say, pure. For to interrupt interruption would be to cease or arrest its force, whereas the interruption that is the other night is without interruption. Suspended and without discernible limits, this is the workless waiting of insomnia: waiting for sleep, waiting for day, an undoing wakefulness, and a neglecting of night.

The event of perception in (that is) the singularity of the other night is a folding of day and a folding of night that occurs within this double-fold (or two-fold) as the hypnagogic: neither sleep nor wakefulness but

the incessant folding, unfolding, and refolding of both. The hypnagogic is at once prior to wakefulness and in the wake of sleep, and prior to sleep and in the wake of wakefulness. This folding is an attenuation or progressive diminution of the difference or distance between sleep and wakefulness, dark and light, rest and work.

As suggested by Giorgio Agamben's recent discussion of Ludwig Binswanger's attempts to conjoin psychiatric and phenomenological vocabularies so as better to describe the relations between life's vital functions (dreaming) and the language/consciousness of subjectivity (waking), Binswanger effectively approached the limits of both discourses.[9] The aporia that emerges is understood to be that which is neither dreaming or waking but the irreducible inflection of both, which I am referring to as the hypnagogic and as insomnia. In other words, neither term denominates some place commonly shared by dreaming and waking, even as they mark the proximity of one to the other, a proximity that is infinitely inflected so as to always remain without coincidence. This is an affirmation of Agamben's sense that there is no point at which a "living being" and a "speaking and thinking 'I'" coincide or are united.[10] Rather they are said to flow alongside each other—to remain infinitely proximate.

And yet the question remains as to that which exists in this neither/nor space of proximity. *Vinculum* is the term Deleuze uses to identify just such "a strange linkage, a bracket, a yoke, a knot."[11] We might understand the vinculum to be the thread by which life precariously dangles—the two-fold inflection of the vinculum being, at once, lifeline and noose. The fragility of existence is not simply a matter of being threatened with non-existence from the outside, but is predicated on the fact that the place of life's potentiality to-be is also, always, the same place as its potential to not-be.[12] Perhaps this is why Deleuze refers to the vinculum as "strange."[13]

The events with which this study are concerned—erotics, the hypnagogic, art's work, and perverse pedagogy—are instances of exposure to this Outside by various permutations of the vinculum: "the unlocalizable primary link that borders the absolute interior" in its inflection of the Outside (Deleuze, 111). It is an infinitely attenuated line, bare and without content, to which are tethered Leibniz' totally naked monads. Totally naked monads are those whatever singularities that "would live in darkness or near-darkness, in the vertigo and giddiness of minute and dark perceptions. No differential mechanism of reciprocal determination would

come to select a few of these tiny perceptions in order to extract a clear perception. They would have nothing remarkable about them" (Deleuze, 91–92).

Deleuze states that this limit-condition of totally naked monads is only present in death, and precisely because of its unknowability as such, is everywhere else nothing but abstraction (a conceptual metaphorics) (Deleuze, 92). Yet as I wish to argue throughout this study, there are instances when it is possible to approach the condition of totally naked monads without necessarily being abstract or, for that matter, dead. Deleuze himself suggests such a potential when he refers to "near-darkness" in a way that is seemingly distinct from a more absolute "darkness." Might we think that the vertigo and giddiness of which Deleuze speaks is caused by this near-darkness, an infinitesimal attenuation or folding of light and dark, the visible and the invisible, sight and blindness? This near-darkness that is never darkness might be the dusk and dust of Caravaggio's chiaroscuro, Blanchot's other night, Stephen Barker's *Nightswimming*, and the shadows cast in David Wojnarowicz' American dream.[14] As residual traces of the non-residuality of unbecoming events (erotics, insomnia, and art's work itself), these are necessarily shadows of shadows, a vertiginous folding that stirs up dust that is taken to be the materiality of perception. The event of perception is the instant the dust falls, an absolute suspension (of objects, subjects) that is perception at its most intense, making it acute through its infinite attenuation, the dust causing a squinting and a blinking.[15] For Wojnarowicz, such an event of perception will necessarily always happen in the shadow of the American Dream, which is also the title of one of his essays, from which the following quotation has been taken.

> I had almost become completely abstracted. At some point I think I woke up; I think it was minutes ago or maybe hours ago in this motel room. I never felt a sensation like this before but the heavy plasticized curtains covering the three windows of my room created what I imagined a flotation tank might feel like, or a dry rug-covered terrarium with the glass painted black and fitted with an airtight lid. When my eyes first opened it took some measure of time to realize I'd stepped away from myself among veils of sleep and with that motion my eyes had disconnected from the nerves of the brain: that area where sight flows uninterrupted. The only vision from back there was a sub-vision: the magnified abstraction of a shiny

black abdomen like a motorcycle gas tank or a mirrored black globe. Straining against the contours of the room and its furniture to reach back into that area and retrieve more of its form from the shadows, I could see or feel it for moments; the soundless click of its eight legs tapping the surfaces of the walls and ceiling of my sleep.[16]

The limits of sleep and wakefulness, interior and exterior, light and dark are no longer discernible, as one feels a sensation that is neither a state of dreaming nor fully awake consciousness. Neither light nor dark, this is a realm of shadows and non-ocular perceptions that reside "back there," "where sight flows uninterrupted" beyond cerebral-cognitive sight, and which exist as "sub-visions." Amidst the folds or "veils" of sleep and a minor architecture where a roadside motel room, a curtained flotation tank, and a carpeted airtight terrarium become indistinguishable spaces, one perceives morphological becomings: black abdomen– motorcycle gas tank–eight-legged creature.

These "present and infinitely minute" perceptions and "hallucinatory microperceptions" are hypnagogic (Deleuze, *Fold*, 86ff.). "It is a lapping of waves, a rumor, a fog, or a mass of dancing particles of dust. It is a state of death or catalepsy, of sleep, drowsiness, or of numbness . . . [a folding movement that] resembles that of agitated sleepers who twist and turn on their mattresses" (ibid.).

A few pages further into "In the Shadow of the American Dream, Soon All This Will Be Picturesque Ruins," Wojnarowicz offers a scenario in which the constitutive interruption of repetition is hypnagogically realized.[17] Here, a former factory worker who for years endured the monotonous labor of casing and packing unlabeled tin cans—and thereby suffered a loss of subjectivity so thoroughly critiqued by Marxist thought —dreams an infinite suspension of this commodity-driven labor. Yet as readers of this passage, we are uncertain as to whether the perceptions that constitute this disruption qualify or can be any longer accurately described as dreams. For it seems that not only is this an interruption of the American dream, but that it resides—as the title of the chapter indicates—"in the shadow" of that mytheme. This particular shadow resembles the architecture of a prison, the place in which, we are told early on, this worker, dreamer, workless worker and dreamer now resides. And yet the folds of this interruption are even more convoluted, since it seems that this scenario has been stirred up by the dust or foam

71

of Wojnarowicz' (or the narrator's—further folds) sleeplessness described a few pages earlier. "Like the ocean's movement where every seventh wave is higher and more furious than the others, small pieces of last night's sleep return in the eddy and flow of the day's turning" (Wojnarowicz, 27). Through the persistence of the hypnagogic, day and night remain difficult to distinguish, resistant as they are to the filter of a differential calculus that will make of each of them something clearly distinct and workable. The sense is that this scenario, in its folding of perception, has stirred up a cloud of dust or a frothy foam, and that its interruptive potentiality is precisely that moment of suspension, just before the dust falls and settles. This interruption or suspension is nothing more or less than waiting: "After years of this work he begins to dream of the cans sitting packed away in the vast recesses of the warehouse waiting" (Wojnarowicz, 28). It is in and through the waiting of the cans themselves that the cycle of production and consumption is short-circuited, perhaps indefinitely. And it is precisely at this moment of suspension that the potential lies to think and do otherwise. Surely this moment is not easy to register, for sounds of waiting are inaudible without being silent, and the warehouse interior is imperceptible without being invisible. It is this condition of seeming worklessness that kept the canning factory worker up at night, "tangled among the bedsheets laden with sweat" (ibid.). All of these foldings occur on planes of immanence that are "the surfaces of the walls and ceiling of my sleep," involutions that I am referring to as hypnagogic.

The hypnagogic, in its singular multiplicity, approaches the event of perception, an event that is, nonetheless, unapproachable and ungraspable in its relation to the Outside. It may be said that it does not exist as much as inhere or subsist at the limits of thought, "something that cannot be thought in finite thought, of a nonself in the finite self." [18] I wish to argue that this defines ethical comportment, erotics, and what Bill Haver has referred to as "art's work." [19]

Todd May's assertion that "a thought of pure difference is not a thought at all" is permissible not because one could ever think this positively or negatively but precisely because of the impossibility of exercising any form of adjudication on this aporetic condition.[20] May's conviction is viable to the extent that it forfeits epistemology and (impossibly) attests to a thinking that cannot think a thought of pure difference. This then is the impossible thinking of thought, if not the impossible thought of think-

ing. It is also an affirmation of Deleuze's sense of the primacy or anteriority of difference, which is a thought that cannot think itself and which thereby inaugurates all thinking.[21] If this is a question of knowledge, it is a matter of "knowledge without an object,"[22] just as the hypnagogic may be understood as a mode of perception which like "every perception is hallucinatory because perception has no object."[23]

As defined by Deleuze, these infinitely inflected micro-perceptions—infinitesimal in their folding movement (their attenuation)—are rather minute, obscure, confused [and disquieting] perceptions. "Pricklings" is a word used by Deleuze to name these instances which might be understood here as the touch of the Outside (imperceptibility) or the touching that is the Outside (an inaugurating blinding in sight, as might happen in Blanchot's "other night").[24] Through what Deleuze refers to as a differential calculus, these microperceptions are translated or filtered from their ordinary to a more remarkable status and thereby come to constitute conscious, clear and discerning macroperceptions—the "draped forms" made up of so many tiny folds.[25]

So as a question of causality, the hypnagogic is not the effect of sleep and wakefulness, nor is it exactly the cause of either of these. Rather, it is "by dint of [their] progressive diminution, [that] they enter into a differential relation that determines" the hypnagogic.[26] The hypnagogic then, is an attenuation of the relation between sleep and wakefulness, dark and light, night and day, rest and work. It is a nearly imperceptible, non-phenomenological interruption of these relations (macro), that puts them in a non-relational relation one to the other, and thereby removes the economic assurance that day will follow night will follow day. The hypnagogic is one way of talking about the event of perception, a folding of visuality (blinking, winking, or some other visual stutter) that is an insomnolent worklessness and sleeplessness. If it is a mode of perception without an object, the hypnagogic is also understood to be a mode of perception without a subject, or more precisely where the subject is touched, that is, located outside or beside itself—wherever.

I have argued in chapter one that this touch of the Outside, which puts one in an indeterminate place that may only be referenced as being beside oneself, is the event of erotics. In what follows, I shall discuss several scenes (of juridical, literary, and filmic origins) that involve a reciprocity between erotics, the hypnagogic, and insomnia.

A few years ago I read a news story in one of Chicago's gay and les-

bian weeklies about a young U.S. Army specialist who had accused a sergeant of sexually abusing him. The incident (a blow job) took place during the night and, depending upon which of the specialist's separate accounts you find more credible, he was either asleep or awake during the incident. What drew my attention to this story—and what continues to interest me here—was the way in which sleep and wakefulness were being used, separately in each of the specialist's testimonies, as evidence that this incident was not erotically pleasurable for him. What this testimony cannot attest to is exactly what it alludes to in its contradictory logic: the hypnagogic. By attempting to find innocence in the apparent oblivion of sleep on the one hand and in a certain form of unwilling subjugation in awakened consciousness on the other, a phenomenological (and legal-juridical) aporia was reached. The specialist's contradictory account of being both alseep and awake suggests that neither state is an adequate description of the condition he was in at the time of the incident. His testimony testifies to the inadequacy of testimony when it comes to instances that are neither sleep nor wakefulness, but rather the progressive diminution of the differential relation between them, a nonrelational relation of sleep and wakefulness—the hypnagogic. It is there, at the singularity of wherever, where the hallucinatory micro-perceptions of the other night occur and where the sweetness of the suck (as Haver might have it) happens. It is only later that these micro-perceptions of erotics are filtered through (homophobic) legal-juridical discourses and rendered as macro-perceptions in an attempt to achieve a degree of clarity that in its effect is cruelly obscurantist.

Marguerite Duras' *The Malady of Death* may be understood as a parable of the inexhaustible relations between erotics, sleep, and insomnia, and the ways in which together they constitute at least one possible definition (explanation) of the sickness alluded to by the title of the work.[27] The story involves a sole male character (referred to by the narrator as "you") that seeks to find love—which up to this point has eluded him— in the sole female character, a woman whom he has hired to be with him at his seaside house. She spends most of the time sleeping naked on the white sheets of his bed, while he stays up all night, pacing around the bed, staring at the sea and at her sleeping on the bed. What keeps him up at night and renders him an insomniac is not the woman or the ocean waves but the interruptive force of the Outside right there, night after night—the vinculum that binds in its interruption of the two of them

together. It is this very inaccessibility—"the marvelous impossibility of reaching her through the difference that separates you"—that is erotic.[28] The malady then is not so much this inaccessibility as it is a lack of resignation to its interruptive force, one that is incessant and therefore without resolution (either as fucking or fusion).

This is what keeps the character named "you" up at night, staring at the sleeping body on the bed, fascinated by its passivity and its blindness (eyes shut) such that "you" is rendered nearly as passive and blind (blank stare) as the body on the bed. This attraction-unto-negligence is insomnia's erotic charge, a turn-on by the potentiality (power) of absolute passivity and blindness that is embodied right there on the bed. The late-night orgasms in the Army barracks and in *The Malady of Death* are scenes of narco/necro-philism in which all of those involved are implicated. The erotic charge is in the passivity-unto-ecstasy, so intense in its betrayal of sleep and wakefulness that it is potentially orgasmic *and* potentially arresting.

Andy Warhol's *Sleep* (1963), like a number of other films he made in the early 1960s (e.g. *Empire, Blow Job*), seems to bring the temporal mobility of the film medium to a standstill (figures 12 and 13). Famous for their nearly motionless and practically unblinking focus on his friend John Giorno sleeping, or the top of the Empire State Building, or the face of a young guy receiving a blow job, these films are less about a friend, an architectural icon, or an anonymous sex act, than they are about waiting. Not waiting for this or that, but just waiting, waiting itself. For although viewers may find themselves waiting for Giorno to wake-up, or a glimpse of the actual blow job taking place just beyond the camera's lens, these films present the interruptive force of waiting and treat it as absolutely irreparable, that is, as "enough."[29]

The interruptive force of waiting effects a suspension of perception that is not a negation but an attention so intense that it approaches a forgetting of perception, thereby rendering it inattentive. Inattentive attention or visual fascination is intense due to its folding of the Outside of perception, an inflection that is interminable, and a waiting of perception that is only fulfilled by a forgetting of perception. Perception is transfixed through this interminable movement of waiting-forgetting. So it is not that fascination provokes one to wait (and thereby to wait for), as much as it is waiting itself that is irreparably fascinating.

Yet this waiting is never reducible to a theme or a subject since its

force is much more interruptive than that. The irreparability of waiting is such that it awaits referentiality, which is another way of saying that it is (purely) "a waiting" without being a waiting "for" anything (it does not involve expectation). The perception that happens in waiting is perception without referentiality (without an object), and it is in this way that Deleuze can state that "every perception is hallucinatory because perception has no object."[30] As films "about" waiting and therefore as films that await nothing, *Sleep, Blow Job, Empire* are, quite properly, films about nothing.

Which is to say that *Sleep* is a film neither about Giorno (and his sleeping) nor Warhol (and his insomnia) but about the non-relational relation between them, something like the hypnagogic, the materiality of which is the film itself. The film is inescapably this *thus*, a thus without objective reference—neither properly sleep nor insomnia—a thus that is the interruptive force of fascination, inspiration, and waiting. The seemingly incessant stillness or passivity of the film is interruptive as it refuses referentiality and the consolations of objective consolidation, and presents what we might now refer to as the insomnia of perception. The visual fascination in staring at someone else sleeping finds its force in the inconsolability of waiting-to-see-oneself sleeping. This is clearly the unrepresentable event of perception as it happens—in all of its impossibility—in erotics, art's work, and insomnia. An event that, as Steven Shaviro has suggested, is "something like the blow job that we do not get to see in Warhol's film of that name."[31]

Sleep is about nothing or, more precisely, the exposure to this nothing: bare, naked, attenuated, unremarkable existence. Thus exposed, it is here —in this placeless place—that being, including sight, is beside itself, approaching that impossible point where it will see itself seeing (or sleeping, or sucking).[32] In the statement above, one might take Shaviro to be making a number of interrelated points about Warhol's *Blow Job:* a) an event of perception is always perception beside itself; b) perception beside itself is perception-unto-blindness; c) Warhol's film is approaching this inaccessible event; d) this approach is a folding that effects a non-relational relation or a rapport with the Outside; e) this Outside, in its incessance, guarantees that perception will always be beside itself; f) Warhol's film is about points *a* through *e*, and to identify it as a film about a blow job would be to greatly misconstrue it. A blow job, as well as sleep, are literally beside the point in the Warhol films named accordingly.

Or one might say that Warhol has done in film what others have done (and continue to do) in anonymous sex: not given face (solicited or bestowed identity) but given head, as the thus or there is (*es gibt*, it gives) of erotic relationality. It is here that we are confronted with a sense that existence is always beside itself in its irredeemable relation to the Outside. *Sleep* and *Blow Job* give good head and, in doing so, remind us that it is always only as good as the intensity of the non-relational relations which they themselves visualize. They are the outside of pornography: a waiting and forgetting of the pornographic.

Being that is beside itself—what I referred to in chapter one as being-with-out—is a form of life without the assurances of inter-subjective relations that inevitably amounts to a different form of relationality altogether. Discussed in that earlier chapter as anonymous and itinerant, here it will be discussed as pseudonymous and folded. Through all of these inflections it effects a comportment that is ethical, artistic, and erotic.

As we know, a pseudonym is a fictitious name that affords its bearer a certain degree of anonymity in its differential relation to the bearer's actual name. Yet as Giorgio Manganelli has demonstrated (as recently discussed by Giorgio Agamben), there is the possibility of anonymity without using a name other than one's own.[33] Warhol actualizes this possibility by giving his films names that also name the action being filmed (even if that action is not entirely visible on screen). Rather than relying upon two different names to identify the same person/thing as in a pseudonym, this naming instead achieves anonymity through a redundancy of the same name.

Through a redundant intensification, a proper name (e.g. the pop star Madonna) is folded and effects "a pseudonym that is in every respect identical to one's name" (Agamben, 130). Manganelli calls this pseudonymy squared or, homopseudonymy. Clearly this is neither a matter of a solipsistic or nihilistic self, nor an appropriating or alienating relation to some "other." Instead, homopseudonymy is one name for a seemingly contradictory yet coexisting incomparable sameness and unrecognizable difference within what Agamben refers to as "the simple 'I.'" It is a relational proximity to the Outside that is at once "absolutely foreign and perfectly intimate" (Agamben, 131). In these very terms it is also "the ontological paradox of the living-speaking (or writing)-being [or filming, etc.], the living being who can say 'I'" (ibid.). Art's work, like erotics, is the event of this paradox, an inescapable homopseudonymy, of which the

work of art is nothing but its insufficient trace (not that there could ever be a trace that would be sufficient).

Sleep and *Blow Job* visualize the anonymity, pseudonymy, and most specifically the homopseudonymy of identity itself. Foucault noted a similar effect in his comment on Warhol's silkscreened soup can images: "A day will come when, by means of similitude relayed indefinitely along the length of a series, the image itself, along with the name it bears, will lose its identity. Campbell, Campbell, Campbell, Campbell."[34] Through an attenuation rather than a widening of the semiotic gap between signifier and signified, *Sleep* and *Blow Job* are, nonetheless, without the subjects identified by their titles and images. They are capable of not being what they are not by denial or internal difference, but by admission and redundant intensification. In this regard, they might find their art historical corollary not in Magritte's *Ceci n'est pas une pipe,* but by imagining Duchamp's *Fountain* retaining the name "urinal."

In an essay on the work of installation artist Doug Ischar, Catherine Lord observes that

> Ischar is less interested in homoerotic desire than in the erotics of homosocial transaction, less interested in spotting the queer in the crowd than in examining how the erotics of the crowd generate the visuality of the queer.[35]

The distinction between "homoerotic desire" and "the erotics of homosocial transaction" is the difference between identity-driven and erotic-driven modes of sociality. An erotics of the crowd, as the erotics of homosociality, is an erotics of social anonymity, of getting lost in the crowd, in which this losing of identity occurs through what Bersani refers to as an "extensibility of sameness" across the social.[36] It is a "nonidentitarian sameness" or anonymous homo-(same)-ness in sociality, distinct from homosexual identity, desire, and subjectivity (Bersani, 13). This mode of relationality is not narcissism per se, but rather social homopseudonymy or a homopseudonymic sociality. It is what Bersani calls "anonymous narcissism," in which relationality is fabricated through a redundant and dissimulating sameness across the social (ibid., 6). Something like gay male clone subcultures, in which a degree of sameness that cannot be claimed as anyone's identity effects a social anonymity that is the source of erotic attraction—Bruce, Bruce, Bruce, if not Campbell, Campbell, Campbell.

Not only is Doug Ischar's work an examination of the ways in which

the visuality of the queer refuses the epistemological imperatives to make social identities visible, it is also, in its own right, this very same refusal. Indeed, since the early 1990s, Doug Ischar's work, by actualizing virtual or unforeseeable forces and forms of relationality, has preferred not to accommodate the need for identities on the part of the social.

Catherine Lord refers to this as the visuality of the queer, and I wish to further evacuate any trace of identity that might remain even in the notion of the queer, by thinking towards a queer visuality that sees prior to, or in the wake of, identity, the evidentiary, epistemological clues, and the social. For the crowd is not (at least not here) some sociologically defined group, community, or nation, but rather the inoperative community, the one that is always coming and is, therefore, unavowable.[37] The crowd is constituted through anonymous spatial relations amongst infinitely substitutable inaccurate (non-mimetic) replications of forms, shapes, surfaces, colors, etc. The pleasure and erotics of the crowd is what Bersani has described as the "pleasure of at once losing the self and discovering it elsewhere, inaccurately replicated."[38] The social-spatial non-relational relationality of the crowd, unlike that of the community, is fundamentally promiscuous and non-reciprocal. If the crowd is the absolutely unrepresentable and unidentifiable community, then the visuality generated by it is imperceptible and inattentive; a becoming-disappeared in and by the crowd that is at the same time a blindness in sight (a folding of vision). It is the inattentive attention of the non-penetrating blank stare—the minutely inflected visuality of the consummate cruise.[39]

To return to Lord, we might now speak of a queer erotic visuality of the crowd: infinitesimal micro-perceptions and miniscule visual inflections (winks, blinks) of anonymous sociality. Doug Ischar's artistic practice is equally minute, not necessarily in terms of scale as much as in his miniscule manipulation of materials and images. The work exists as a series of micro-perceptions and ordinary, unremarkable minor elements that are even less than fragments since all reference and calculation towards a whole is gone. "Infallibly fastidious, he [Ischar] excises with skill the folded scrap of paper, the slip of the tongue, the rejected snapshot, the few frames of film that will in an instant irrevocably alter certain conditions of visibility."[40]

The smallest displacement of whatever singularity (i.e. folding a scrap of paper) is what effects this irrevocable alteration of visibility, a

shift that is a "non-threatening supplement to sameness," which renders the materiality of whatever singularity to be, quite simply, irreparable.[41] Such a shift calls for an attention to the ways in which irreparable materiality may be understood as coextensive with irrevocable visuality. It is as though visibility is most intensely effected by the slightest extension or supplementation of whatever singularity. And that this intensification is less a reinforcing of the visual than it is a matter of approaching the limits of the visual, the space of infinitesimal micro-perceptions that is also the inexhaustible exhausting of space, the inexhaustibility of the infinitesimal, and an inconspicuous visuality of the crowd.[42]

This entire study is devoted to thinking forms, modes, and forces of visuality, sociality, and spatiality that persist in a refusal of the evidentiary. Ischar's work suggests what remains after this refusal, which might also be a glimpse of what is anterior to this refusal, and prior to any remainder: the irreducible refusal in imperceptible visuality, anonymous sociality, and itinerant spatiality. I have argued that these are erotic modes of relationality, and that they suggest an ethics of promiscuity that we might call queer.

In all of these non-evidentiary ways, Ischar's work defies the logic of the forensic, and places him in an extremely remote relation to Henri Michaux's notion of the artist as "the one who, with all his might, resists the fundamental drive not to leave traces."[43] To pursue the (death or destructive) drive not to leave traces is to be a criminal. The *scene* of such criminal activity is invested in the particular form of criminality, however as Tony Vidler suggests, the *scene of the crime* can be reversed and one can speak of a *crime of the scene,* in which the crime is in the very fact of a scene (the taking of a place-in-space).[44] Ischar's work, I would argue, is far more criminal than even this, being less a matter of not leaving traces (single criminality) or of criminalizing the scene (reversed criminality) than it is a *stealing* of the *crime of the scene* (doubled or folded criminality). This crime against criminality (the work is *that* criminal—a traitorous criminality) does not even leave a trace of the crime of making a scene. It steals *the scene of the crime* and it steals the *crime of the scene,* leaving neither criminal traces nor criminal scenes, but something like the sense or force of criminality itself. The work therefore is not only concerned with the after-effects of an event, but is as much if not more interested in the moment(s) just prior, in that which is not the origin but something anterior to the origin.

The materiality of the work then, in its refusal to render visible, to leave a trace, and to take (a) place, is a withdrawing of evidence from the evidentiary, as though offering a glimpse of whatever singularity before its being subsumed by a logic of the evidentiary and rendered as evidence. Perhaps we should refer to it as extra-evidentiary or the evidentiary Outside, rather than as simply non-evidentiary. In a certain sense, it might also be the secret: not as finite hidden content, but as the form of an infinite force, the secret that no one will ever know. As described by Deleuze and Guattari, it is "the a priori general form of a nonlocalizable *something* that has happened."[45] Not a box in which something has been secreted, but a surface that is the folding of the inside outside, an exhausting of space (of both interiority and exteriority), which is what makes it unlocalizable, potentially pervasive, and absolutely perplexing. Perplexing in the sense that the secret exists right there on the surface (which may also be a way to think the secret of the surface). Because of the innocuous, ordinary, and mundane surface condition of the secret, it is literally incapable of being remarked upon. The secret's secret, its force, and privileged power, is its sheer unremarkability. It is this unremarkable status of the secret that allows it to retain its secrecy and to remain a secret. The force of the secret—its secret—is that it is without secrecy (either as form or content). The a priori secret and the secret prior to secrecy, this is the secret that one will never know since it is that much (or that little) of a secret.

At this point we begin to get a sense of how the force of the secret relates to the notion of evidence prior to the evidentiary: innocuous, overlooked, and unremarkable. The means of accessing this moment before the event is an anticipatory inclination, one that is also the gift of the paranoiac, which allows for the perception of secrets or evidence before they are formed, "guilty a priori, and in any event" (Deleuze and Guattari, 289). The force of the secret effects this uneasiness in relation to the evidentiary, an uneasiness that the paranoiac will insist is the fundamental relation to anything, in that this anything always bears the potential of becoming evidence. Ironically, this potentiality is proportional to the innocuousness and unremarkability of whatever. "It is because we no longer have nothing to hide that we can no longer be apprehended" (Deleuze and Guattari, 197).

Now the point I wish to make is that the force of the secret can assume more than one form, and so to Deleuze and Guattari's "eminently

virile paranoid form" (Deleuze and Guattari, 288), I find a counter-example in an erotically promiscuous form. There are then, at least two different and opposing (although proximate) ways in which imperceptible visuality, anonymous sociality, and itinerant spatiality (affects of the secret)—the logic of the lure—might take form. For the logic of the lure is an exposure to the power of potentiality which includes both the potential to-be and to not-be, at once. The charge of erotic existentiality is the power of potentiality, and this is why waiting can be erotic, how the passivity of a sleeping body can be so fascinating, and why Foucault was led to remark that "the best moment of love is when the lover leaves in the taxi." [46] Yet there is always the risk that an attraction-unto-negligence will be actualized as an extreme form of neglect, the absolute existential negligence that is death. This risk is an erotic necessity.

It is in this way that one can speak of queer erotic sociality as an "art of dosages." [47] For one must be cautious not to turn the pleasure of losing oneself into suicidal self-destruction; to transform the pleasure of finding oneself inaccurately replicated (being just similar) into the violent annihilation of this double (paranoid identification, evil twin). In other words attraction-unto-negligence and not attraction-unto-violence; cruising and anonymous sex versus compulsive sexualized violence; interminable waiting (infinitely insatiable) versus repeated satiation (violent consumption); stranger-intimacy rather than stranger-violence; pervert, deviant, fuckbuddy, and cockhound as opposed to serial rapist and murderer. The proximity between erotic sociality and sexual criminality is what interests me, not as a way to villainize one or apologize for the other, but as a way to understand how they share the affective traits of imperceptible visuality, anonymous sociality, and itinerant spatiality. There is no pretense here that any such understanding will save erotic sociality from being treated as criminal activity, or will stop sexual criminality before it violates bodies and extinguishes lives; the unimaginable possibility of either is insured by an invested sharing between the two. One of these investments bears the name of Jeffrey Dahmer: Milwaukee-based serial killer and a spectral presence in some of Ischar's recent work.

Although the prevailing sense has been that Dahmer killed out of a fear of being alone, I would argue to the contrary and in line with Leo Bersani's estimation of Jean Genet, that Dahmer "embrace[d] crime in order to be alone." [48] As a way of luring the young, good-looking, relatively poor African American and Southeast Asian men whom he idealized

back to his apartment, Dahmer often promised money in exchange for a few Polaroids of these guys naked. Many of these young men did not identify as gay and so their acceptance of Dahmer's offer was not solely or perhaps even largely based upon sexual interest. I might note here that this is not meant to suggest that if these men self-identified as gay their interest would have been of a solely sexual kind. In fact it is their complicated relation to sex and sexual identity that forces one to radically rethink many of the premises and categories upon which one conceptualizes sexuality and sociality. As Bruce Benderson expertly explains, the sexual economy within "the culture of poverty" effectively confuses many of the neat categories used by the middle class to organize (control) sex and sexual identity, including that between hetero- and homosexuality.[49] Benderson's insights, in their ability to elucidate the conditions that made these pick-ups possible, are well worth quoting at length.

> Bisexuality in prison, on the street, and throughout much of the Third World does not resemble that careful and philosophical bisexuality of our contemporary post-feminist, post-Freudian enlightenment. The street macho can be intensely homophobic and homosexual at the same time. The mixture of libido and flamboyant ego that spills out of the underclass male, as well as his familiarity with the skills of prostitution, make him available to both sexes in many instances. It's the role he plays that matters, regardless of which sex he does it with. . . . Although homosexuality may be vilified in macho settings, everyone knows that this is a policy for the surface and that many of the participants also have developed fully articulated same-sex sidelines, partly for survival and subsequently for pleasure. In the Anglo-Saxon world, with its heritage of philosophical materialism, the surface claims an exact match with what goes on underneath. But not so in the culture of poverty, where the bravado of appearances is one thing and off-the-record experiences and feelings are another. A man's got to have an image but he must not become a slave to it.[50]

Rather than positing a radical disjuncture between surface and that which presumably lies at its outer limits—a configuration that would simply be the structural reversal of surface and its inner depths—one might argue that in the culture of poverty's sexual economy, all is on the surface. This then, would offer a sense of social-sexual spatiality that exists without either interiority or exteriority, but rather a folding of the two across a plane of relations that is this very surface itself, something

approaching a co-im-pli-cating if not an absolute equality. The image that a man must have would exist on and as this enfolded surface, and would begin to suggest how it is that he need not become a slave to it (identify with it). For it was this complicating image of sexuality as an evacuating or betrayal of sexual identity that made the young guys in Milwaukee available, and drew Dahmer to them as the idealized images that he imagined them to be. The Polaroids taken by Dahmer of these young men emblematize this economy of exchange between surface and image, and the non-relational form of relationality shared between Dahmer and his victims.

The betrayal shared between Dahmer and his victims was a mode of erotic non-relationality so thorough in its abandonment of the social that it cannot be simply construed as a transgression of loyalty, commitment, or obligation. For it is even more irrecoverable and irredeemable than that: in its betrayal of the bond between loyalty and betrayal, which is to say of sociality itself, it is what Bersani has referred to as "sex without exchanges."[51] Non-reciprocal and non-relational, betrayal (social, erotic, ethical) becomes a way to think forms of resistance or refusal that bear "no relation whatsoever to the laws, categories, and values it would contest and, ideally, destroy."[52] Betrayal as an exposure unto the irrecoverable and irredeemable operates in its utter perversity, beyond such oppositions as normal/abnormal, and is unjustifiable and unverifiable. Betrayal is evidence that turns its back on the evidentiary, and this abandonment and "movement out of everything" is what led Genet to understand betrayal as an ethical necessity. For as Bersani understands the ethical-political import of Genet's conviction regarding the ethical necessity of betrayal, "without such a rejection, social revolt is doomed to repeat the oppressive conditions that provoked the revolt."[53] Which is to say that betrayal must be understood as a necessary mode of refusal, of turning one's back and walking away. Herein lies betrayal's exultant perversity.

After several hours of heavy drinking, perhaps some drug use, and the most modest amount of sex—during which Dahmer's guests were completely naked while he remained fully clothed—these guys were ready to get dressed, take the money promised them and return to their homes, girlfriends, or the neighborhood's streets. With no intention of fulfilling his promise, Dahmer at this point attempted to detain his guest, efforts that ultimately led—each time, except in the case of the one who ended up being the last and survived—to the death of each of his tricks.

To paraphrase Jean Genet, one might say that Dahmer's betrayal was, for him, an erotic necessity. It was an attraction of such intensity that it led to an equally intense and brutally violent negligence, treacherously transforming stranger-intimacy into stranger-murder. This transformation of attraction-unto-negligence into attraction-as-negligence marks the aggressivity inherent in any form of idealization, such that the latter can be understood as "the source of the aggressivity it refuses to recognize."[54]

In most accounts of Dahmer, the imminent departure of each guest has served as an explanation for his murderous actions, the sense being that Dahmer was a person who was afraid to be left alone. I wish to re-think this explanation and, based upon a particular theory of what it means to be alone, offer an opposing explanation. For if we accept Blanchot's statement that "a being is either alone or knows itself to be alone only when it is not,"[55] then Dahmer's fear of being alone lies not in the actual departure and absence of his guest, but a departure immanent in the guest who is still there. One's existence, understood as fundamentally relational, is a being-with-out, in which one's being alone is predicated upon the existence of another. In other words, one cannot be alone with oneself, but only in relation to another, the one who reminds you that you are alone. *One literally finds oneself alone with another.* It is this non-relational relation that is here being understood as ontological.

Dahmer's murderous appropriation and the resulting absolute material presence of corpses only further intensified his sense of not being alone. As a result, the bodies needed to be disposed of and he attempted to do this in a number of different ways: vats of acid (disintegration, especially of bones), dismemberment (fragmentation), and cannibalism (consumption). With each of these methods of disposal there was, nevertheless, a persistent residuality: remnants of bodies that were reminders for Dahmer of his existence as someone living with these parts, alone. It is here that one can locate his most intense source of pleasure, one that was derived from an (albeit murderous) intensification of an onto-logic that defines existence as being-with-out, in which one is alone only when one is not. It is not that he wanted to be alone, or for that matter that he wanted to be with someone, but that he constantly feared the possibility that he might not be alone. It is as though Dahmer could never be alone enough, that his hunger for being alone was insatiable, and that he repeatedly attempted to find satisfaction in the departure and subsequent murder of his young male tricks. An ecstatic wasting provoked Dahmer's

insatiable hunger such that his incessant satiation of that which is insatiable might be best understood, in the full force of the paradox, as a *cannibalistic wasting*. He found himself most alone, over there in the non-relational place he shared with each of these guys: inaccurate replications of himself that provoked violent rage rather than erotic pleasure, stranger-violence rather than stranger-intimacy. It is a form of murder that has been referred to as "suicide by proxy," a killing of the stranger in me, provoked by the drive to transform similarity into identity.[56]

"Nothing there." Supposedly these words were part of a report—filed by Milwaukee police officers—concerning what they found in the apartment at 924 North 25th Street, Milwaukee. "A typical one-bedroom apartment, one that was unusually tidy for being the residence of a single male. A couple of power tools lay on the living room carpet. Polaroid photographs of men in various stages of undress were strewn about, and the Asian's clothes lay on the couch."[57] Based upon the optics of the evidentiary this had yet to become "Jeffery Dahmer's" apartment. At this point, it was still any-space-whatever: indeterminate in its singularity, neither an abstract nor an individuated space, but a typical space, perhaps a stereotypical space. If one is to speak of it architecturally, it might be in terms of an architecture of the crowd, implying a sense that there is an inexact many more of these spaces in the neighborhood, in the city.[58] It is architecture without qualities (content), austere, generic, zero-degree architecture occupied by men without qualities—anonymous men in anonymous architecture. No wonder the police officers found "nothing there" as inhabitant and architecture receded into the background. Dahmer's serial killings took place right there in the same place, again and again. Although the scene of many crimes, at this particular moment in time it was—*evidently*—without traces of criminality. Almost as though the repetition of the crimes committed right there in the same place effected an exhausting of that very space.

The "Asian" mentioned above was Konerak Sinthasomphone, a fourteen-year-old Laotian boy who earlier that day was noticed running naked with blood dripping from his ass, down North 25th Street. This incident prompted a report to the police department by someone living in the neighborhood. Dahmer convinced the police who answered the call that the young boy was older than he appeared to be and that the two were lovers. As photographic evidence of Konerak's identity, Dahmer presented the officers with a Polaroid of the boy in his underwear, and

this was accepted as legitimating evidence of Konerak's identity. Following inspection of Dahmer's apartment, the naked, drugged, and bleeding boy was turned over by the police officers to Dahmer. For they accepted all of this visual evidence as verifying a lack of criminal evidence or, perhaps more accurately, as substantiating evidence of their own homophobic and racist stereotypes of gay men, gay male sex, Asian immigrants, and the lower-class urban neighborhood where the incident occurred, all as socially-sexually if not technically criminal. In the few hours immediately following the police officers' visit, Dahmer finished the crime he had begun and killed Konerak Sinthasomphone.[59]

In the eyes of the police officers, if there was any criminal evidence, it was not to materialize in the form of traces that would constitute a scene of a crime, but rather in the phantasmatic stereotyping of the domestic space of a gay man or gay men. In other words, Dahmer's apartment itself may have been regarded as a crime of the scene, the criminality of which lies in the homophobic judgment of the conjuncture of gay and home. But such a sense of judgment most likely grants too much criticality to the officers at the expense of ignoring their very own oversights.

It is this blindness-in-sight, this betrayal of vision, that Ischar renders in his work and in the interruption of one's perceptions effected while (and perhaps even after) viewing the work. In other words, Ischar remains true to this betrayal, in its impossibility of being borne witness to. Ischar does not represent betrayal, which, as discussed in chapter two, would amount to its redress or reclamation, but rather he persists or remains loyal to betrayal. Broadly speaking, this is achieved through an attenuation of visual evidence, and an engagement with the visually innocuous and non-spectacular.[60]

Siren (1996) was the name of a video installation in which Ischar explored, through a constellation of works, this evidently unremarkable visual and aural logic of Dahmer's social-spatial criminality (figure 14).[61] In its signifying resonance, the title of this installation names both Dahmer as seductive lure and the police call summoned by and summoning (naming or sounding) criminality. It is through *Siren* that one can register the mutual resonance between illegality and the law, the innocuous lure of equally innocuous instances of visuality and aurality.

Yet representational references to anything as specific as "Dahmer," are absolutely absent from Ischar's work. It is this radical non-referentiality and non-identification that I would argue opens up or

exposes a degree of familiarity in the viewer, that in its literal immediacy denies the privilege of distancing effects, of separating oneself out from these scenes. Such a separation would have been much more possible if these scenes were relegated to the imagined discreet domain of Dahmer. The fact that they defy such identification and remain familiar is where their power of implication lies. Dahmer, in *Siren*, is simply a point on an infinite line that runs through us, perhaps differently (then again and in certain immeasurable degrees, perhaps not so differently), but shared nonetheless. It is this sharing in something that remains imperceptible, this infinitesimal line of non-relational relationality, that Ischar approaches in his betrayal of aesthetic logics of referentiality, representation, and identification. Again, this is not some imagined metaphysical plane or transcendent elsewhere, but that which is right here, on and as the surface of these minimal, abstract and yet absolutely familiar visualizations.

In its title, *Lab* (figure 15) makes an oblique reference to Dahmer's apartment as a laboratory of sex, dismemberment, cryonics, and perhaps most directly, the incomplete acidic disintegration of bodies. This work consists of a video monitor that is seemingly nothing more than its own monochromatic white screen surface, illuminated internally. At the bottom of the screen rests a half-spent cigarette that has been prematurely extinguished. A thin trail of faint darkness *bleeds* from one of its ends, reminiscent of the effects of dropping a lit cigarette into water, most typically the water in a toilet bowl. The bleed of the cigarette, along with the very fact of its persistent visual presence, attests to an equally persistent residuality, of that which refuses to entirely disappear.

Shade (figure 16), an audio-video work, is most likely heard before it is seen, as its sound disrupts the quiet of the darkened gallery space with a loud cracking noise that is repeated every 40 seconds. In fact, at the moment the sound is heard, its visual presence—a monochromatic white field projected onto the white wall of the gallery—disappears.

Barely perceptible and extending across the entire width of the uppermost limit of the projection is a narrow cylindrical form that, in conjunction with the loud cracking sound, repeatedly suggests the quick retraction of a window shade. And yet there is a reversal and double refusal or betrayal of a shade's visual effects at that very moment when the sound of its retraction is heard. A reversal in the sense that light typically masked when the shade is drawn is instead visible, only to be rendered

visually absent once the shade is retracted. A double refusal in the sense that, on the one hand, at the moment of retraction, the moment when something else might be made visible behind or beyond the shade's occlusion, one is in fact left with an empty, darkened wall surface—the absence of image, the collapse of vision. On the other hand, prior to its loud retraction, the shade is visible but only as a monochromatic white field, and therefore once again being the absence of image and a blindness—hence the notion of a double refusal.

In its serially repetitive folding of light and dark, visibility and invisibility, *Shade* puts into question distinctions between interior/exterior and private/public, the very dialectical structures that constitute the ideology of middle-class domesticity. Things no longer line up so easily, such that visibility or publicity perversely become the means of obscuring interiority and privacy. This attests to the invisibility that imperceptibly persists in the visible, and to the privacy, in the form of secrecy, that boldly and uncompromisingly shows itself in public.

Lights (figures 17–19) takes the form of a tiny video monitor mounted to a wall, in which one sees a photo of Dahmer's living room. In the accompanying audio one hears the sounds of a door being closed and locked with a key, and then re-opened, at which point the image of the living room darkens and fades. The audio continues with the sounds of the door being locked once again, footsteps, and a dog barking. Not only does the work not make specific references to Dahmer, details of the photographed interior—a poster-sized reproduction of a half-naked male model photographed by Herb Ritts, a lava lamp, a set of dumbbells—index the stereotypical trappings of a late-twentieth-century gay man's apartment.

In each of these works, Ischar is neither offering a sense of the extraordinariness of Dahmer's story, nor even its ordinariness, but rather something like the unavowable exceptionality that is the inconspicuous and imperceptible within the ordinary. *Lab* may be said to reference Dahmer's vats of acid, Konerak's bleeding ass, or an economy of waste and disposal, but it never allows us to forget its more immediate familiarity as seemingly nothing more than a lit cigarette extinguished as it comes in contact with water. This familiarity is not only shared between Ischar's work and Dahmer's story, but between our lives and this work and this story. The work implicates us not in the crimes committed by Dahmer (a preposterous notion) but in the innocuousness that we share with him,

an innocuousness that was the condition for his crimes. This work puts us in touch not with the criminals that we are or are not, but in a less resolute way with the potential criminality of our own everyday lives. It makes it difficult to locate oneself in a place outside of and detached from this potentiality, and thereby exposes us to one of sociality's secrets, namely that of its ordinariness, its sheer unremarkability as a surface upon which just about anything is rendered possible and imperceptible.

Jeffrey Dahmer, in the full signifying force of that name, was simply an intensification of this logic of the social, exceptional precisely because Dahmer occurred across the surface of the ordinary, in broad daylight one might say, right under the nose of the law. Dahmer's crimes relied upon a treachery inherent within representational logics that constitute what we refer to as the ordinary and mundane, a treachery that is implicit within yet impossible to attest to, hence its potential power. It is in this respect that treachery names one of the secrets or lies (those things that betray testimony) of normalized sociality. The secret of the ordinary is that it lies about its ordinariness, and thereby functions as a traitor, as that which cannot be trusted. It is this secret that underlies what is often described as the perplexity of serial murderers. Which is to say that serial murder is committed by those who are seemingly normal and ordinary types. It is in this way that one might argue that the secret of the serial killer is this very ordinariness. And yet the serial killer's secret is not his alone, but is one of the secrets of sociality itself. Ischar's work testifies to this secret that is so difficult to bear witness to, by working on the sheer literality and surfaciality of the visual. His work offers a crucial reminder regarding the limits of the evidentiary and the importance of those things that go without saying or seeing. These limitations are the enabling constraints of an ethics.

"Geography" is the word that Bernard Cache uses to name relational and networked spaces that are not delimited in the sense of contextual closure.[62] Which is to say that this is, strictly speaking, an un-mappable geography, made up of foldings of planes and surfaces (involutions) and movements along abstract lines and vectors (inflections), that together constitute the specificity or one might say the event of any site, in terms of the Outside. "Geography is not the field next door, nor even the neighboring district, but a line that passes through our objects, from the city

to the teaspoon, along which there exists an absolute outside. This outside is not relative to a given inside; it exceeds any attempt at interiority" (Cache, 70). It is in this way that one can speak of sharing a geography with Jeffrey Dahmer. Not in terms of the city of Milwaukee, or the neighborhood in which he lived and committed his crimes, but in terms of a line—as indeterminate in its form as in its content—that runs through him and us, and specifies the difference yet proximity of spatial punctuation. It is this unavoidable relation to the Outside that defines geography as "a principle of rupture of scale" (ibid.), an incessantly interruptive exposure that is the ethical counter-force to the limitations of interiority, be they architectural, subjective, or communitarian.

It is this sense of geography that was operative in Ischar's site-specific installation for InSite97, a triennial exhibition of public art projects by North and South American artists whose works are intended to address the geo-political border between the two host cities: San Diego, California, and Tijuana, Mexico.[63] For Ischar and many of the other artists affiliated with InSite, the ideology of the border as a geo-political delineation of inside and outside needed to be disrupted so as to reveal a geography that is not mapped in terms of a dichotomous spatial logic of the State. Instead, Ischar's project redefined this space as a zone of proximity, involution, inflection, and interruption—the geography of the itinerant and anonymous moving imperceptibly, perhaps even while standing still and yet prior to a taking-place, a de-situating spatiality that defines its clandestine, perverse, and literally ob-scene specificity.

The site that Ischar chose for his installation project was, undeniably, an architectural interior, currently the gymnasium of a public school in the barrio of San Diego's Mexican American population, and earlier used as a military storage facility by the U.S. government. Both of these uses seem to be referenced by the title of the installation, *Drill*, a single monosyllabic word typical of Ischar's semantic play in naming his projects, an enactment through nomenclature of the singular multiplicity that is the logic, method, and effect of the work (figure 20).

Curiously, although perhaps not surprisingly (given his attraction to "out of field images"),[64] Ischar was initially drawn to this space by the large industrial fan that is built into the upper reaches of one of the building's walls. The fan is the only aperture of this windowless space, the only place at which exterior and interior meet and interpenetrate. Through the use of a minimal amount of artificial lighting, the gym

interior was kept quite dark, and the fan became a focal point or, perhaps more accurately, the principle source of light that goes largely unnoticed, something like a cinematic film projector. But what does it mean for a fan to function as a light source?

The fan is a single architectural oculus, and the building then is something like a cyclopean architecture. The fan/eye looks outward and inward at once, yet due to its height, is an aperture that one cannot see through, in a way not unlike those window/easel paintings featured in several of Magritte's paintings.

As a machine of perception, at times activated by the rotation of its blades, the fan/eye effects an optical blinking or winking caused by its stirring up of particles of matter (dust, sand, soot, fog), the materiality of perception. Ischar's fan, as a folding of spatiality and visuality, is not unlike Mallarmé's poetics, as described by Deleuze.

> The fold of the world is the fan or "l'unanime pli" (unanimous fold). At times the open fan makes all particles of matter, ashes, and fog rise and fall . . . "fold after fold," revealing the city. The fan reveals absence or withdrawal, a conglomeration of dust, hollow collectivities, armies and hallucinating assemblies.[65]

The fan then, is a geographic image, not in the sense of a map or landscape (obviously), but as a mode of perceiving "the fold of the world," a spatial involution that is less the geo-political border of State-inscription than it is the line and the plane that runs through and disrupts those maps and landscapes. Geographic images may also be understood as movement images, in that they do not picture movement (they are not images of movement) but rather function as movement. Such images exist prior to representational stasis (landscape or map), and in their itinerancy and relation to the Outside, are the zones of indetermination through which passes heteroclite sociality, erotics, and visuality (anonymous public sex, cruising grounds, illegal border crossings, a wink: non-relational forms or modes of relationality).

What needs to be thought here, in regard to Ischar's San Diego project, are ways in which the border, as a zone of difference, may be differentiated in turn, through foldings and unfoldings that open it back out onto an Outside that "exceeds any attempt at interiority."[66] It is a two-fold operation: "a fold that differentiates and is differentiated. . . . When Heidegger calls upon the *Zweifalt* to be the differentiator of difference, he

means above all that differentiation does not refer to a pregiven undifferentiated, but to a Difference that endlessly unfolds and folds over from each of its two sides, and that unfolds the one only while refolding the other."[67]

It is this folding, unfolding, and refolding of virtual and actual territories, perceptions, events, and bodies that is the drill alluded to by the title of Ischar's project, an operation that is enacted by many of its components, including the industrial fan. A drill is that form of movement that doubles back, again and again, a moving in place that effectively confuses dichotomies of inside and outside, beginning and end, and amounts to an (inexhaustible?) exhausting of space, perception, and body. It might be said that the repetitiveness of a drill is a means of boring into something and at the same time can be described, in its own right, as boring. But what if a drill was thought differently, neither positively nor negatively, but rather as an incessant folding of such judgments that generates an irresolvable yet exhilarating exhaustion?[68]

Leo Bersani has identified just such an instance in "Genet's cherished activity of rimming, which turns out to be just as suggestive aesthetically as it is ethically . . . [whereby Genet] resurrects a world as his tongue drills into his lover's anus."[69] One of the values of Bersani's reading—beyond its affirmation of the transformative force of rimming—is to offer a way in which to think aesthetics and ethics as an interruptive exhausting of the self, social relationality, perception, and place. A non-annihilating exhausting or drilling or folding that generates involuted spaces and microperceptions: fans and pockets, hypnagogic and out of field images.

The gymnasium's dark interior is punctuated by small, intense spots of light, caused by one of several sources: three industrial lamps reminiscent of a construction or repair site, two video monitors placed side-by-side, and a projection on a portable movie screen. Each of the lamps illuminates an object that appears to have been inadvertently left behind: an Adidas shoebox, a white button-down shirt, and a pair of white gym shorts (figures 21 and 22). They are isolated from each other, the shoebox sitting on the gym floor, while the shorts and shirt are each tucked into the bleachers at opposite ends of the gym.

They are less components of a narrative than moments of interruption in any story that one might tell through them. The shoebox has a

series of holes drilled into its lid, which allows light to penetrate into its otherwise covered interior. A button lies in the breast pocket of the shirt barely perceptible through the fabric, and the shorts have a noticeable lump caused by some unidentifiable thing in one of the pockets. Each of these spatial foldings—shoebox interior, shorts and shirt-breast pockets—also has, contained within, a tiny camera, no more than a couple inches square. Clues to the presence of these otherwise invisible devices lie in the thin cables that run from out of these foldings. They connect the miniature surveillance cameras to the two monitors and the projector, located far from the actual objects themselves. It is by tracing these technological lines of transmission that one surmises a connection—however remote—between these objects, their enfolded spaces, and the images that one sees on the monitors and the projection screen. Yet even there, little visual information is conveyed by these images (in fact it almost seems inaccurate to refer to them as images). Each monitor appears to be a white screen interrupted by a small and highly indiscernible shape or form, while the screen seems to present an image of the very architectural interior in which this art installation is taking place.

These objects function as metonymies and synecdoches for a series of events, desires, and constraints: a new pair of sneakers, phys. ed. class, school uniforms. Their foldings suggest social spaces that are neither inside nor outside, included nor excluded, but rather exist somewhere between and beyond, in an indeterminate zone that has the potential to offer a place of escape, better luck (it's a rabbit's foot in the shorts pocket), the insatiable pursuit of something or someone that must go unnoticed and unrecognized, or the hope, against all odds, of fitting in, or at least not sticking out too much. For some, it is a daily drill of finding without taking (a) place, of neither being hidden nor exposed but inhering, in the very non-place "where relation happens,"[70] and thereby being neither recognized nor unnoticed.

In her absolutely insightful historical and theoretical investigation of site-specific art practices, Miwon Kwon ultimately argues for contemporary cultural practices that bear a "relational sensibility," as the only means of "demarcating the relational specificity," that I am attempting to think here. She goes on to argue that "[o]nly those cultural practices that have this relational sensibility can turn local encounters into long-term commitments and transform passing intimacies into indelible, unretractable social marks."[71] Yet it is precisely in refusing the necessity of

these effects and transformations (in the forms of identification, permanence, and legibility) that certain spatial, social, and visual practices can be understood as queer. As this study has attempted to demonstrate, queer forms of spatiality, sociality, and visuality are constituted through "local encounters" and "passing intimacies" that do not require any further development or recording for their full force to be felt. Such forms put into question the values that are ascribed to "long-term commitments" and "unretractable social marks," and argue for the legitimacy of social, sexual, and visual promiscuities (the potential invested in the singular multiplicity of whomever, whatever, wherever), as modes of pleasure and survival, and the possible grounds for an ethics that operates without assured futures and codified parameters.

I would venture to say that only those cultural practices that acknowledge the interruptive singularity and thereby potentially transformative potential of local encounters and passing intimacies have the capacity to think social-sexual-visual sites in all of their relational specificity. These then would be practices whose site-specificity would lie less in the discursive than at the limits of discourse, as they suggest ways in which queer erotic itinerancy makes it difficult to do culture, to make the social, and to fabricate such representations as the architectural, the geographic, and the mnemonic. As William Haver has said of queer research and pedagogy so too can we say of their site-specificity: they do not reproduce or represent these forms of sociality, sexuality, and visuality but deploy them as the techniques of unmappable promiscuities.[72] Such an approach towards the limits of discourse may only be provisionally demarcated as a site, due to its non-referential, non-relational specificity, which is to say, its betrayal. The following discussion rethinks site-specificity by addressing those practices that take the spatiality, sociality, and visuality of queer erotics as "subject," and the effects that the latter has on the ways in which the former operates.

The sites of Swedish artist Matts Leiderstam's installation projects are very often the discursive limits of art history, travel and tourism, and globalization. Further, these projects suggest, in subtle and multivalent ways, the convergence of these various discursive Outsides, specifically as the sites of gay male cruising and anonymous sex. Leiderstam's work over the past few years has shifted the spatial-geographic scale of its critical

95

site-specificity, moving from work to frame to institutional setting and further towards increasingly less circumscribed cultural-sexual spaces.

For instance, whereas early works such as *The Shepherds* (1994) and *The Family?/The Club?* (1995) (figures 23 and 24) critically question discourses of portraiture, historical subjectivities, and artistic originality, his installation *No Difference at All* (1996) (figure 25) shifted the site of investigation from questions of that which is framed to the very space of the frame itself.

The Shepherds is a series of monochromatic ceramic vases, each bearing a slightly different flesh color (white, beige, ebony, etc.) and a male first name as title: Björn is ashen, Steve has a mild bronze tan, Hassan is black, and Lance is milky white.[73] The opening or "mouth" of each of these longneck bulb vases is folded in, to create a recessed pucker of ceramic material that resembles the surface contours of an anus. This series of ceramic objects operates through the specificity of social-sexual anonymity, and a minimal visual vocabulary of shapes, sizes, colors, textures, and first names that together constitute these generic specificities. This seeming contradiction of specificity without identity is in part what facilitates the recognition of porn stars and one-night stands: Claude, Steve, Lance, Chuck—porno-tropic shepherds and clones of masculinity or masculinity as cloning. We might remind ourselves that a shepherd is he who watches over his fold, which in turn is a singular multiplicity amongst which perhaps only the shepherd can recognize the differences. It is this singular multiplicity of the specificity of social-sexual anonymity that Leiderstam materializes through a simple ceramic folding of each vase's rim, a mutual becoming mouth/becoming anus as in the ecstatic loss of distinctions through rimming.

The goatherd or shepherd is also a figural trope in those well-known seventeenth- and eighteenth-century landscape paintings by Nicholas, Claude, and John. These artists—whose singularity and art historical exemplarity is pronounced by the nominal economy that enables them to be known on a first-name basis—engaged in a serial logic as they painted arcadian and bucolic landscapes, and reproduced at times the work of an artist of an earlier generation. In his installation for the Tenth Biennale of Sydney (1996), entitled *No Difference at All,* Leiderstam folds himself into this history of landscape painting by repainting (with a slight difference) John Constable's *Landscape with Goatherd and Goats* (1823), a work that was itself based upon a painting by Claude Lorrain (1637) of the

exact same subject and title (figures 27 and 28). In Leiderstam's version, the direction of the goatherd's gaze has been shifted beyond the pictorial space, outward towards an imagined viewer of the work. This effectively creates the sense of a mutual exchange of glances, a barely noticeable connection, something like the non-relational relation that is the rapport that one has with any work of art, or with anyone cruising a gallery or a park (as constructed landscape). In Sydney, Leiderstam's "cloning" of Constable's painting was installed alongside the actual English romantic landscape painting, a work in the permanent collection of the Art Gallery of New South Wales, Sydney. The specificity of Leiderstam's work is to be located in these historical repetitions, and multiple sites, at once enabled by and affirming the sense that culture does not simply travel, but that it is a form of travel. This also seems to be a particularly appropriate way of understanding the current globalized cultural economy, of which multi-national art exhibitions such as the Sydney Biennial are one hegemonic strata.

Accompanying the pair of paintings in Sydney was a traditional glass display case that housed another pair of objects emblematic, yet again, of geo-historical differences and an unwitting sameness (figure 26). Here, a small porcelain figurine made by Leiderstam, of a male with one hand on his hip (akimbo) and his other arm extended up and out to his side, wrist limp, is placed next to an early-nineteenth-century Spode enamel English teapot, painted in vermilion blue with a landscape reminiscent of Claude, Nicholas, or John. It is in the forced proximity of these objects that taxonomic logics are disrupted or, perhaps more radically, elided, as "no difference at all" serves not only as the name for this art installation, but as the answer to a popular Swedish homophobic joke (What is the difference between a fag and a teapot?), a pun on the bodily comport-ment of the figurine and the shape and silhouette of the teapot. In this work (and others), Leiderstam is engaged in a mode of institutional cri-tique that disrupts art historical and museological categorizations and differentiations, by insinuating that along certain lines of desire between things, there is no difference at all.

In three more recent installations—*Returned, The Rambles; Grand Tour;* and *Room G, Lower Floor* (all 1997) (figures 4, 31–32, and 29)—Leiderstam jumps scales by moving beyond, without ever losing sight of or connection to, the sanctioned spaces and frames of cultural produc-tion and exhibition. This critical engagement with art historical and

museological discourses, practices, artifacts, and institutional forma-
tions involves a series of foldings that do not simply expose the presence
of the outside inside (cruising, homophobia, etc.), but allow the force of
the Outside to generate effects that are irrecoverable. One might think of
these effects as the approach towards an inconsolable queer art history,
in which the pleasures of visual, social, and spatial relationality lie be-
yond the epistemological, the phenomenological, and the psychological.[74]
These are the pleasures of erotic uncertainty, spatial indeterminacy, and
visual imperceptibility, the forces through which something like cruising
gets its charge, what I am calling the logic of the lure. The three instal-
lations mentioned above and discussed presently are cruising grounds
not simply because they reference places where such activity might take
place, but more importantly because each operates through an incessant
and insatiable relational logic or promiscuity.

98 This habitual going out or back for more, this insatiability, is reflected
in *Returned, The Rambles,* the title for a site-specific art installation in an
area of New York City's Central Park named the Rambles, a favorite spot
for birdwatchers and male-to-male anonymous sex. In both cases it is a
question of nesting. Here, not far from the Metropolitan Museum of Art
and other major cultural institutions, Leiderstam placed one of his mod-
ified copies of an eighteenth-century landscape painting on an artist's
easel and simply left it there. By "returning" the landscape painting to an
outdoor setting with which it has no direct connection, except its sharing
with the park in a constructed fantasy of idyllic nature, Leiderstam marks
the site as a place of temporary, non-relational relations, of abandonment
and return, a series of foldings that constitute the specificity of the site
in all of its transience. This is the real work being done, while the easel
and painting are only slightly more significant (but how and why?) than
the spent condoms, beer bottles, articles of clothing, and makeshift me-
morial that also litter the place. Significance only comes by way of pho-
tographic reproduction, indicating the persistence of what Derrida has
referred to as "archive fever," an equally insatiable desire to return to the
origin and an impossible attempt to preserve the instant of the event, as
artifact, so that it can be returned to again and again.[75] Unfortunately,
the artifact is actually nothing more than the evidence of this instant hav-
ing been missed. Nonetheless, like so many art historical artifacts, it is
through photographic reproduction that I know and thereby think my-
self capable of writing about *Returned, The Rambles.* Perhaps the greatest

power of the work is in assuring me that I am unable to do either, and it is this disruptive force that renders art history inconsolable.

The Rambles installation happened concurrently with an installation that Leiderstam created for CRG Gallery in the SoHo neighborhood of Manhattan, entitled *Room G, Lower Floor*. Here, an art exhibition catalogue sits on a wooden bench in the middle of the gallery, its pages opened to reproductions of landscape paintings by Nicholas Poussin that Matts has copied, once again altering, by turning outward, the gaze of the solitary shepherd in each of two paintings that hang on the gallery wall across from the bench and catalogue. As an epistemological tool of art historical discourse, including its reliance upon photographic reproduction, the exhibition catalogue is a site worthy of critical investigation, in ways suggested by the work of Walter Benjamin and Michel Foucault.[76] The bench, in its Scandinavian design and its resemblance more to furniture found in a public park or perhaps a private garden rather than in a gallery, effects a shift towards other geographies and histories, including the artist's home country. A single ceramic cup (similar in its minimal design to the vases of *The Shepherds*) has been placed on top of the opened catalogue, as though holding down a place in the book, a marker not so much of identity but of an anonymous relation to these geographies and histories, a generic specificity equally captured by the title of the exhibition, in its reference to the division and categorization of institutional architectures such as art museums and galleries. The cup might also be taken as a sign of availability or exposure to the Outside, that is, the capacity to be stacked with another cup, as Leiderstam has done in the past (figure 30), and here as well, in a part of the installation entitled *Grand Tour*, by nesting two drinking glasses, one on top of the other. These glasses resemble English pints and have been placed on a white ledge or countertop rather innocuously installed in the window of the gallery's storefront façade (figure 31). The countertop effects an architectural folding of gallery and bar, in which the two glasses seem at once to be no less than aesthetic objects on display and no more than two drinking glasses inadvertently left behind after a night of drinking (abandonment, once again).

Due to their small size in comparison to the storefront windows, and the way in which they seem to have been placed there so nonchalantly, in addition to their transparency, the two drinking glasses are barely noticeable. I imagine that many visitors to the gallery, or passersby on the

99

street, never noticed them, or if they did, took them and their placement to be unintended, literally an oversight. If looked at more closely, one noticed that the glass nested into and supported by the other has a rounded bottom, suggesting that it would be incapable of standing on its own. A sense of co-dependence seems to be less interesting or relevant than the way in which these two objects imperceptibly occupy space right there out in the open, in the storefront display window, itself an enfolded space as is the space shared by these two glasses. This is a nesting of forms and architectures that is anonymous in its double refusal of transparency/ opacity, visibility-invisibility. It attests to those "things that are present and that we don't perceive are images in the full light of day," those things that are "absolutely translucid and give back all that they receive as they continually interact with each other and with us . . . these images have neither form nor duration; they are simply trace surfaces of propagation."[77]

A propagation of geographies, histories, places, and events—public parks, art galleries and museums, gay bars, eighteenth-century landscape painting, nineteenth-century cultural tourism, twentieth-century international art exhibitions, New York, Stockholm, France, Rome—that constitute the singular multiplicity of Leiderstam's site-specific art practice. Taking the operable logic of cruising as its principle concern and as its method, this practice promiscuously materializes an itinerant, imperceptible, and thereby insatiable and inconsolable art history. A grand tour without a map of any sort, simply innumerable vectors of minor excursions within major narratives and histories that attest to all histories, geographies, and images as perpetual foldings of history, geography, and representation.

Images that have "neither form nor duration," what I refer to as movement images, are the traces of these folding vectors. Such movement images also compose a photo-text work by Glenn Ligon, generically titled *Snapshots* (1994) (figures 33–36). The work was included in the exhibition *Dark O'Clock*, held at the Museum of Modern Art, São Paulo, Brazil, concurrent with the international Biennial of São Paulo, one of the largest exhibitions of its kind.

The 5″ × 7″ color photographs displayed in ordinary photo albums go beyond the informality and amateurism of conventional snapshot photographs, as they appear to be throwaway prints, those snapshots that would not even be regarded as worthy of a place in a personal photo album. In certain instances unfocused, and nearly all without a subject or

object of representation, these photos seem to record nothing more than a park bench or path, a cluster of bushes or a grove of trees, and in a seemingly accidental way, a solitary and unidentifiable human figure. If such an anonymous figure is included in a picture, it is always at a distance from the camera, and if there is more than one figure, they seem to be without any relation to each other.

In this sense, the photos are non-referential and non-relational, and the short texts that at regular intervals occupy a place in the album that otherwise might have been held by other photographs only seem to intensify this sense of non-relationality. For these texts do not function as captions for any of the images, nor do they constitute a narrative, especially one in which the photographs would serve as illustrations. The texts and images are equally destitute in their representational capacities, records of non-evidentiary forms of seeing and speaking. As a collection of these photos and texts, the albums archive events that approach the limits of vision and speech. In and of themselves, the albums neither offer scenes of a crime nor crimes of a scene, but like Ischar's and Leiderstam's work, a criminality that lies in the betrayal of visuality, spatiality, and sociality.

In these ways, the albums are the perverse archives of obscene events. Ob-scene in the literal sense of being prior to a scene, and perhaps to being seen, a spatial, visual, and one might go so far as to say ontological prior. In addition, this may include an uncanny (unhomely) sense of having been here before, an iteration that poses the potential that any-space-whatever may feel like, without actually being or needing to become, home. This spatial folding is expressed in one of the texts, which reads: "This part of Parque do Ibirapuera reminded me of the Ramble [*sic*] in Central Park. I guess there is a little bit of home wherever you go." This sense of an iterative ob-scene is reinforced by the fact that the photographs were taken by Jackson Arajo, a native of São Paulo, and someone who has not only lived there a long time prior to Ligon's visit, but whose photography precedes Ligon's use of it as part of his (Ligon's) artistic practice. This use represents a non-relational or non-collaborative relation between these two cultural practitioners as though there is a momentary suspension of ownership and claims to property rights, as Arajo gives Ligon images of places that might already "belong" to Ligon.

The Parque do Ibirapuera is in fact the public park adjacent to the Museum of Modern Art, where this work was exhibited. Like Leiderstam's

Returned, The Rambles, Ligon's *Snapshots* concerns a refusal or neglect of epistemological and phenomenological certainty, and an attraction towards an Outside by the latter's force of indetermination. It is this attraction-unto-negligence that is the lure that draws out, and it is only through its logic that cruising can even be said to have a ground. This is the non-relational space "shared" by Arajo, Ligon, and innumerable anonymous others, an indeterminate Outside that is not so much a ground, but the force of attraction-unto-negligence, by which these sites (snapshots and public parks both) become lures.

The visual destitution of the photos and the verbal obliqueness of the texts are formless traces of what Cindy Patton has referred to as a "cruising vernacular,"[78] a tactical specificity that relies upon sustaining social, visual, and spatial non-relationality (*informe*). A cruising vernacular does not operate by articulating inter-subjective relations but rather by intensifying anonymity and pseudonymity. A text in one of the albums gives us a sense of what this vernacular sounds like: "He had been sitting by himself for a long time, watching other men walk by. No one was paying attention to him. When I sat down he gave me a long, hard stare. He pointed at me and said, 'Spike Lee?' I looked at him for a moment and said, 'Pele?' We ended up spending two nights together" (Ligon, *Snapshots*).

In an essay on Ligon's *Snapshots,* Columbia University law professor and cultural critic Kendall Thomas presents a theory of contemporary global tourism, a "queer tourist theory," that enables one to think queer erotic itinerancy in terms of a network of visual, spatial, and linguistic discourses and practices.[79] Thomas relies upon Dean MacCannell's *The Tourist* (1976) to theorize the similarities and differences between Ligon's project and the travel photography of tourism. Thomas argues that the photos in *Snapshots* are identical to the snapshots that tourists in a place such as São Paulo may be imagined to take. Clearly the photos in Ligon's albums bear the same "utter impersonality" of travel photography, and yet they disrupt the visual logic of the latter in ways that effect important differences between the two.

For even if the sites of "attraction" for the queer tourist are places that also might be found on any tourist's map, the cruising vernacular that passes through these sites effects a visual destitution and a social-spatial anonymity (whomever, wherever), registered by *Snapshots,* and lying outside of conventional tourist photography. Ligon's photo albums collect traces of the folds that constitute a globalized queer erotic itinerancy.

Visual folds as in the nod of a head or the wink of an eye, social folds as in an intensified anonymity, and spatial folds as in the force of the Outside felt right here, now, in a zone that is, for instance, neither the domestic nor the foreign, but something like the minor, the obscene, a pocket, a nest. These folds are the betrayal of visual epistemologies, phenomenological experiences, and psychological conditions.

> I gave him money and asked him to meet me back here at 8pm. Of course, he didn't show up. The next day I saw him downtown in his police uniform but I didn't have the nerve to confront him. (Ligon, *Snapshots*)

These are the folds that attest to the fact that betrayal is not only an ethical and an artistic necessity, but an erotic one as well. Roland Barthes affirms this sense, as he recounts what can barely be referred to as an encounter, nor is it an attempt to rid one's conscience, and as an event is certainly not to be judged a failure. It is a vignette of the betrayal of a wink and a nod, an attraction-unto-negligence that is the lure.

> Always this difficulty about working in the afternoon. I went out at around six-thirty, for no good reason; in the Rue de Rennes noticed a new hustler, hair in his eyes, a tiny earring: since the Rue Bernard-Palissy was completely deserted, we discussed terms; his name was François; but the hotel was full; I gave him some money, he promised to be at the rendezvous an hour later, and of course never showed. I asked myself if I was really so mistaken (the received wisdom about giving money to a hustler *in advance!*), and concluded that since I really didn't want him all that much (nor even to make love), the result was the same: sex or no sex, at eight o'clock I would find myself back at the same point in my life; and since mere eye contact and an exchange of words eroticizes me, it was that pleasure that I paid for.[80]
>
> ...

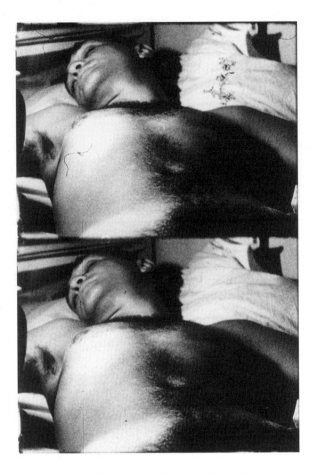

12. Andy Warhol, *Sleep* (1963), frames from film. © 2002 The Andy Warhol Museum, Pittsburgh, PA, a museum of Carnegie Institute.

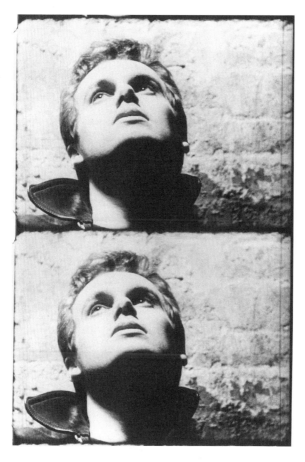

13. Andy Warhol, *Blow Job* (1963), frames from film. © 2002 The Andy Warhol
Museum, Pittsburgh, PA, a museum of Carnegie Institute.

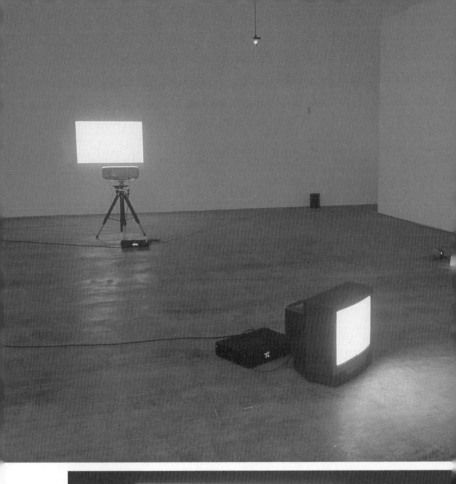

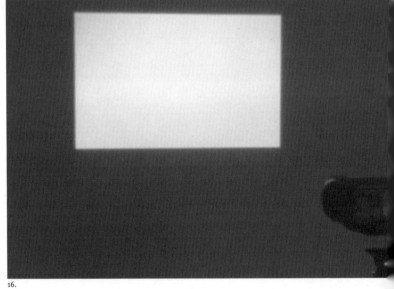

16.

14. 15.

14–16. Doug Ischar, *Siren* (1997), Brent Sikkema Gallery, New York City; featuring *Lab* (1996) and *Shade* (1996). Courtesy of Doug Ischar. (14: installation view of *Siren;* 15: still from *Lab,* videotape and monitor, Site Santa Fe, Santa Fe, New Mexico; 16: *Shade,* video projection with audio, Site Santa Fe.)

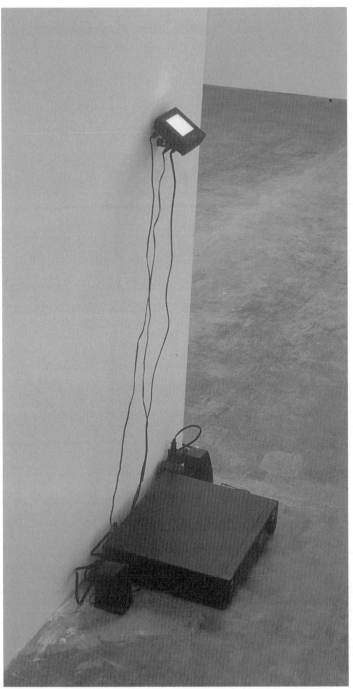

17.

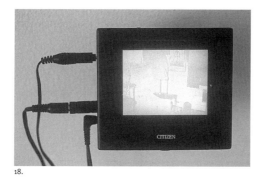

18.

19.

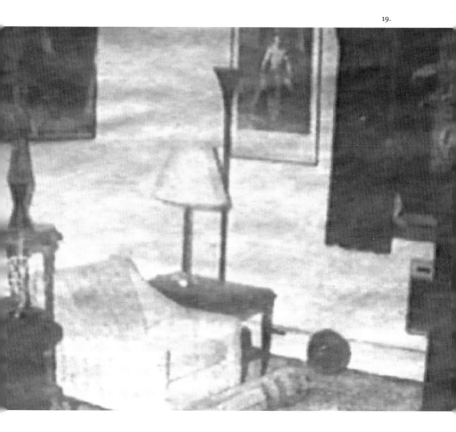

17–19. Doug Ischar, *Lights* (1996), video with audio on LCD monitor; Site Santa Fe, New Mexico. Courtesy of Doug Ischar. (17: installation view; 18: close-up of LCD monitor; 19: still, showing Jeffrey Dahmer's living room.)

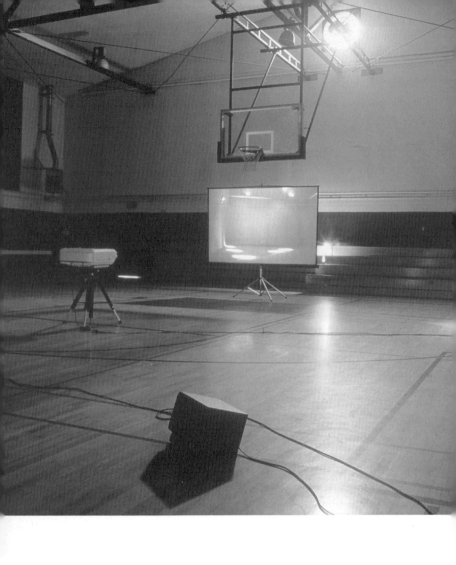

20–22. Doug Ischar, *Drill*; InSite97, San Diego, California, 1997. Courtesy of Doug Ischar. (20: installation view; 21: detail, Adidas shoebox and miniature surveillance camera; 22: detail, white gym shorts with rabbit's foot and miniature surveillance camera in pocket.)

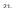

21.

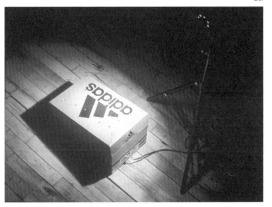

20.

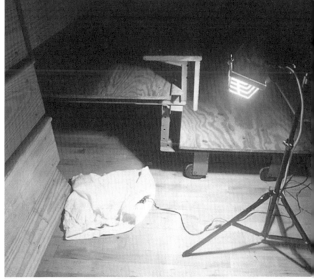

22.

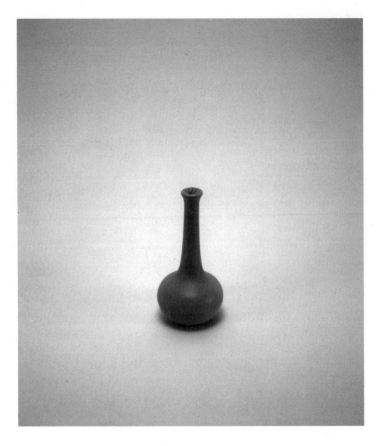

23. Matts Leiderstam, *Claude,* ceramic vase; from
the series *The Shepherds* (1994–98). Courtesy of
Matts Leiderstam.

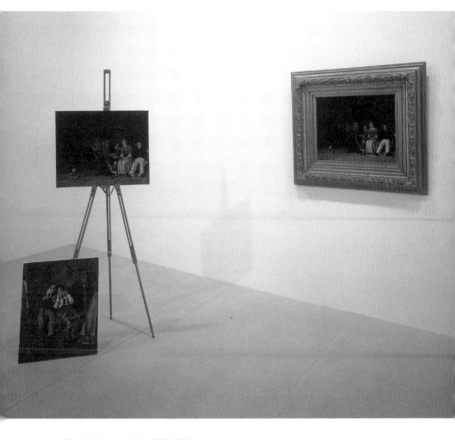

24. Matts Leiderstam, *The Family?/The Club?*
(1995), oil on linen and an easel; Malmö Konst-
museum. Courtesy of Matts Leiderstam.

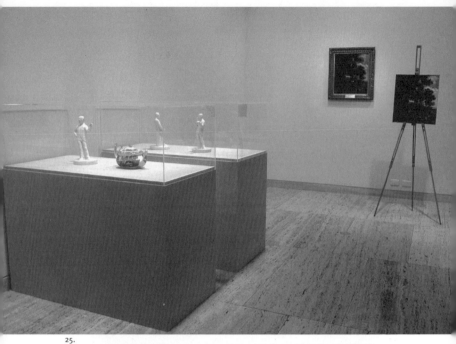

25.

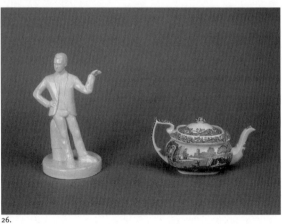

26.

25–27. Matts Leiderstam, *No Difference At All* (1996), mixed media; Jurassic Technologies Revenant, Tenth Biennale of Sydney, Australia. Courtesy of Matts Leiderstam. (25: view of installation; 26: detail, porcelain figurine and teapot [Spode Design, England, c. 1816]; 27: *Landscape with Goatherd and Goats*, oil on linen and an easel.)

28. John Constable, *Landscape with Goatherd and Goats* (1823), oil on canvas; 53.3 × 44.5 cm; Gift of the National Art Collections Fund 1961, Art Gallery of New South Wales, Sydney, Australia. Photo by Jenni Carter for AGNSW.

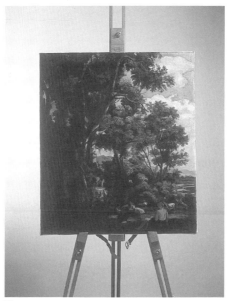

27.

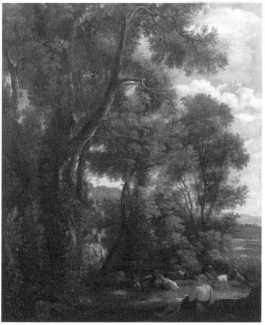

28.

29. Matts Leiderstam, view of installation *Room G,*
Lower Floor (1997), mixed media; CRG Gallery.
Courtesy of Matts Leiderstam.

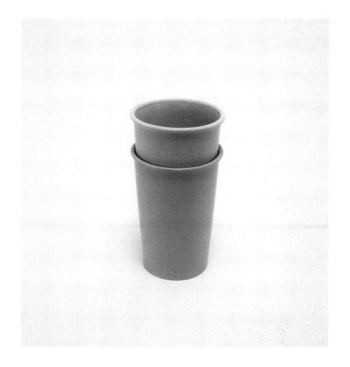

30. Matts Leiderstam, *Two of Us* (1994); stacked ceramic cups. Courtesy of Matts Leiderstam.

31. Matts Leiderstam, *Grand Tour* (detail; 1997),
drinking glasses and countertop; CRG Gallery.
Courtesy of Matts Leiderstam.

32. Matts Leiderstam, *Grand Tour* (detail; 1997), drinking glasses; CRG Gallery, New York City. Courtesy of Matts Leiderstam.

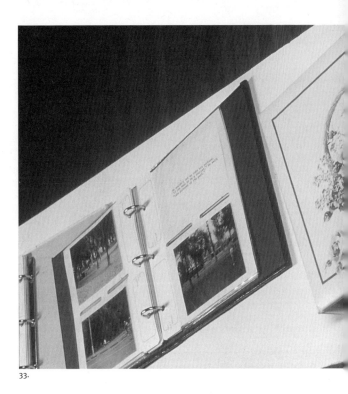

33.

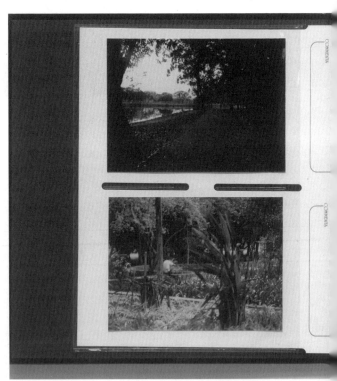

34.

33–36. Glenn Ligon, *Snapshots* (1994), color photographs in albums, text; as featured in the exhibition *fag-o-sites*, Gallery 400, University of Illinois–Chicago, 1995. Courtesy of Glenn Ligon.

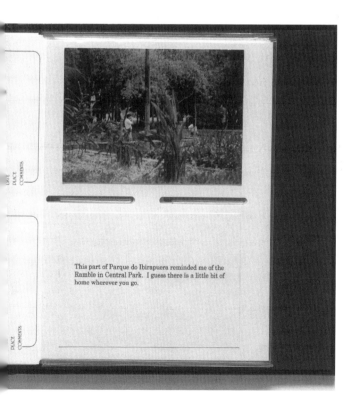

This part of Parque do Ibirapuera reminded me of the Ramble in Central Park. I guess there is a little bit of home wherever you go.

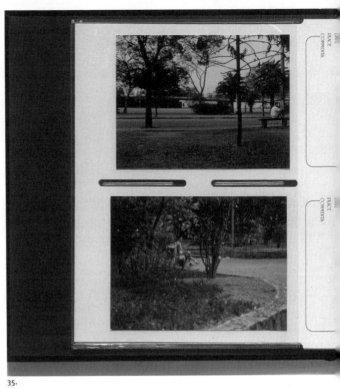

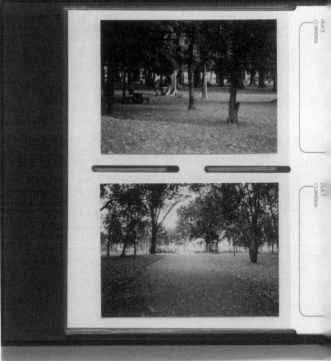

He had been sitting by himself for a long time, watching other men walk by. No one was paying any attention to him. When I sat down he gave me a long, hard stare. He pointed at me and said, "Spike Lee?" I pointed back at him and said, "Pelé?" We ended up spending two nights together.

I gave him money and asked him to meet me back here at 8 p.m. Of course, he didn't show up. The next day I saw him downtown in his police uniform but I didn't have the nerve to confront him.

....................................

The parenthetical, as the folding of writing by and in writing, is a means of creating this space of non-relational relationality. The following few pages should be read as though entirely written within parentheses, in the space between, for instance, a writer and an artist, articulated in writing.

> No, he doesn't invite me to write, he doesn't ask it of me, but he seeks to persuade me that I am not doing anything else.
> ...
> "Are you writing, are you writing at this moment?"
> —Maurice Blanchot, *The One Who Was Standing Apart from Me*

The relationality intimated in these lines is, first and foremost, and perhaps only and always, the relationality of writing itself. Writing—the very act itself—is an act of relationality that occurs, one might say, within the space of writing or writing's space. This is the space across which every writer moves, where every writer becomes a "he" or "she," and therefore where one is no longer him/her-self. Therefore although this definitively imaginary space necessarily provokes a notion of an other to whom one is always writing towards, that other is, regardless of specific conditions, no one other than the writer—"he." A strange form or sense of relationality no doubt, and yet one no more strange than the familiarity of writing itself.

The epigraphic lines from Blanchot quoted above seem to contradict or to be at odds with each other. For it certainly seems as though the second sentence, in its inquiry about writing, betrays the absence of an invitation or imperative of which we are assured in the first sentence. And yet, this is precisely not the case. To understand why this is so, one must free oneself from the impulse to treat these sentences as representations of intersubjective moments, either imagined or real. Rather, one must begin to register the anonymity that is essential to each, and that thereby defies both the personal and the impersonal. "He" and "you" are (in their duplicitous multiplicity) anonymous third persons that inhabit the space of writing, absolutely regardless of who "he" is, or "you" are. They identify the anonymity of writing itself.

"Are you writing, are you writing at this moment?"[81] This is the question that is asked of writing, perhaps the only question asked of it, the one that allows for the notion of writers, readers, and the forms of relationality that constitute the space of writing yet are not essential to writing. Writing, in

other words, is an anonymous practice, and to exist in the space of writing
is neither to exist as oneself or as an other, but simply to be some-one,
someone writing. Therefore the question persists: "Are you writing, are
you writing at this moment?"

"No, he doesn't invite me to write, he doesn't ask it of me, but he seeks
to persuade me that I am not doing anything else."[82] In so doing, he has
never actually asked me, "Are you writing, are you writing at this moment?"
since it is the question that is most beside the point. For if writing is rela-
tionality, then to ask this question is to step out of the space of relational-
ity, to be beside relationality. Therefore, writing can only ask one question
of itself and can only be asked one question, and these are the same, the
one that I have already reiterated, again and again. This is the one question
that he poses to me, perhaps the only question he poses to me, without
ever actually asking it of me.

The very potential of this relation, of he and I, is the potential of writing,
and cannot exist outside of this relational potential that is writing. For in
certain ways, it seems as though I have written only about him, as though
my writing has only found its place in relation to him. Indeed, he has been
very persuasive in posing writing as the only thing that I have done. Yet this
writing is never "done," but rather opens out into a space of incessance, in
which the question of writing is repeated, again and again. He and I then,
have never been beside this relationality, perhaps up until this point, in this
text, when I allow the question that has gone unasked, the question that as
I have said, must go unasked, to finally enter and speak. This necessarily
occurs at the outset of the text, in an epigraphic space that is neither inside
nor outside but precisely beside or alongside the text. This is the way in
which writing can reiterate the questions that it poses, about anonymous
forms of relationality, about "the one who was standing apart from me," in
the space of writing, itself.

If the question of writing insinuates itself into the space of writing, it
does so parenthetically. Parentheses are the interval of relationality itself: a
proximity constituted by and as that which is ever receding, never conjoin-
ing. This textual interruption marks the location of the writer in writing, he
who is always, at once, not yet and no longer in the space of writing. This
paradoxical situation of being at once prior to and in the wake of is cap-
tured by the two sentences that form this section's epigraph from Blanchot,
respectively. The writer is always about to be in the space of writing, and
yet, in writing, he is perpetually in flight from the space of writing. This

125

impossible in-between that is not yet and no longer is a parenthetical place, an "interrupted becoming." It is the status of the writer, the fold where writing is open to question. This, then, is why the question of writing, reiterated here, remains absolutely inaudible and unanswerable. This is not merely due to the fact that the word "moment" is part of this question, since the temporality of the moment, of the fragment, is in fact the time of writing itself. It comes from no place other than writing (this is how it can be asked in the "first" place), and yet to hear it, let alone respond to it, would be to find oneself farthest from writing. The question of writing puts itself and the writer into question by suspending both between parentheses, a web that supports and entraps. Imagine all writing as cast between parentheses.

This is also the space of what Haver has referred to as art's work, or the work of the artist (in neither case is it simply a matter of the work of art, as object, artifact).[83] For art is that which operates beyond itself, that which approaches the very limits of art. By approaching this place, which can only be referred to as elsewhere—a referential paucity that is, at the same time, elsewhere's plenitude (its unboundedness)—one risks approaching the dissolution of the work. Therefore, art's work is actually an unworking, an aesthetics-as-ascesis (a radical paring down). This is a reversal of the Greek sense of the uncanniness of human production or poesis (including artistic production), insofar as it is no longer a matter of bringing a thing from non-being into being, but of moving a thing from being towards its unavoidable non-being, and yet without the result of complete annihilation, which is as much of a god-trick as the Greeks' uncanny poesis.[84] Artistic practice (art's work) is thereby re-defined as never-ending in its approach toward a nothingness in plenitude, and the work of art is recast as a substantiality without content (e.g. meaning, being "about" something). A nothingness of plenitude is that place where an "availability-toward-nothingness" opens up, an always present potentiality to not not-be—something like art's unworking, its fundamental betrayal (e.g. of aesthetics, art history).[85] This sense of art being nothing more and nothing less than this work, this operation is a form of literality that might be characterized as irreparable.

In many ways, the epigraphic writing ("epigraphesis") that I have undertaken here provokes a sense of betrayal in its own right. By reiterating writing's questions, it would seem that I am no longer remaining faithful to the subject at hand, but rather have turned the lens onto myself, and that as criticism, historiography, or biography (the monographic), this text is an

absolute failure. I must protest against each of these accusations since—as
I have suggested thus far and intend to make clearer in what follows—the
betrayal of the subject (or object) has always been the subject [sic] at hand.
Furthermore, notions of authorial sovereignty and of historiographic en-
deavors are, at once, too close to, and too far from, this and all prior writ-
ing that I have undertaken with him. The difference lies in friendship.

Friendship is that which gives nothing but what is already there. It is in
this regard that we might understand it as sharing the same relation to the
irreparable as art. For it is not, nor has it ever been, a matter of not writing
prior to him. Nor is it, nor has it ever been a matter of needing him in order
to write, as though I was afflicted with a lack, some sort of writer's block.
Rather, it is that he has led me to realize that I have been writing all along,
although perhaps without knowing it, at least not in the ways in which I
know it now. It is in this way that he has not persuaded me simply to write,
either through invitation or imperative (which would be the easiest of tasks
and the most rudimentary form of relation), but that I am not doing any-
thing else. It is this plentitude of writing, of writing's potential relationality,
that has made this friendship happen, and that continues to make it hap-
pen. The voice of this friendship, which is neither his voice nor mine, is the
silent voice of writing, the one that poses the question that is never asked,
"Are you writing, are you writing at this moment?" Never asked in writing,
although always asked of writing, unable to be answered either in, or out-
side of, writing. This is the very impossible moment that makes writing pos-
sible. Writing's self-effacement, its anonymity.

This, then, cannot be confined to the work, to him, nor to me, since it
neither comes from nor approaches any of these places or persons. Rather,
and not unlike both art and friendship, it is directed elsewhere, towards
some-thing else and some-one else, beyond intimacy and intersubjectivity,
interiority or privacy. It is the place of relationality itself, which is really the
only place, a place that cannot be substantiated, represented, or occupied,
since it is precisely at the point of departure, always leaving towards else-
where. This fleeting relationality conditions writing's incessant repetition,
and anonymity. This is the space of friendship and the place of art's work—
pure relationality—where neither of us is himself. Perhaps it is not a voice
at all, but a sound, perpetually repeated, to no avail or avowal, and yet un-
able to be disavowed either. Something like the sound of a combination
lock dial being turned, incessantly and indefinitely, as though without a
proper combination and thus one that could not be memorized, and there-

fore does not even pose the threat of having been forgotten. The sort of ir-resolvability that necessarily conditions writing and that unavoidably escapes it.

Nothing is demanded, not much is necessary, except perhaps for inattention, however an inattention that is not compromised by either disdain or (self-)indulgence, but is neutral, such that things are left as is. Inattention is neither appropriative nor solicitous, it is neither a producing nor a putting to work, and to this extent is workless.

"The one who was standing apart from me" is spoken by no one other than (at least sometimes) the insomniac himself, the "he" who is the one who cannot sleep, and finds himself in this indefinite place speaking of, or perhaps even to, the one who stands apart. This does not occur in a refusal of sleep that in its deliberate wakefulness would still be closely aligned with an attention to sleep. Rather, insomnia is a failure of sleep, an absolute inattention to sleep as well as to wakefulness, an interruption of this economy. It lies outside of tiredness (day) and rest (night), and therefore outside of work (which is really what puts one to sleep). This failure then, is neither caused by, nor is it the effect of, exhaustion; it is the state of exhaustion itself. Insomnia is a form of negligence, yet one that is as fascinating as the intensity of inattention. It is a "nocturnal intensity."[86] For in its fascinating negligence, it attracts—yet without soliciting—and this inattentive attraction, this "torpor beyond all seeking," in the "long night of insomnia," is a workless working: forgetting sleep, forgetting rest.[87]

Outside of sleep and wakefulness, the insomniac is the one who can most closely approach himself sleeping, the one who is the voice of the "one," of the "who" in 'the one who was standing (or lying) apart from me." Obviously this is an impossible vantage point, a gaze toward something that cannot be seen, and yet it is precisely this impossibility, this imperceptibility, that makes it fascinating. For this blind spot is, strangely, also a *blind sight,* materialized through and as night visions, of being able to see in the dark of night, and of nightlights illuminating night's light. Isn't this not only what we have been seeing, but also how we have been seeing, in the spaces that he has presented to us, over the past eight years?

This visuality is hypnagogic, and auto/homo-erotic, since the insomniac is the one who stays up with himself, and relies upon a resemblance of (himself) sleeping as the only means of saving himself from the risks of this potentially inexhaustible exhausting sickness (absolute forgetting of self, death). The fascination of the insomniac is the stare at the becoming-

disappeared of self, space, day, night. It is an interruption that cannot be filled, the parenthetical itself, in its bracketing of emptiness. He has given us glimpses of this folded place—neither inside nor outside, but the "insidious inside"—a pocket, a shoebox, a mock handkerchief.[88] "Seek, then—seeking nothing—that which exhausts being exactly where it represents itself as inexhaustible. Seek the vanity of the incessant, the repetitiveness of the interminable."[89]

Perhaps it is in Rimbaud's insomnia and not his sleep that one might locate the unworking of the self as the relation to the absolute other.[90] Just as much as one might agree that Warhol's *Sleep* is a film of sleeplessness. It comes from no place (neither the place of sleep nor wakefulness, neither at home nor at work), which is to say, no place other than the approach of a notoriously intense inattention, toward a semblance of something fascinating, like being without being asleep or awake. Or, to speak in big (or is it small) philosophical terms: Being or existence without being, without positivity or negativity. "Sheer resemblance—resembling nothing, incomparable."[91] Something like fascination with that which is irreparable. Nothing more or less than the whip and crack of a window shade, the bleed of a spent cigarette, a button saved in a breast pocket, a note from a perfect stranger.

These are just the kinds of things that always go unattended. Singular in their double refusal of visibility-invisibility (they are, rather, imperceptible), of memory-forgetting (they exist thanks to inattention). Because of this neither-nor logic, it is impossible to relate to them, to interiorize or, for that matter, to exteriorize them. They are the remains of relationality itself, an "availability-to-nothingness,"[92] what persists in the not yet and the no longer, even. Precisely that which cannot be posited, and therefore cannot be negated, it is art's work as unworking—the swept up in its own sweeping (all of that). It is what one cannot live with or without, a familiar reconciliation of that which is irreconcilable, or absolutely unfamiliar, strange. Not unlike the bond between an artist and a writer or, if this isn't undermined by that, then something like friendship.

CHAPTER FOUR

Public

···

In the introductory essay to his book
On the Museum's Ruins, Douglas Crimp offers an anecdotal view into his
bedroom as a space in which the production of knowledge through clear
and authoritative speech is temporarily interrupted. Here it is a question
of identities, specifically non-hegemonic social identities: his own, and
the artist's whose photographs hang in his bedroom, and perhaps even the
subject portrayed in the photographs. In fact it is the identity of the pho-
tographed subject that is raised as a question by a curious and otherwise
unidentified "certain kind of visitor to my bedroom." Crimp, perhaps not
unexpectedly, is suddenly thrust into the position of teacher, as a visitor to
his bedroom, who if identifiable, nonetheless may not necessarily bear the
title of student, asks him to speak in response to a question of identity.

> For several years I had hanging in my bedroom [Sherrie] Levine's series of
> [Edward] Weston's photographs of his son Neil. On a number of occasions,
> a certain kind of visitor to my bedroom would ask, 'Who's the kid in the
> photographs?'—generally with the implication that I was into child por-
> nography. Wanting to counter that implication but unable to easily explain
> what those photographs meant to me, or at least what I thought they meant
> to me, I usually told a little white lie, saying only that they were pictures by
> a famous photographer of his son. I was thereby able to establish a credible
> reason for having the photos without having to explain postmodernism to
> someone I figured—given the nature of these encounters—wouldn't be
> particularly interested anyway.[1]

The possible yet as one might infer rather inappropriate need "to explain postmodernism" was, of course, predicated on the fact that the photographs hanging in Crimp's bedroom were works by Sherrie Levine in which she appropriated (literally re-took), Edward Weston's famous nude photos of his young son Neil (figure 37). Such artistic appropriations that radically put into question notions of authenticity, originality, and authorship have become hallmarks of postmodern cultural practice, in no small part due to Crimp's own writings on such practices.

The overall argument of the essay in which this anecdote appears is for modes of cultural practice that are thoroughly integrated into multiple levels of social praxis; function beyond the institutionalized spaces of art and culture; and address non-hegemonic social positions. These constitute further criteria for Crimp's definition of postmodernism, and find their exemplary materialization in late-'80s/early-'90s AIDS activism, most notably in the urban public protests and street graphics of ACT-UP. In avowing the difference between his pre- and post-ACT-UP thinking and writing, Crimp admits that by "remaining within the world of high art, neglecting all forms of difference but those of aesthetic function, I was unable to comprehend the genuine significance of postmodernism as, precisely, the eruption of difference itself within the domains of knowledge."[2]

Yet in the anecdote quoted above, it is precisely postmodernism that goes unexplained in Crimp's speech, just as a certain kind of visitor goes unidentified in his writing. It is in the chiasmus of these elisions that I wish to locate the potential force, or risk, of a perverse pedagogy that would have less to do with either denying or affirming an interest in child pornography (which in comparison is not nearly as perverse) than it is an interruption of knowledge production in the forms of a mastery of interpretation and the management of identities. This then, would be a pedagogy whose object was not "postmodernism," "photographic appropriation," "curious visitors," or "white lies," but the objectless supplement of all of these epistemological designations, and the exposure to this undecidable, unknowable, un-locatable elsewhere, that is nonetheless nowhere else but in that bedroom, with that trick, asking about those photos of a naked boy. A pedagogy that is always out of place, a promiscuous itinerancy that is incessantly lured by what Haver and Britzman might refer to as inconsolable uncertainty, toward the Outside, as in the form of unfounded curiosity.[3] This is what we might refer to as queer pedagogy.

Queer pedagogy is an educational instance that does not simply concern itself with the rescue of subjugated identities and histories, but more radically, precipitates a thought that thinks the impossibility of its thinking, or speaking, or writing. Rather than regard such scenes as occasions of epistemological elision or escape (being saved by one's own quick wits), I would like to consider them as moments that elicit epistemological limits (being brought to the brink of what one knows). The limit of pedagogy is where pedagogy becomes illicit: prohibited, even though it is already there in its potentiality, as the very threat or risk of thinking.[4]

I do not wish to take issue with (and therefore make an issue of) any instance of pedagogical oversight, so as much as I wish to consider— partly through Crimp's anecdote—a missed opportunity to break down hierarchies of knowledge and to relinquish positions of power, even in those instances that may appear to be the least likely sites of pedagogical practice, such as the bedroom, or places where such hierarchies and positions may be essential to maintaining a degree of sexual attraction. In this way, I am less interested in critiquing Crimp's anecdote than I am in its positive potential to allegorize queer pedagogical practice, and in particular, the latter's location or, perhaps more accurately, its dislocation. In other words, what happens, and where does one end up, when sexuality and pedagogy suddenly find themselves as bedfellows?

> And is it not thus, changing the scale, that political consciousness begins, in un-ease?[5]

What if we were to understand this bedroom scene as not only a pedagogical anecdote (about Levine and postmodernism), but also an anecdote about pedagogy, not only a means of instruction, but also a site of instruction? This may require us to see the allegorical in the anecdotal, and even to ask whether the notion of an anecdote about pedagogy is not, instructively, redundant. For once we acknowledge that "all talk about pedagogy is itself pedagogical,"[6] then we might begin to foresee ways in which, by twisting this precept, most if not all anecdotal talk is itself about or an enactment of pedagogy. And with this inflection, we might discover a means of theorizing *and* practicing pedagogy. But still . . . theorizing and practicing pedagogy in the *bedroom?!*

In his essay on queer research and pedagogy, William Haver theorizes the enactment of queer pedagogy in ways that are in part informed by Judith Butler's notions of performativity as the non-ontological grounds for

making and doing gender. Haver's reading of Butler allows us to see the capacity and limitations of discursively constituted notions of subjectivity, and how it is that queer research and pedagogy disrupt these processes precisely by approaching their limits.

Transcribing Butler's theory of gender performativity into an investigation of pedagogical practice allows for the latter to be equally understood as effectively "differentiating relations by which speaking subjects come into being."[7] This implies that subjectivity is always constituted relationally, and that it is centered in speech acts: one becomes someone through the very act of speaking amongst others. In this way, subjectivity is neither assumed to exist prior to nor in the wake of these relational utterances, but rather as the event of relationality. As Butler has argued, the "I" of individuation "emerges only within and as the matrix of gender relations themselves."[8] By substituting "pedagogy" for the word "gender" in this definition, it too is understood as a discourse that in its relational structure or "matrix" fabricates an educated as well as a gendered subject. In fact, one might argue that these fabrications are mutually and inextricably interwoven. I take this to be Haver's purpose in referencing Butler's theory, in his discussion of pedagogy's predication of subjectivity, that which "precedes and enables that 'I'" of pedagogical utterance.[9]

133

Crimp's anecdote captures the pedagogical as that moment when he is called upon to answer to the identity of the boy represented in the framed photographs in the room, and thereby to assume an identity or subject position that does not exist prior to this moment, but is precipitated by and as an indefinite matrix that includes the question posed, the photographs, two male bodies, a bedroom, a response. In turn, this matrix is the coincidence of the principle of reason (in which the latter is rendered as explanation or account of something) and the interpretation of the essence of things in objects. This reason-by-reification, in which objects are posited vis-à-vis subjects, is what provides assurance as to the presence of the self, and the ability to utter "I."

The discrepancy between the visitor's question ("Who's the kid in the photographs?") and Crimp's self-reflexive translation of this question ("What do these photos mean to me?") indicates a breakdown in the adequation between theory/concept and object, between representation and representamen, and this breakdown amounts to a crisis of pedagogy and identity. Indeed, Crimp's move can be understood as an attempt to regain control not only of the situation but also of his identity or, more precisely,

his sense of self in relation to boys in his bedroom, both those in photographs and in actuality, and in their co-existence right then and there.

The visitor's question is a destabilizing and interruptive force that affirms the difference that difference can make in the domain of knowledge, especially when that difference is sexuality and that domain is a sex space (even, or perhaps especially, when it is a middle-class domestic interior). Crimp is caught by surprise, as a discursive multiplicity threatens to fully occupy the space, posing the risk that the pedagogical as well as the sexual potential of the moment may be lost. The risk to the sexual is relatively easy to understand if one imagines the visitor being turned off by evidence of an interest in child pornography. As Crimp attests, this risk is doubled by the potential threat of a prolonged explanation of the photographs, a mini-seminar on postmodernism, held in the bedroom. As Haver might characterize it, this would be a "conflict of interpretations, a struggle for intellectual and pedagogical hegemony: in short, to condemn ourselves to death by conversation."[10] In the tension between these two risks lies the convergence of pedagogy and erotics, and it is a queer pedagogy that avoids the temptation to err on the side of one or the other. This double bind makes the ability to utter a response difficult if not impossible. This is where speech and the relations that it articulates begin to break down. For Roland Barthes, the pedagogical is located in the inextricable relation between teaching and speech. Based upon this relation, there seem to be two choices: either one can side with authority and speak well, without hesitation, or one can disrupt these laws of speaking and exercise a largely non-communicative form of speech. In the latter case, pedagogy goes unauthorized, and the agent of pedagogy is thereby de-authorized or stripped of authority. Such an occurrence is commonly considered a moment of failure, yet in the pedagogy that is at stake here, in a queer pedagogy, this is a failure that must be elicited and recognized as an ethical moment and a becoming responsible of the teacher.

What is being called for, then, is not a rush to discourse and an impressive demonstration of interpretive skill (e.g. a method, "death by conversation"), but an infinite suspension of pedagogical mastery and an ethical adherence to the epistemological stutter that is at once the condition and the interruption of the production of knowledge, something like the force of difference itself.

This is what Barthes may have meant when he mentioned, ever so briefly yet therefore in a way that enacts his point, a third possibility in

the relations between speech and pedagogy. "In order to subvert the Law (and not simply get around it), the teacher would have to undermine voice delivery, word speed, and rhythm to the point of *another* intelligibility." [11] It is through such an un-determined intelligibility that a queer pedagogical enunciation may occur, one that would neither have recourse to authoritative loquacity nor the voicelessness of "the great silent mind" (Barthes, 192).

An epistemological if not an actual vocal stuttering occurs as Crimp finds himself the subject of analysis, which is to say, put into question and exposed in his singular multiplicity. At that very moment, Crimp reaches for an imagined sense of self in order to counter or escape implication—to avoid not only the accusation of child pornography, but also the epistemological-sexual interruption that is queer pedagogy.

> I usually told a little white lie, saying only that they were pictures by a famous photographer of his son. I was thereby able to establish a credible reason for having the photos without having to explain postmodernism to someone I figured—given the nature of these encounters—wouldn't be particularly interested anyway.

His writing of this incident is at least a partial smoothing out of an epistemological stammering, not a confession or at least not only that, but also a means of further regaining a principle of reason following a seemingly un-principled (illicit) incident. As Barthes has written, "Writing begins at the point where speech becomes *impossible* (a word that can be understood in the sense it has when applied to a child)" (Barthes, 190). In Crimp's anecdote, speech becomes impossible like a child, perhaps even the impossible child of child pornography, that which is impossible to approach in speech and in writing.

Crimp's bedroom scene does not represent the refusal to teach, since such a refusal would be based upon the implied presence of a subjective rationality that would, in turn, enable the pedagogical to be excused through appeals rendered as "here? and at a moment like this?!" A number of rationalizations would extend this logic into questions of bio-pathology (the student is unteachable), economies of epistemology (the student is not worth being taught), and of the psycho-social (the student is not interested in being taught).[12] Such excuses remove the bedroom scene, erotics, and non-relational sociality from the pedagogical (and vice versa), whereas these conjunctures are precisely what a queer peda-

gogy solicits in its approach towards epistemological limits and re-
gimes of power. In order not to simply reproduce forms of knowledge,
one must betray or undo what one knows, and approach the limits of
thought in one's thinking. It is here that thinking begins rather than
ends, in that difficult spot where thought confronts its own "essential,
enabling insufficiency."[13]

A queer pedagogy takes this crisis of knowledge production as its
praxis, enabling one to understand that what the photos might mean to
Crimp may be the very unease or uncertainty of knowing what they
mean to him. Their inexplicability, which one might ascribe to the spe-
cifics of the situation, is in fact unable to be excused by the "nature of
these encounters," but is rather further intensified and rendered as an
epistemological stammering. In other words, the axis of epistemological
uncertainty is as erotic as the uncertainty of this social-sexual relation.
This multi-axiality is what effects a queer pedagogy as an erotic prag-
matics, whether in the bedroom or the classroom. A queer pedagogy pro-
vokes attention to the very unease and uncertainty of what one thinks
one knows. This is what Haver means when he writes that "one thinks
where it is impossible to think, and to think where it is impossible to
think is to sustain an erotic relation."[14]

Not even Crimp's recourse to an over-determined referential lan-
guage ("without having to explain postmodernism") can contain the sin-
gular multiplicities that are generated, relationally, out of this moment of
crisis. For it is not as though an explanation of postmodernism would
even adequately answer the question posed, let alone put a stop to the
stammering. Since postmodernism is simply a concept and not an ex-
planation, it is, itself, in need of explanation, and therefore cannot be
used to secure pedagogical mastery. In a situation like this, it is impos-
sible to claim such authority and at the same time remain ethical. If
there is a failure in Crimp's bedroom scene, it is in the way that an in-
ability to identify and explain, an inability to find one's proper place, is
not recognized as a queer pedagogical moment. For in a pedagogical re-
lationship articulated through speech, both teacher and student are dis-
located through and across a multiplicity of roles and places that come
to constitute the field of the pedagogical in all of its uncontainable pro-
liferation. It is due to this un-boundedness and excess that pedagogy is
compelled to persist. As Barthes has suggested, the "our place" of peda-
gogy is a "space [where] nobody should anywhere be in his place," and

goes so far as to say, "(I am comforted by this constant displacement: were I to find my place, I would not even go on pretending to teach, I would give up)." [15]

Crimp's attempt to overcome this self-described unease through an appeal to patriarchal-familial forms of cultural production ("pictures by a famous photographer of his son"), while somewhat accurate and true, at the same attests to the lack of innocence that white lies, in their racist coloration, intend to secure. [16] Through this duplicitous appeal or doubling back on oneself, and regardless of its (partial) veracity, Crimp regains authoritative control through an epistemological prophylaxis. Rather than an epistemological closeting of sexual and other forms of social identity, we might configure this scene as a closeting of epistemology, a place where one gets by, by telling "white lies."

The mundane smallness of this scenario is a significant aspect of its relevance for a discussion of pedagogy. This minor scale—like the architectural, representational, and social registers examined in the previous three chapters—is the condition for a multiplying practice, absolutely uncontainable in its proliferation and resonance, across spaces that might otherwise go unacknowledged as potential sites of pedagogical practice.

> The question of the pedagogical must undoubtedly be allowed to resonate in several registers simultaneously: in the formal and informal disciplinary and epistemological structures of our learning, certainly; in institutional classrooms, of course, not excepting the university classroom and the seminar; but also, and perhaps most importantly, in our microscopic learnings, unlearnings and relearnings, the infinitesimal negotiations by which we learn and unlearn the world. In no case, of course, are these registers mutually exclusive. [17]

It is in this that one can understand that a bedroom, even when it is the scene of a one-night stand (but we are not certain that this is the case for Crimp), is not exempt from but rather tests the limits of the pedagogical. Simply because Douglas Crimp does not treat this moment, either during its actual unfolding or in its retelling as anecdote (of course in both cases existing as and within a single text), in terms of the pedagogical we should not be distracted from the ways in which the relations that it captures suggest the potential force of queer pedagogy. This then, is much more than simply a matter of Sherrie Levine's photographic appropria-

tions, or the concept of postmodernism, or even a mini-conversation prior to or following sex (small talk indeed), but rather the way in which each of these identities, theoretical paradigms, and erotic moments are predicated upon the pedagogical, and the way in which the latter continuously exposes us to its, ours, and their un-boundedness. Again, to quote Haver,

> These infinitesimal negotiations by which we learn the "world" never, in fact, coagulate into identities, cultures, subjectivities; the pedagogy of these infinitesimal—empirical—negotiations always exceeds the objectness of its effects. And it is this disjunction, between a pragmatics and its residues, between an effectivity and its effects, that concerns queer pedagogy; it is this supplementary excess, crossing the several registers of the pedagogical, that concerns queer research.[18]

138 Clearly, this calls for a pedagogical practice that can venture beyond the institutionalized spaces and legitimized roles of education, without necessarily losing sight of these sites. It requires a form of pedagogical trespass; a promiscuous pedagogy that at times is anonymous, imperceptible, and itinerant. Such movement is the indeterminate path towards the Outside of pedagogy, an exposure that is pedagogy at its most responsible, which is to say, unanchored, yet no less materialist than the very surfaces across which this trajectory is inscribed, and only as it is traversed. It is in these any-spaces-whatever that "the problem, then, becomes one of working out ethical relations and not asserting identity hierarchies."[19]

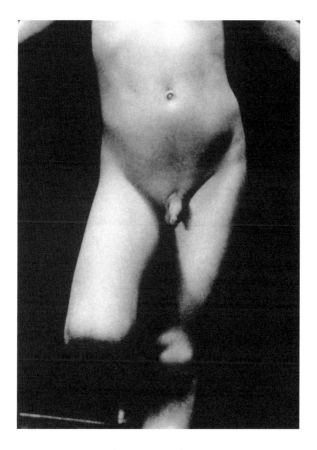

37. Sherrie Levine, *Untitled* (after Edward Weston), 1981. Courtesy Paula Cooper
Gallery, New York.

A Quarterly Journal For Men
Volume 1 • Issue 4 • Winter 1993 • $4.95 USA • $5.95 CAN

STEAM is published by PDA Press, Inc., Route 2, Box 1215, Cazenovia, WI 53924

38. Cover of the journal *Steam*, vol. 1, no. 4 (Winter 1994).

39. *It's Time to End the Gay Rights Movement as We Know It* (1997), political broadside, Chicago.

..

What follows is being written across
and in the wake of a number of provocative statements concerning queer
theory/research in the academy, put forth by several queer theorists, at
least two of whom have made significant contributions to what I shall re-
fer to as "queer sex space theory," as a way to name the kind of endeavor
in which you are presently engaged as well as work that will be discussed
below. In doing so, I would like to preserve the political/ethical tension
that resonates between these statements, and to use this as a barometer
to gauge the demands on, and of, queer theory to be more than merely
a school of thought (e.g. an academic discipline, a method of interpreta-
tion, etc.). This would be queer theory as an unavowable community of
thought, one that is always coming never arriving, just as much as it is a
matter of being both *out in* and *out of* the academy at once. Here are three
provocations:

> You can't build a critical line of thinking around people who are al-
> ways on the verge of departing.[20]

We desperately need to think about how we can become public
intellectuals.[21]

Pedagogy becomes merely an instrumental technique or strategy for
the occlusion of the erotic, the heteroclite social. . . . It may well be that
the university, or education institutions generally, will not be the site of
queer research.[22]

The production of queer sex space theory, in its commitment to think-
ing a post-identity social-sexual politics and to fabricating queer counter-
publics, extends its pedagogical potential across innumerable sites and
registers—the very places where theory happens. Clearly, theoretical pro-
duction is a primary mode of articulating a queer social-sexual ethics and
not simply a mode of reproducing already established knowledges and
identities (for instance, in the mode of interpretation and explication).
This, then, is less a matter of theory for theory's sake, than it is an effort
to ceaselessly explore the multivalent capacities of theoretical production
across social and cultural terrains. Katie King's notion of "theory in press"[23]
provides a means of examining the politics of theoretical production, distri-
bution, and reception, and in the process suggests the need for a more ex-
pansive and anti-hierarchical understanding of these activities. King's proj-
ect is motivated by a political question: "[W]hat counts as theory and for
whom?"[24] Resisting the increasing reification of theory as a single genre
and form of critical thinking, she wishes to configure things in a more
socially-political relational manner so as to ascertain the ways "in which
reified 'theory' in the academy depends upon communities *theorizing*"
(King, 91, emphasis in the original). Without denying the place of the acad-
emy and academics within these communities, one must think in terms of
networks of theorizing, in which the former are simply some but not all of
the nodes.

King lists a multiplicity of activities that come to constitute these net-
works, and which dissolve false distinctions between theory and practice:
"active thinking, speaking, conversation, action grounded in theory, action
producing theory, action suggesting theory, drafts, letters, unpublished
manuscripts, stories in writing and not, poems said and written, art events
like shows, readings, enactments, zap actions such as ACT-UP does: or
for that matter, incomplete theorizing, sporadic suggestiveness, general-
izations correct and incorrect, inadequate theory, images and actions in-
citing theoretical interventions and so on" (King, 89). A "reinvention of

reading protocols" is necessary in order to access this multiplicity of genres.

The democratization of knowledge production and the articulation of queer (counter-)publics has always been a political aspiration for practitioners of queer theory. Like King, who thinks of theory as a re-mapping practice, I too regard the politics of theoretical practice to be fundamentally spatial. In what follows, I attempt to trace some of the ways in which queer sex space theory "travels," and what forms this movement takes. I will focus upon a moment of the recent historical past, in which a growing split developed between conservative and more radical forces in an (albeit) imagined queer culture or, more accurately, in the differences between gay and lesbian political movement, on the one hand, and queer, on the other.[25] Much of this took the form of debates over the place of sexuality and sex practices within movement politics and in theoretical production, which is to say, the public place of sex.[26] The crossing of this politics and this theory is where one might locate small-press, underground, and independent publication projects—the non-hegemonic sites of theoretical activity. This is also the place where academically reified notions of theory reach their limits of intelligibility or recognition, and where new reading and writing protocols are called for.

In the historical narrativization of AIDS, in its historicization, 1995 marked the crest of the "second wave" of the AIDS pandemic, a second wave that was said to have begun around 1991, a decade after the first public/media reference to what would eventually be referred to as AIDS. Based upon this historicization, a so-called "first wave" coincided with the first decade of the crisis. These utterly discursive "waves" naturalize spatio-temporal events, as they render the historicity of these events as part of cycles or flows, inevitable recessions and ascendances, that can be easily charted or mapped and perhaps even projected into the future. Ostensibly, these waves are meant to describe the flow of HIV transmission and an increase or cresting of incidences in the mid-'90s. As with the "first wave," the second was articulated by a number of highly visible, primarily New York–based, gay male journalists who set out to write causal narratives in which they linked these reported increases in HIV transmission to public or, more accurately, non-domestic, social-sexual spaces such as bathhouses, sex clubs, jack-off rooms, porn theaters, and adult bookstores—sites of minor architecture.

It was this agoraphobic logic, most loudly pronounced by San Francisco–

based gay male journalist Randy Shilts in his best-selling novel *And the Band Played On* (1987), that encouraged public officials and private property owners to shut down these urban spaces in the mid-1980s. Larry Waller, owner and operator of the sex club Hellfire in New York City, defined the difference between debates around public sex cultures and AIDS in 1985 and 1995 this way: the mid-1980s were characterized by attempts to curb transmission of a little-understood virus, and in the mid-1990s there was exasperation over the fact that and the extent to which public sex cultures had survived the past decade. In the mid-1990s and even continuing somewhat today, many public spokespeople expressed their moral repulsion and sexphobic horror that public sex cultures were still alive, and that men were still fucking each other in the second decade of the AIDS pandemic.

In the mid-1990s, the most notorious anti-public-sex journalists were Gabriel Rotello and Michelangelo Signorile. In 1995, Rotello and Signorile established the Gay and Lesbian HIV Prevention Activists (GALPHA), and set out to shut down spaces of anonymous, promiscuous sex. Their actions were provoked by the recent opening (February 1995) of the West Side Club, a bathhouse-like sex space in the Chelsea neighborhood of Manhattan, the new gay ghetto in the city. In counter-response to GALPHA, two activist groups were formed: AIDS Prevention Action League (APAL), which included queer theorist Michael Warner as one of its members; and Community AIDS Prevention Activists (CAPA). These two groups reiterated a longstanding pro-sex AIDS activist conviction as to the importance of public sex as a means of creating a sense of belonging, and public sex spaces as critical sites for the dissemination of safe-sex educational information. Once again, critical distinctions were made between public sex, promiscuous sex, and unsafe sex practices.

Two years later, in an essay published in *The Nation,* Michael Warner restaged a battle between what he termed "neoconservative gay journalists" and "thinking queers."[27] As captured by the words of its subtitle ("Thinking Queers have stopped writing for a movement, leaving only neocons"), Warner's article was at once an impassioned critique of Rotello, Signorile, Larry Kramer, and Andrew Sullivan (the neocons), and a call for the re-involvement of other, more left-leaning queers In political movement, especially as articulated in theoretical forms and presented in the kinds of non-hegemonic publications enumerated by King and quoted above.

Warner traces the emergence of this conservative/mainstream politics

to sometime around 1992, a time that witnessed, as he notes, the emergence of queer theory as a discourse in the U.S. academic world. The charting of historical connections between these two antithetical political positions suggests not only their mutual historicity, but also perhaps a mutual implication in the assimilation of queer social-political action, including theoretical action. Which is to suggest that the institutionalization of queer thinking and writing, and perforce its reification as "queer theory," may have played an instrumental role in this process of assimilation. As Warner chronicles this history:

> Many of these trends were set about five years ago, just as queer theory
> was emerging. Political energies shifted from direct action groups like
> ACT UP, in which intellectual and activist efforts often required one an-
> other, to national electioneering, in which money talks. The notion that
> what we really wanted was to be represented—either by officials or by
> celebrities—dislodged the sense of belonging actively to a movement; it
> made having a vital public seem less urgent.[28]

However, just as Warner does not script the emergence of queer theory within a greater historical narrative of normalization, neither do I wish to make what would surely be a highly reductive and causal argument concerning queer thinking and writing and the academy. For although there is little doubt, following Foucault on regimes of power, that the housing of queer theoretical practice within the academy is a means for its containment and control, there are, nonetheless, other ways to write the historical conditions and relations between queer theoretical practice; insurgent, itinerant, and anonymous sex practices; and the politics of queer publication and pedagogy.

In his discussion of queer publics, publication, a public queer movement, and public sex, Warner overlooks the queer counter-publics and sex space theory that were being produced around 1992. His argument is based upon a false dichotomy that reductively offers the following options: gay neoconservative journalism, or queer left-leaning academic theory. One must question the paucity of theoretical possibilities presented here, and wonder what might lie between and beyond these opposite poles of practice. Why is it that these other sites are seemingly so difficult to locate, the very places where the activity that he seems to be interested in had been taking place, since the early-'90s?

In part, it is due to a presentist logic that underlies his dichotomous

characterization, in which the period between 1992 and 1997 is solely un-
derstood in terms of the latter. Although a five-year period may seem negli-
gible, the volatile rate at which practices, theories, and sites shifted and
changed during these years renders each moment as critical. Yet radical sex
activism has a history (beyond the scope and principal interest of this chap-
ter) that greatly precedes the formation of groups such as Sex Panic in New
York, and their reactionary responses to journalistic and municipal cam-
paigns to eliminate public sex cultures from New York.

It seems as though it simply took well-established queer theorists in the
academy half a decade to attune themselves to these political issues and to
write about them, and that it required the publication of books by Rotello
et al. to gain their attention and textual interpretation. Yet for some of us,
the early-'90s was a critical moment in the articulation of queer sex pub-
lics, occurring in the spaces that we frequented at night and in the essays
that we were writing at the time for graduate seminars *and* independent,
movement publications, often with very little editorial revision.

In fact, my own memory of 1992 includes the recent re-opening/re-
invention of public sex spaces in cities such as New York, active public dis-
cussion and debate over these spaces in terms of safe/unsafe sex, gender
and sexual differences, media representation, and so forth. And perhaps
most importantly for my purposes here, instances of queer theoretical prac-
tice that addressed these places and practices, published in non-academic,
movement publications.

Informed by some of the earliest manifestations of queer theory in
press, and the concurrent incorporation of feminist, gay and lesbian, and
queer history into architectural theory and criticism, a number of writers,
activists, and theorists published essays that paralleled, in their "opposi-
tional consciousness" (Sandoval), the inventive social-sexual practices that
filled backrooms, jack-off parties, and sex clubs around New York. As Katie
King pointedly remarks, "This may not be *your* historical memory, but
maybe that means that you are overhearing, eavesdropping on a recen-
tered history." [29]

There are any number of viable reasons why these forms of theory
may be overlooked by academics: they often were not published in "peer-
review" academic journals; the rate of production and distribution differs
dramatically between the urgent schedules of movement publication and
the incremental editing processes of an academic press; movement pub-
lications are usually not registered by systems of archival acquisition,

categorization, preservation, and cataloguing (i.e. they typically do not have Library of Congress numbers). To invoke Ann Pellegrini, one might say that movement publications are written by and for "people who are always on the verge of departing." [30]

In the midst of mourning the passing of "thinking queers" writing for "a movement public," Warner, like most queer theorists in the academy, disregards or is entirely unaware of the fact that just this sort of theory was being published, as early as 1992, in publications such as the queer 'zines and sex journals *Steam, Holy Titclamps, Diseased Pariah News,* and in architectural journals such as *Sites.*

Steam, published by PDA Press (an acronym for public displays of affection) and edited by ex-porn star and writer Scott O'Hara, self-proclaimed its mission as "intended for gay and bisexual men with an interest in public and semi-public sex" (figure 38). The journal was subtitled "the literate queer's guide to sex and controversy." In its editorial mission and publication format, *Steam* was a unique and unprecedented combination of research journal, porn magazine, and travel guide. Approximately twelve issues were published over the course of three years, 1993–1995. The roughly square shape and physical dimensions of the publication were comparable to any number of academic journals, and like these, it printed its table of contents on the cover of each issue, with a continuous pagination sequence across issues in each of the three volumes. Initially, it was dedicated to "life, liberty, and the pursuit (that eternal, ineffable pursuit . . .) of happiness," whereas by the end of its run the wording had changed to "dedicated to life, longing, lust, and the liberty of pursuit," a further reinflection of a national rhetoric of inalienable rights in support of cruising.

One its disclaimers inverted the usual editorial disavowal of the presence and identity of homosexual subjects by stating that the "[d]epiction or mention of any person in these pages should never be construed as an implication that said person is a heterosexual." In the pages of *Steam,* no one was able to seek shelter behind presumptive heterosexuality. It was stridently anti-assimilationist in its politics, and regularly addressed conservative gay rhetoric, all the while promoting some of the most hotly contested sex practices.

Its distribution was concentrated in the United States, although its circulation extended to an international readership. In the years just prior to the World Wide Web revolution, *Steam* was a forum for the discussion and debate of current political issues, especially those that concerned

questions of sex, public culture, AIDS, and mechanisms of social control and punishment.[31] It published art photography of male bodies and pornographic images; obituaries of writers, activists, and other members of the radical sex movement; excerpts from literature, sometimes prior to their release by publishers (i.e. Samuel Delany's *Mad Man*, Pat Califia's *Public Sex*, Bill T. Jones's *Last Night on Earth*); and most pragmatically, directories and reviews of, and personal reports on, public places where men could find sex with other men. *Steam* was the first publication of queer sex space theory, and since its discontinuation a number of Internet websites have appeared that attempt to provide many of the same features and services, but as far as I am aware, no other printed publication has taken its place.

As Judith Butler and others in their readings of Foucault have reminded us, "discourse has a history, that not only precedes but conditions its contemporary usages."[32] This is discourse's historicity: that specific moment and matrix in which, in terms of queer sex space theory, *Steam* was a vital constitutive force. Based upon Butler's formulation, the discourse of queer sex space theory is not simply located in history, but had a particular role to play in the materialization of this history. *Steam* exemplifies a short-lived political movement in the early-to-mid-'90s (did any of us really think that it would endure?), a historical moment marked by the early years of the second decade of the AIDS pandemic and intense sexual persistence and invention. It is this conjuncture that was written and documented, and which is now preserved (as counter-memory and continued potentiality) in the pages of *Steam*.

Since the publication of the last issue of *Steam* in 1995, a sub-discourse of queer theory has been developed, dedicated to questions of space, called "queer space."[33] Seemingly more inclusive due to the brevity of its naming, queer space, unlike my notion of queer sex space theory, does not immediately represent itself as a discursive formation, but instead gains epistemological authority through its designation of an object of inquiry. Yet this object of inquiry, posited as "queer space," is purely a product of that discourse which is in turn named by it. Through insights provided by Judith Butler's theory of performativity, we can further delineate important differences between "queer space" discourse and the discourse of queer sex space theory.

Based upon Butler's definition, in which "[w]ithin speech act theory, a performative is that discursive practice that enacts or produces that which it names," both "queer space" and "queer sex space theory" may be under-

stood as performative. Yet in its discursive specificity, "queer space" attempts to dissimulate (or leave un[re]marked) the fact of its discursivity, in order to gain authority through a logic of originary authenticity and phenomenological immediacy. Queer sex space theory, on the other hand, foregrounds its discursivity and configures itself as simply one materialization of queer sexual insurgency and erotic itinerancy. It does this by citing that which forever eludes the capacities of identity, representation, and objectification—mechanisms of referentiality and the evidentiary. It is in this way that the forms of theory and practice being put forth here are antinormative or, more specifically, queer (i.e. difficult and nearly impossible to cite and site).

Of the many "queer space" essays and books that have been published, no other makes more of an attempt to totalize the field than Aaron Betsky's *Queer Space: Architecture and Same-Sex Desire.*[34] Through a historicizing logic, Betsky interpretively excavates queer content trans-globally from ancient to contemporary cultures, and writes a reformist history of architecture through an exploration of same-sex desire. Throughout this history, a lack of closure or completion in forms of privacy, community, intersubjective union, and orgasm is pathologized. To the extent that queer erotic insurgency has little or no use for these social ideals, Betsky scripts them as early stages in an evolutionary schema, a trajectory that finds its beginning and end points in the title of chapter four: "From Cruising to Community."

The section of this chapter that tropes on cruising is citationally framed by two essays, one that I published in *Steam* in 1993, the other by architecture gallery owner and critic Henry Urbach. These essays were written around 1992–93, while both of us were graduate students in the School of Architecture at Princeton (I as an Exchange Scholar from the University of Chicago). These essays, written for sex movement and architectural theory publications, respectively, are two of the earliest examples of queer sex space theory.[35] Urbach's essay was on The Zone, a popular (although long since closed) sex club in Los Angeles; while my essay addressed newly reopened backrooms in gay bars and clubs in New York City. Both of us were interested in the inventive sexual persistence of these spaces and their users. They were the promise of a non-utopic vigilant future in the midst of AIDS.

The succession and incorporation of *Steam* and other movement publications by the discourse of queer space suggests a shift in the politics of theoretical publication, and calls for an examination of the relations be-

tween these modes of production and perhaps suggests a neutralization and normalization of the former by the latter. For although Betsky attests to the ways in which queer erotic insurgency (i.e. cruising) defies architectural closure or containment, and is therefore difficult to represent, he nonetheless persists in a structuralist notion of these spatial practices by which, he argues, it is possible to "define [their] parts and pieces." Betsky's communitarian model understands these "parts and pieces" as the constituent elements of a cruising network, and in turn, as communicative/signifying networks for the expression and coalescence of identity and community.

In queer erotic insurgency's defiance of community, in its formless itinerancy, Betsky posits a fatal pathology ("a world of death") in which "the spaces of cruising," characterized as "spaces of negation," function as vehicles for the destruction of community, most explicitly through viral transmission. The positive antinomy that rises out of this nihilistic, suicidal void (the title of the fifth and final chapter is "The Void and Other Queer Spaces") is a thoroughly normative territorialization of spatial and social relations: urban renewal, gentrification, commercial zones, the Castro as "a gay Disneyland version of a normal neighborhood." [36] Queer erotic insurgency and AIDS are phobically coupled in a cause-and-effect rationale, and then relegated to the past as no more than ruins upon which queer communities and queer spaces are being built. "The alternative to such spaces of negation is formed by the communities queer men and women have built out of cruising grounds. Instead of only using their invisible networks as routes between places of assignations, queers have also formalized them into real spaces where they can lead every aspect of their lives in an overt manner" (Betsky, 168). The unavowable materiality of the cruising ground, in its double refusal and force, is cast as a museological artifact for the purposes of mournful remembrance: from cruising ground to Names Project AIDS Quilt, without any recognition as to how the latter, when publicly exhibited, can, at the same time, become the former.

QUASH (Queers United Against Straight-acting Homosexuals) was a Chicago-based queer activist collective that in the mid-to-late-'90s was composed largely of graduate students who put their queer theoretical studies to work in the production of broadsides and manifestoes that critiqued the increasing heteronormalizing of gays and lesbians—for some often in a self-willed manner.

Operating in relative anonymity, QUASH produced indictments of the

mainstreaming of gay and lesbian politics. Reproduced on inexpensive, recycled newsprint-quality paper, with a bold red, white and black design reminiscent of Russian revolutionary agitprop graphics as well as the recent work of artist Barbara Kruger, these broadsides are distributed free-of-charge across activist networks, academic environments, sites of "alternative" culture, independent bookstores, etc. The layout and design is always straightforward and at times humorous. Sexual, political, and cultural vernaculars are used to compose the tracts. They are part of a history of pamphleteering that underlies much of the political history of the U.S. and other modern states.[37]

Impressive in their fusion of queer theory, activism, social commentary, and information/statistical gathering, QUASH broadsides attest to the way in which "theorizing-as-a-verb [is] a necessity for survival by oppressed people."[38] These publications were impassioned calls to action, and they addressed a multiplicity of interrelated issues: AIDS, incarceration, heterosexism and homophobia, genetics, racism, classism, and conservatism within white, middle-class dominated gay and lesbian culture. Questioning the political utility of visibility and representational politics, QUASH sought social power through a non-utopic politics of impossibility—insurgent survival against all odds.

In the spring of 1997, an unnamed group of queer women, simply identified by the image of a screaming woman, produced a broadside that in its layout, design, and its political message shared much in common with the activism of QUASH.[39] The title reads "It's Time to End the Gay Rights Movement as We Know It" (the cover features a photograph of Ellen DeGeneres with a cartoon voice bubble that irately asks, "I came out for this?") (figure 39). Here they set their sights on a Blanchotian political future as they "imagine a future which seems unreachable, but which is impossible to stop fighting for."

Due to logics of archivization and the ascription of historical value, these activist works may not be preserved. Yet perhaps they were never meant to be collected, preserved, or historicized. They had a more tactical social-political function, and as conditions change so too must such representations.

Their argument for a politics of love, in which they put forth a radically queer definition of intimacy, may suggest possible trajectories or futures of the work, their message, and this politics. In a final section entitled "Love Explosion," they write,

We have the potential to wrench apart a social order where the personal, the private and the public are maintained as separate realms. We have the capacity to upset the strict rules prescribing what is allowed to take place in each one. To be queer is to make love public, to take love and sex and desire out of the enclosed, private space of the heterosexual couple and the mythic family unit. Will you take the risk?

The risk is one that has been traced throughout this book, across architectures and geographies, imperceptible residues, and anonymous modes of sociality that abandon situated identities as they become itinerant intensities. These are the risks that threaten the ground, the floor, the four walls, and the ceiling, the familiar, the recognizable, the recuperated, and the knowable—all of those anchors in which we think we find assurance of a self and a world.

152

As he walked away, he turned, and winked.

NOTES

PREFACE

1. William Haver, "Queer Research; or, How to Practise Invention to the Brink of Intelligibility," in *The Eight Technologies of Otherness,* ed. Sue Golding (New York and London: Routledge, 1997), 277–92.

2. William Haver, "Really Bad Infinities: Queer's Honour and the Pornographic Life," *parallax* 13 (October–December 1999): 9–21.

3. Samuel R. Delany, *The Mad Man* (New York: Masquerade Books, 1994).

4. This endeavor is less a matter of succeeding or failing, or even succeeding to fail, than it is a question of not failing failure. For related thinking on this dynamic, see Leo Bersani and Ulysse Dutoit, *Arts of Impoverishment* (Cambridge: Harvard University Press, 1993).

5. Giorgio Agamben, *Remnants of Auschwitz: The Witness and the Archive,* trans. Daniel Heller-Roazen (New York: Zone Books, 1999), 139.

6. Jean-Luc Nancy, *The Inoperative Community,* trans. Peter Connor, Lisa Garbus, Michael Holland, and Simona Sawhney, Theory and History of Literature, no. 76, ser. ed. Wlad Godzich and Jochen Schulte-Sasse (Minneapolis and London: University of Minnesota, 1991), 25–26.

CHAPTER ONE

1. In their emphasis on the linguistic relations between "now here" and "nowhere," John Rajchman and Tom Conley have each suggested ways of thinking and writing "singular multiplicity." Tom Conley, "A Plea for Leibniz," in Gilles Deleuze, *The Fold: Leibniz and the Baroque,* trans. Tom Conley (Minneapolis and London: University of Minnesota Press, 1993), ix–xx. John Rajchman, *Constructions,* Writing Architecture (Cambridge and London: MIT Press, 1998), 31. Even more proximate to my own undertaking is William Haver's work on the material specificity of the pornographic life as here, now. See William Haver, "Really Bad Infinities: Queer's Honour and the Pornographic Life," *parallax* 13 (October–December 1999): 9–21.

2. William Haver, "Queer Research; or, How to Practise Invention to the Brink of Intelligibility," in *The Eight Technologies of Otherness,* ed. Sue Golding (New York and London: Routledge, 1997), 283.

3. Rajchman, *Constructions,* 31.

4. Gerald Bruns succinctly defines this notion of relationality as a "relation without context." Bruns, *Maurice Blanchot: The Refusal of Philosophy* (Baltimore and London: Johns Hopkins University Press, 1997).

5. Jacques Derrida, *Aporias,* trans. Thomas Dutoit, Meridian: Crossing Aesthetics, ser. ed. Werner Hamacher and David E. Wellbery (Stanford: Stanford University Press, 1993), 23. Derrida is here characterizing the "single border" space articulated by the diacritical slash ("/").

6. Jacques Derrida, "The Rhetoric of Drugs: An Interview," *differences* 5.1 (1993), 20.

7. "Being-with-out" is a notion that Simon Critchley—in his reading of Jean-Luc Nancy's *Être singulier pluriel*—has also used in order to think relationality that is beyond such forms as intersubjectivity, intimacy, and mutual recognition. Critchley, "With Being-With? Notes on Jean-Luc Nancy's Rewriting of Being and Time," in *Ethics, Politics, Subjectivity* (New York and London: Verso, 1999), 239–53.

8. Michel Foucault, "Maurice Blanchot: The Thought from Outside," in *Foucault/Blanchot* (New York and Cambridge, MA: Zone Books, 1987). Maurice Blanchot, *The Infinite Conversation*, trans. Susan Hanson, Theory and History of Literature, no. 82, ser. ed. Wlad Godzich and Jochen Schulte-Sasse (Minneapolis and London: University of Minnesota Press, 1993).

9. Michel Foucault, "Different Spaces," in *Aesthetics, Method, and Epistemology*, ed. James D. Faubion (New York: The New Press, 1998), 175–85.

10. In response to the question "who comes after the subject?" Blanchot wrote a short essay as an imagined conversation in which he repeats the question only this time asking "what was there before the subject?" In this way he suggests that something comes at once before and after the subject, and that it is precisely the force of this coming that is "incapable of letting Being or the logos give it a place." Blanchot, "Who?" in *Who Comes after the Subject?* ed. Peter Connor, Eduardo Cadava, and Jean-Luc Nancy (New York and London: Routledge, 1991), 58–60.

11. Rajchman, *Constructions*, 18.

12. In these terms, the anonymous, itinerant, and uncertain spatiality and sociality of queer erotics is not unlike Foucault's notion of the localization of power. "Here we can see that 'local' has two very different meanings: power is local because it is never global, but it is not local or localized because it is diffuse." Gilles Deleuze, *Foucault*, trans. Sean Hand (Minneapolis and London: University of Minnesota Press, 1988), 26. In other words, power functions in ways that radically interrupt the dichotomizing differences of universalizing and minoritizing discourses that produce notions of totality and minority, and as a singular multiplicity is "neither axiomatic nor typological, but topological" (ibid, 14). Whether the singular multiplicity that is erotics, power, or some other force, this is "the insistence of the interruption that is a nothing but relationality." Haver, "Queer Research."

13. Michel Foucault, "Friendship as a Way of Life," in *Ethics: Subjectivity and Truth*, ed. Paul Rabinow (New York: New Press, 1997), 138.

14. Rajchman, *Constructions*, 112.

15. Elizabeth Grosz similarly characterizes this as "a refusal to link sexual pleasure [what I will refer to as *erotics*] with the struggle of freedom, the refusal to validate sexuality in terms of a greater cause or a higher purpose (whether political, spiritual, or reproductive), the desire to enjoy, to experience, to make pleasure for its own sake, for where it takes us [precisely *wherever*], for how it changes and makes us, to see it as one but not the only trajectory or direction in the lives of sexed bodies." This would be an ethics and a politics operating without imperatives of transcendence, liberation, release, etc. Elizabeth Grosz, "Experimental Desire: Rethinking Queer Subjectivity," in Grosz, *Space, Time, and Perversion: Essays on the Politics of Bodies* (New York and London: Routledge, 1995), 227.

16. Maurice Blanchot defines existence "as an always prior exteriority." Blanchot, *The Unavowable Community*, trans. Pierre Joris (Barrytown, N.Y.: Station Hill Press, 1988), 6.

17. To my knowledge, Jennifer Bloomer was the first to write of "minor architecture," as inspired by Gilles Deleuze and Felix Guattari's notion of minor literature, put forth in their book *Kafka: Toward a Minor Literature*, trans. Dana Polan, Theory and History of Literature, no. 36, ser. ed. Wlad Godzich and Jochen Schulte-Sasse (Minneapolis: University of Minnesota Press, 1986). Jennifer Bloomer, "A Lay a Stone a Patch a Post a Pen the Ruddyrun: Minor Architectural Possibilities," in *Strategies in Architectural Thinking*, ed. Jeffrey Kipnis, John Whiteman, and Richard Burdett (Cambridge and London: MIT Press, 1992), 48–66. Bloomer,

Architecture and the Text: The (S)crypts of Joyce and Piranesi, Theoretical Perspectives in Architectural History and Criticism, ser. ed. Mark Rakatansky, (New Haven and London: Yale University Press, 1993).

18. William Haver, *The Body of This Death* (Stanford: Stanford University Press, 1996), 53.

19. Elizabeth Grosz, "Architecture from the Outside," in Grosz, *Space, Time, and Perversion,* 135.

20. Rajchman, *Constructions,* 116.

21. Sue Golding, "The Poetics of Foucault's Politics, or, Better Yet: The Ethical Demand of Ecstatic Fetish," *New Formations* 25 (Summer 1995): 46.

22. Herman Melville, *Bartleby the Scrivener: A Story of Wall Street* (1853; New York: Simon and Schuster, 1997).

23. Stephen Barker, *Nightswimming* (Santa Fe, NM: Twin Palms, 1999). For a discussion of the work of Doug Ischar and Matts Leiderstam, see chapter 3, below.

24. Deleuze and Guattari, *Kafka,* 4.

25. Deborah Britzman names this perverse spatiality/temporality, "between what is taken as the real and the afterthought of recognition," as queer. Deborah P. Britzman, "Is There a Queer Pedagogy? Or, Stop Reading Straight," *Educational Theory* 45 (Spring 1995): 163.

26. Foucault, "The Thought from Outside," 24.

27. Maurice Blanchot, *The Space of Literature,* trans. Ann Smock (Lincoln and London: University of Nebraska Press, 1982), 170.

28. Rajchman, *Constructions,* 85.

29. Blanchot, *The Space of Literature,* 170.

30. Elizabeth Grosz, "Animal Sex," in Grosz, *Space, Time, and Perversion,* 199.

31. Roger Caillois, "Mimicry and Legendary Psychasthenia," trans. John Shepley, *October* 31 (1984): 17–32; originally published in 1935 in the surrealist journal *Minotaure.*

32. Grosz, "Animal Sex," 190.

33. Blanchot, *The Space of Literature,* 170.

34. Foucault, Michel. "Friendship as a Way of Life," 137.

35. Maurice Blanchot, *Awaiting Oblivion,* trans. John Gregg, French Modernist Library (Lincoln and London: University of Nebraska Press, 1997), 23.

36. The untimeliness of waiting raises the question as to whether waiting is a wasting of time, in particular of one's own time, which is the only time that one might be said to have, especially in waiting. If waiting is a wasting of one's own time, it is also awaiting one's own time—waiting for oneself. The possibility that waiting may be a wasting of one's time—waiting's untimeliness—is surely the reason why waiting is considered unworkable, unproductive, and a useless use of time, to the point of being a wasting or negligence of oneself.

37. Blanchot, *Awaiting Oblivion,* 23.

38. Ibid., 73.

39. Blanchot, *The Unavowable Community,* 25.

40. Blanchot, *Awaiting Oblivion,* 52.

41. "After the Fact" is the title of the essay by Blanchot that includes the commentary (or refusal of commentary) on Bataille's *Madame Edwarda.* Blanchot, *Vicious Circles,* trans. Paul Auster, 1st ed. (Barrytown, NY: Station Hill Press, 1985), 59–69.

42. Ibid.

43. Maurice Blanchot, *The Last Man,* trans. Lydia Davis (New York: Columbia University Press, 1987).

44. Giorgio Agamben, *The Coming Community*, trans. Michael Hardt, Theory Out of Bounds, no. 1, ser. ed. Michael Hardt, Sandra Buckley, and Brian Massumi (Minneapolis and London: University of Minnesota Press, 1993), 86.

45. Roland Barthes, "Preface," in *Tricks* (New York: Serpent's Tail, 1981), vii–x.

46. Leo Bersani, *Homos* (Cambridge and London: Harvard University Press, 1995), 149.

47. Haver, *The Body of This Death*, 120.

48. Michael Warner, *The Trouble with Normal: Sex, Politics, and the Ethics of Queer Life* (New York: Free Press, 1999).

49. David Halperin, "Forgetting Foucault: Acts, Identities, and the History of Sexuality," *Representations* 63 (Summer 1998): 94.

50. This is what Judith Butler has referred to as a "sexing" that is "part of the very temporality of sexual regulation." Butler, "Revisiting Bodies and Pleasures," *Theory, Culture & Society* 16, no. 2 (1999): 11–20.

51. For an excellent analysis of the relations between positive and negative affirmations, enabling and constraining forces, and acting and reacting power moves, see Grosz, "Experimental Desire."

52. Rajchman, *Constructions*, 86.

53. "When I say, following Nietzsche, *'il faut'* ['it is necessary']—with the play between *falloir* [to be necessary] and *faillir* [to fail]—I also say, it lacks, falls short, deceives. Such is the beginning of the downfall: in its very failing the law commands, and thereby escapes safe and sound yet again as law." Maurice Blanchot, *The Writing of the Disaster*, trans. Ann Smock (Lincoln and London: University of Nebraska Press, 1995), 44.

54. Foucault, "The Thought from Outside," 36.

55. Barthes, "Preface," x.

56. Michel Foucault, *The Use of Pleasure*, vol. 2 of *The History of Sexuality*, trans. Robert Hurley (New York: Random House, 1985), 10.

57. Michel Foucault, "On the Genealogy of Ethics: An Overview of Work in Progress," in Rabinow, *Ethics*, 260.

58. Blanchot, *The Writing of the Disaster*, 121.

59. Alphonso Lingis, *The Community of Those Who Have Nothing in Common* (Bloomington: Indiana University Press, 1994). This, of course, is a re-phrasing of Georges Bataille's "the community of those who do not have a community." It also resonates with Derrida's description of the Marrano, as precisely "anyone who remains faithful to a secret that he has chosen, in the very place where he lives, in the home of the inhabitant or of the occupant, in the home of the first or of the second *arrivant*, in the very place where he stays without saying no but without identifying himself as belonging to." Derrida, *Aporias*, 81.

60. In defining Foucault's conception of infamy as distinct from either Bataille's excessive infamy or Borges' narratively exhausting infamy, Deleuze states that "Foucault conceives of a third infamy, which is properly speaking an infamy of rareness, that of insignificant, obscure, simple men, who are spotlighted only for a moment by police reports or complaints. This is a conception that comes close to Chekhov." Deleuze, *Foucault*, 145 n. 3.

In a similar vein Blanchot writes that "men who are destroyed (destroyed without destruction) are as though incapable of appearing, and invisible even when one sees them. And if they speak, it is with the voice of others, a voice always other than theirs which somehow accuses them, interrogates them and obliges them to answer for a silent affliction which they bear without awareness." Blanchot, *The Writing of the Disaster*, 21–22.

61. Rajchman, *Constructions,* 88.

62. Haver's critical formulation is as follows: "I think there is considerable confusion abroad in current writing on space and spaces, a confusion codified by Ms. Kant and other philosophy queens, to the effect that 'place' is simply a phenomenological instance of 'space,' that 'place' is merely an experienced place-in-space. And therefore can be 'regioned' (to use the Heideggerianism) and ultimately subjected to the rationality of a cartography." William Haver, letter to author, 17 August 1997.

63. Foucault, "The Thought from Outside," 47.

64. Foucault, "Friendship as a Way of Life," 137.

65. Michel Foucault, "The Life of Infamous Men," in *Michel Foucault: Power, Truth, Strategy,* ed. Meaghan Morris and Paul Foss (Sydney: Feral Publications, 1979), 79.

66. Foucault, "The Thought from Outside," 48.

67. Haver, *The Body of This Death.* Haver, "Queer Research."

68. Michel Foucault, *The Archaeology of Knowledge,* trans. A. M. Sheridan Smith (New York: Pantheon Books, 1972), 17.

69. Melville, *Bartleby the Scrivener.*

70. Derrida says as much, in his preferential treatment of the word "perishing," which, he notes, "retains something of *per,* of the passage of the limit, of the traversal marked in Latin by the *pereo, perire* (which means exactly: to leave, disappear, pass—on the other side of life, *transire*)" (Derrida, *Aporias,* 31). In these terms, Bartleby's perplexing speech is understood to be a passage of the limit of language, and therefore is a way of enacting Foucault's desire to disappear through language, discourse, speech, writing.

CHAPTER TWO

1. D. A. Miller, *Bringing Out Roland Barthes* (Berkeley, Los Angeles, and London: University of California Press, 1992). Paul Morrison, "End Pleasure," *GLQ* 1, no. 1 (1993): 53–78.

2. Miller, *Bringing Out Roland Barthes,* 43.

3. Douglas Crimp, "Mourning and Militancy," in *Out There: Marginalization and Contemporary Cultures,* ed. Martha Gever, Russell Ferguson, Trinh T. Minh-ha, and Cornel West (New York: Museum of Contemporary Art; Cambridge: MIT Press, 1990), 236.

4. Jacques Derrida, *Aporias,* trans. Thomas Dutoit, Meridian: Crossing Aesthetics, ser. ed. Werner Hamacher and David E. Wellbery (Stanford: Stanford University Press, 1993), 76.

5. Jean-François Lyotard refers to this exclusion as the "absolute wrong." As summarized by Jean-Luc Nancy, the "absolute wrong" is that which is "done to the one who is exploited and who does not even have the language to express the wrong done to him." Nancy, *The Inoperative Community,* trans. Peter Connor, Lisa Garbus, Michael Holland, and Simona Sawhney, Theory and History of Literature, no. 76, ser. ed. Wlad Godzich and Jochen Schulte-Sasse (Minneapolis and London: University of Minnesota, 1991), 35–36.

6. Maurice Blanchot, "Refusal," in *Friendship* (Stanford: Stanford University Press, 1997), 111–12.

7. Morrison, "End Pleasure," 54.

8. William Haver, *The Body of This Death* (Stanford: Stanford University Press, 1996), 182.

157

9. Ibid., 1.

10. My notion of living as losing finds resonance in Novalis's affirmation that "the true philosophical act is the putting to death of oneself (the dying of the self, or the self as dying—*Selbsttötung*, not *Selbstmord*—the mortal movement of self —the same—toward the other)." Cited in Maurice Blanchot, *The Writing of the Disaster,* trans. Ann Smock. (Lincoln and London: University of Nebraska Press, 1995), 32. The movement in relation to death, "the mortal movement," is what I mean when I speak of an itinerancy that puts one in relation to the Outside, to the limit of oneself, a becoming-disappeared that is, indeed, the non-relational relation to one's death.

11. Hélène Cixous, "Castration or Decapitation?" in Gever, et al., *Out There,* 345–56.

12. Ibid., 355.

13. Derrida, *Aporias,* 20.

14. Ibid., 55.

15. I am guided here by Blanchot, who writes, "Thinking as dying excludes the 'as' of thought, in a manner such that even if we suppress this 'as' by paratactic simplification and write 'to think: to die,' it forms an enigma in its absence, a practically unbridgeable space. The un-relation of thinking and dying is also the form of their relation: not that thinking proceeds toward dying, proceeding thus toward its other, but not that it proceeds toward its likeness either. It is thus that 'as' acquires the impetuousness of its meaning: neither like nor different, neither other nor same." Blanchot, *The Writing of the Disaster,* 39.

16. Carl Phillips, *Cortège* (St. Paul, MN: Graywolf Press, 1995), 23.

17. It also requires a "new negotiation with memory," as Mark Doty discusses in *Heaven's Coast,* his memoir of the loss of his lover Wally and of his own survival in the wake of Wally's death. "Death requires a new negotiation with memory. Because the story of Wally's life came to a conclusion, at least those parts of the story in which he would take an *active* role, the experiences of our past needed to be re-seen, re-viewed. Not exactly for his story to be finished, but in service of the way his life would continue in me, braided with the story of mine." Mark Doty, *Heaven's Coast: A Memoir* (New York: HarperCollins, 1996), 40.

18. Tim Lawrence, "AIDS, the Problem of Representation, and Plurality in Derek Jarman's *Blue*" *Social Text* 15, nos. 3 and 4 (Fall/Winter 1997): 241–64.

19. Ibid., 243.

20. Derek Jarman, *Blue* (Great Britain: Zeitgeist Films, 1993).

21. Quoted in Lawrence, "AIDS, the Problem of Representation, and Plurality in Derek Jarman's *Blue,*" 242.

22. Michel Foucault, *The Archaeology of Knowledge,* trans. A. M. Sheridan Smith (New York: Pantheon Books, 1972), Appendix: The Discourse on Language, 215.

23. Derrida, *Aporias,* 23.

24. Blanchot, *The Writing of the Disaster,* 39.

25. Incessantly, but perhaps also incrementally, as prescribed by Deleuze and Guattari in their "art of dosages," in which they address, post-Nietzsche, "how necessary caution is, the art of dosages, since overdose is a danger. You don't do it with a sledgehammer, you use a very fine file. You invent self-destructions that have nothing to do with the death drive." Gilles Deleuze and Felix Guattari, *A Thousand Plateaus: Capitalism and Schizophrenia,* trans. Brian Massumi (Minneapolis and London: University of Minnesota, 1987), 162. Note that in 1995 Gilles

Deleuze, following years of suffering from a lung disease, ended his life by jumping from a window of his Paris apartment.

26. For example, the ubiquitous AIDS awareness red ribbons; stories such as Jonathan Demme's film *Philadelphia;* and Nicholas Nixon's photographic portraits of people dying of AIDS.

27. This notion is neither mine nor is it new. It finds historical precedent and ethical-political alliance in a number of events, writings, and artistic practices. A fairly random yet no less salient list of citations might include Eugene Atget's deserted Parisian streets photographed as though the scene of a crime; and the reworking of this evacuated aesthetic under the rubric of "forensic aesthetics." Walter Benjamin, "The Work of Art in the Age of Mechanical Reproduction," in *Illuminations,* trans. Harry Zohn, ed. Hannah Arendt (New York: Schocken Books, 1969), 217–51. Ralph Rugoff, *Scene of the Crime* (Cambridge and London: MIT Press, 1997). A corresponding ethics to this aesthetics is suggested by Peggy Phelan's sense that "to live for a love whose goal is to share the Impossible is both a humbling project and an exceedingly ambitious one, for it seeks to find connection only in that which is no longer there." Phelan, *Unmarked: The Politics of Performance* (New York and London: Routledge, 1993), 148. As concerns the historicity and sociality of AIDS, William Haver refers to it as "the body of this death," the title of his aforementioned book, and Hervé Guibert has Foucault—in the guise of the character Muzil (a man without qualities or content indeed)—imagine it as an act of disappearing through representation. "This is what I told your little buddy [Dr. Nacier]: that nursing home of his, it shouldn't be a place where people go to die, but a place where they pretend to die. Everything there should be luxurious, with fancy paintings and soothing music, but it would all be just camouflage for the real mystery, because there'd be a little door hidden away in a corner of the clinic, perhaps behind one of those dreamily exotic pictures, and to the torpid melody of a hypodermic nirvana, you'd secretly slip behind the painting, and presto, you'd vanish, quite dead in the eyes of the world, since no one would see you reappear on the other side of the wall, in the alley, with no baggage, no name, no nothing, forced to reinvent a new identity for yourself." Guibert, *To the Friend Who Did Not Save My Life,* trans. Linda Coverdale, High Risk Books (New York: Serpent's Tail, 1994), 16–17.

28. In reading of Hegel's *Lectures on Aesthetics,* Giorgio Agamben locates a sense of the criticality of art's work, in which art approaches its limits, "suspended in a kind of diaphanous limbo between no-longer-being and not-yet-being." Giorgio Agamben, *The Man Without Content,* trans. Georgia Albert, Meridian: Crossing Aesthetics, ser. ed. Werner Hamacher and David E. Wellbery (Stanford: Stanford University Press, 1999), 53.

29. Maurice Blanchot, *The Space of Literature,* trans. Ann Smock (Lincoln and London: University of Nebraska Press, 1982), 274.

30. Ann Smock, translator's introduction to Blanchot, *The Space of Literature,* 9.

31. Quoted in, Derrida, *Aporias,* 68.

32. Michel Foucault, "Maurice Blanchot: The Thought from Outside," in *Foucault/Blanchot* (New York and Cambridge, MA: Zone Books, 1987), 24.

33. As Philippe Lacoue-Labarthe points out, this is what it might mean to "draw a blank." Lacoue-Labarthe, *Poetry as Experience,* trans. Andrea Tarnowski, Meridian: Crossing Aesthetics, ser. ed. Werner Hamacher and David E. Wellbery (Stanford: Stanford University Press, 1999), 19.

34. Herman Melville, *Bartleby the Scrivener: A Story of Wall Street* (1853; New York: Simon and Schuster, 1997).

35. Gerald L. Bruns, *Maurice Blanchot: The Refusal of Philosophy* (Baltimore and London: Johns Hopkins University Press, 1997), 162.

36. Deleuze, and Guattari, *A Thousand Plateaus*, 187.

37. Derrida, *Aporias*, 15.

38. Partially relying upon Greek etymology, Derrida notes that the word *problem* "can signify projection or protection, that which one poses or throws out in front of oneself, either as the projection of a project, of a task to accomplish, or as the protection created by a substitute, a prosthesis that we put forth in order to represent, replace, shelter, or dissimulate ourselves, or so as to hide something unavowable—like a shield." Derrida, *Aporias*, 11–12.

39. Derek Jarman, *Derek Jarman's Garden* (Woodstock, NY: Overlook Press, 1996). The book is a photographic and textual journal of Jarman's garden on the Dungeness coast of England.

40. "I shall not win the battle against the virus—in spite of the slogans like 'Living with AIDS.' The virus is appropriated by the well—so we have to live with AIDS while they spread the quilt for the moths of Ithaca across the wine dark sea." Both in the garden book and in this quote from *Blue*, Jarman's condemnation of the AIDS Quilt takes the form of an absolute refusal, one that refuses even to refer to it by proper or official name.

41. Jarman, *Blue*.

42. Jacques Derrida, *Adieu to Emmanuel Levinas,* trans. Pascale-Anne Brault and Michael Naas, Meridian: Crossing Aesthetics, ser. ed. Werner Hamacher and David E. Wellbery (Stanford: Stanford University Press, 1999), 111.

43. Ibid., 120.

44. Gilles Deleuze and Felix Guattari, *What Is Philosophy?* trans. Hugh Tomlinson and Graham Burchell, European Perspectives, ser. ed. Lawrence D. Kritzman (New York: Columbia University Press, 1994), 180ff.

45. Lacoue-Labarthe, *Poetry as Experience*, 116–17.

46. Ibid., 110. The quotations are from Paul Celan's "Snow-bed," "Tübingen, Jänner," and "Snow-bed," respectively.

47. Leo Bersani and Ulysse Dutoit, *Arts of Impoverishment* (Cambridge and London: Harvard University Press, 1993), 185.

48. Ibid., 159.

49. Bernard Cache, *Earth Moves: The Furnishing of Territories,* trans. Anne Boymans, Writing Architecture (Cambridge: MIT Press, 1995), 70.

50. Jarman, *Derek Jarman's Garden*, 67–68.

51. Jarman, *Blue*.

52. Friedrich Hölderlin, *Poems and Fragments,* trans. Michael Hamburger (Cambridge: Cambridge University Press, 1980), 601–5.

53. Martin Heidegger, " . . . Poetically Man Dwells . . . ," in *Poetry, Language, Thought* (New York: Harper and Row, 1971), 213–29.

54. Lacoue-Labarthe, *Poetry as Experience*, 116.

55. Paul Celan, *Poems of Paul Celan,* trans. Michael Hamburger (New York: Persea Books, 1989), 117.

56. Jarman, *Derek Jarman's Garden*, 57.

57. Lacoue-Labarthe, *Poetry as Experience*, 116–17.

58. Ibid.

59. Jarman, *Blue*.

60. Lacoue-Labarthe, *Poetry as Experience:* "a near nothing," 112; "evident as the invisible is evident," 117.

61. Blanchot, *The Space of Literature*, 174.

62. Jarman, *Blue*.

63. The blind gardener effects a disruption of the Linnaean privileging of vision in plant morphology, in part by substituting a sense of smell for sight.

64. James Meyer, "Tom Burr," *Frieze* 27 (March/April 1996): 82–83.

65. Bersani, and Dutoit, *Arts of Impoverishment*, 159.

66. Ibid., 157.

67. Ibid., 6.

68. As quoted by Derrida in *Adieu to Emmanuel Levinas*, 93.

69. This notion of a response that is prior to any call, invitation, or command and which awaits a response occurs in Derrida's reading of Levinas' *Totality and Infinity*. Derrida, *Adieu to Emmanuel Levinas*, 24–25ff.

70. Derrida, *Aporias*, 34.

71. Quoted in Lacoue-Labarthe, *Poetry as Experience*, 101.

72. Smock, translator's introduction to Blanchot, *The Space of Literature*, 9.

73. Blanchot, *The Space of Literature*. Maurice Blanchot, *The Infinite Conversation*, trans. Susan Hanson, Theory and History of Literature, no. 82, ser. ed. Wlad Godzich and Jochen Schulte-Sasse (Minneapolis and London: University of Minnesota Press, 1993). Blanchot, *The Writing of the Disaster*.

74. Maurice Blanchot, *Vicious Circles*, trans. Paul Auster, 1st ed. (Barrytown, NY: Station Hill Press, 1985), 59–60.

75. Blanchot, *The Space of Literature*, 176.

76. Much of the recent discourse of performativity and performance studies relies upon a notion of disappearance as the ontology of performance. Many practitioners in the field, then, work under the assumption that disappearance actually happens in performance, and several others have recently responded by acknowledging this assumption but rather than put it into question have instead attempted to rescue whatever it is that is thought to run the risk of being-disappeared, in performance. The presumption that disappearance actually happens, and that we can know this in its fulfillment, is motivated by an attempt, impossible as it may be, to control the finitude of absolute singularity. This implicitly relies upon a notion of performance as a form of work, and is an attempt to catch performance at work. In this way, the discourse of performativity and performance studies, in its presumption that disappearance is not only the ontology of performance but that it also actually happens, runs the risk of reintroducing the force of will into performativity, a will as subjectivity that is a remainderless totality, in other words a form of dissolution (for a guide against these theoretical pitfalls, see Nancy, *The Inoperative Community*). In future projects I hope to suggest ways in which one might replace a theory of performance with a Blanchot-inspired theory of unworking as the undoing of subjectivity, and negativity as well as positivity, and therefore as something much more irrecoverable than performance.

77. Giorgio Agamben, "*Pardes:* The Writing of Potentiality," in *Potentialities*, ed. Daniel Heller-Roazen (Stanford: Stanford University Press, 1999), 218.

CHAPTER THREE

1. Gilles Deleuze and Felix Guattari, *What Is Philosophy?* trans. Hugh Tomlinson and Graham Burchell, European Perspectives, ser. ed. Lawrence D. Kritzman (New York: Columbia University Press, 1994), 60.

2. The incessance of this withdrawal is key, since this is not a matter of an absenting of the visual but of a becoming-disappeared without ever being-disappeared. See my discussion of a disappeared aesthetics in chapter two.

3. Giorgio Agamben, *Remnants of Auschwitz: The Witness and the Archive,* trans. Daniel Heller-Roazen (New York: Zone Books, 1999), 139.

4. Giorgio Agamben finds an analogy for the extent to which the invisibility of the visible is invisible in "the expanding universe, [where] the farthest galaxies move away from us at a speed greater than that of their light, which cannot reach us, such that the darkness we see in the sky is nothing but the invisibility of the light of unknown stars" (ibid., 162). Might we not find a certain non-positive affirmation of becoming-disappeared in this cosmological withdrawal or unbecoming event that is the universe itself, an approach to the Outside that is surely beyond any inside-outside spatial oppositions?

5. Gilles Deleuze, *The Fold: Leibniz and the Baroque,* trans. Tom Conley (Minneapolis and London: University of Minnesota Press, 1993), 86.

6. Maurice Blanchot, *The Space of Literature,* trans. Ann Smock (Lincoln and London: University of Nebraska Press, 1982), 169.

7. Ibid., 163ff.

8. Marguerite Duras, *The Malady of Death,* trans. Barbara Bray (New York: Grove Press, 1986), 46.

9. Agamben, *Remnants of Auschwitz,* 123–25.

10. Ibid., 124–25.

11. Deleuze, *The Fold,* 110ff.

12. My thinking on potentiality is entirely indebted to the work of Giorgio Agamben. Agamben, "*Pardes:* The Writing of Potentiality," in *Potentialities,* ed. Daniel Heller-Roazen (Stanford, CA: Stanford University Press, 1999), 205–19. Agamben, *Remnants of Auschwitz.* Agamben, *Homo Sacer: Sovereign Power and Bare Life,* trans. Daniel Heller-Roazen, Meridian: Crossing Aesthetics, ser. ed. Werner Hamacher and David E. Wellbery (Stanford, California: Stanford University Press, 1998). Agamben, *Means without End: Notes on Politics,* trans. Vincenzo Binetti and Cesare Casarino, Theory out of Bounds, no. 20, ser. ed. Michael Hardt, Sandra Buckley, and Brian Massumi (Minneapolis and London: University of Minnesota, 2000).

13. Deleuze, *The Fold,* 110.

14. Leo Bersani and Ulysse Dutoit, *Caravaggio's Secrets* (Cambridge and London: MIT Press, 1998). Blanchot, *The Space of Literature.* Stephen Barker, *Nightswimming* (Santa Fe, NM: Twin Palms, 1999). David Wojnarowicz, *Close to the Knives: A Memoir of Disintegration* (New York: Vintage Books, 1991).

15. Deleuze, *The Fold,* esp. 85–99. Alain Badiou, "Gilles Deleuze, 'The Fold: Leibniz and the Baroque,'" In *Gilles Deleuze and the Theater of Philosophy,* ed. Constantin V. Boundas and Dorothea Olkowski (New York and London: Routledge, 1994), 51–69.

16. Wojnarowicz, *Close to the Knives,* 24–25.

17. Ibid.

18. Deleuze, *The Fold,* 89.

19. William Haver, "Really Bad Infinities: Queer's Honour and the Pornographic Life," *parallax* 13 (October–December 1999): 9–21.

20. Todd May, "Difference and Unity in Gilles Deleuze," in Boundas and Olkowski, *Gilles Deleuze and the Theater of Philosophy,* 46.

21. "If, with Kant, it is objected that such a conception reintroduces infinite understanding, we might be impelled to remark that the infinite is taken here

only as the presence of an unconscious in finite understanding, of something that cannot be thought in finite thought, of a nonself in the finite self." Deleuze, *The Fold,* 89.

22. Badiou, "Gilles Deleuze," 52.

23. Deleuze, *The Fold,* 93.

24. Ibid., 87. Blanchot, *The Space of Literature.*

25. Deleuze, *The Fold,* 87.

26. Ibid.

27. Duras, *The Malady of Death.*

28. Ibid., 54.

29. On waiting, see Maurice Blanchot, *The Writing of the Disaster,* trans. Ann Smock (Lincoln and London: University of Nebraska Press, 1995). On the irreparable, see Giorgio Agamben, *The Coming Community,* trans. Michael Hardt, Theory Out of Bounds, no. 1, ser. ed. Michael Hardt, Sandra Buckley, and Brian Massumi (Minneapolis and London: University of Minnesota Press, 1993), 89–106.

30. Deleuze, *The Fold,* 93.

31. Steven Shaviro, *The Cinematic Body,* Theory Out of Bounds, no. 2, ser. ed. Michael Hardt, Sandra Buckley, and Brian Massumi (Minneapolis and London: University of Minnesota Press, 1993), 25.

32. This recalls the joke, "What's the worst thing about oral sex? The view." Lydia Stux, ed., and Russell Denver Harold, *Imagine That: Letters from Russell* (Chicago: Lambda Publications, 1999).

33. Agamben, *Remnants of Auschwitz,* 130–32.

34. Michel Foucault, *This Is Not a Pipe,* trans. James Harkness (Berkeley, Los Angeles, and London: University of California Press, 1983), 54.

35 Catherine Lord, "Doug Ischar: Smoking Guns," *Art/Text* 57 (Summer 1997): 42–45.

36. Leo Bersani, "A Conversation with Leo Bersani," ed. Hal Foster, Tim Dean, and Kaja Silverman, *October* 82 (1997): 3–16.

37. For recent attempts to rethink community in precisely these terms, see Agamben, *The Coming Community;* Maurice Blanchot, *The Unavowable Community,* trans. Pierre Joris (Barrytown, NY: Station Hill Press, 1988); and Jean-Luc Nancy, *The Inoperative Community,* trans. Peter Connor, Lisa Garbus, Michael Holland, and Simona Sawhney, Theory and History of Literature, no. 76, ser. ed. Wlad Godzich and Jochen Schulte-Sasse (Minneapolis and London: University of Minnesota, 1991).

38. Bersani, "Conversation," 6.

39. This in opposition to the seductive, penetrating gaze. In their collaborations, Leo Bersani and Ulysse Dutoit have elucidated the ways in which the seductive gaze is part of a visual economy of paranoid fascination over enigmatic signifiers (i.e. secrets), and a desire to aggressively wrest the secret from its hidden interiority, and possess it for oneself. See Bersani and Dutoit, *Arts of Impoverishment* (Cambridge and London: Harvard University Press, 1993); and Bersani, and Dutoit, *Caravaggio's Secrets.*

40. Lord, "Doug Ischar," 43.

41. Bersani, "Conversation," 13.

42. Anthony Vidler, "The Exhaustion of Space at the Scene of the Crime," in *Scene of the Crime,* ed. Ralph Rugoff (Cambridge and London): MIT Press, 1997), 130–41.

43. Quoted in Rugoff, *Scene of the Crime,* 20.

44. Vidler, "Exhaustion."

45. Gilles Deleuze and Felix Guattari, *A Thousand Plateaus: Capitalism and Schizophrenia,* trans. Brian Massumi (Minneapolis and London: University of Minnesota, 1987), 288.

46. Michel Foucault, "Sexual Choice, Sexual Act," in *Ethics: Subjectivity and Truth,* ed. Paul Rabinow (New York: The New Press, 1997), 150.

47. Deleuze and Guattari, *A Thousand Plateaus,* especially chapter 10, "1730: Becoming-Intense, Becoming-Animal, Becoming-Imperceptible . . . ," 232–309.

48. Leo Bersani, *Homos* (Cambridge and London: Harvard University Press, 1995), 163.

49. Bruce Benderson, *Toward the New Degeneracy: An Essay* (New York, Paris, and Turin: Edgewise Press, 1997).

50. Ibid., 48.

51. Leo Bersani has theorized betrayal in his reading of Jean Genet's *Funeral Rites.* See Bersani, *Homos,* 164ff.

52. Ibid., 152.

53. Ibid., 172.

54. Shaviro, *The Cinematic Body,* 55.

55. Blanchot, *The Unavowable Community,* 5.

56. "What becomes visible is the excruciated crossing of the subject's social interest in having a social interest and the subject's self-interest in protecting its nonsociality and autonomy: 'I am not myself and . . . my most proper being is over there, in that double that enrages me.' 'No doubt the double is loved, since I love myself in him; but that is also why he provokes hatred and hostility, precisely inasmuch as he is close to me, too close.'" Mark Seltzer, *Serial Killers: Death and Life in America's Wound Culture* (New York and London: Routledge, 1998). Seltzer is here quoting Mikkel Borch-Jacobsen.

57. Don Davis, *The Milwaukee Murders: Nightmare in Apartment 213: The True Story* (New York: St. Martin's, 1991).

58. My thinking on the typicality of Dahmer's apartment has been greatly informed by Rem Koolhaas's brilliant exposition of a modern architecture without qualities as "typical plan." See Rem Koolhaas and Bruce Mau, "Typical Plan," in *S,M,L,XL,* ed. Jennifer Sigler (New York: Monacelli Press, 1995), 334–50.

59. "When the cops got downstairs, they were somewhat amused by the interrogation they had just conducted, totally unaware of the horror that was going on in the very apartment where they had been standing moments before. One called in to the station to report, 'Intoxicated Asian, naked male, was returned to his boyfriend.' On a tape recording of the call, laughter was audible. 'My partner is going to get deloused at the station,' the reporting officer said." Davis, *The Milwaukee Murders,* 12.

60. As an example of an artist's work on the subject of Dahmer that takes a much more representational and perhaps one might say spectacular approach, see Lyle Ashton Harris's *The Watering Hole VIII* (1996), reproduced in Rugoff, *Scene of the Crime.*

61. With the video-based installation project *Siren* (1996) Doug Ischar introduced sound into his work for the first time.

62. Bernard Cache, *Earth Moves: The Furnishing of Territories,* trans. Anne Boymans, Writing Architecture (Cambridge, MA: The MIT Press, 1995).

63. In the current global cultural economy of international biennials; itinerant artists, curators, and writers; transnational exhibitions and curators; networks of metropolitan centers; and multi-lingual travel guides and exhibition catalogues, site-specific art practices are being reinvented as nomadic artistic practices. Yet in

certain instances, artists are not simply moving their work along transnational routes of cultural exchange, they are also taking this itinerary as a problematic to be addressed by their work. It is, then, not simply a matter of culture traveling, but of what James Clifford has theorized as "culture as travel." Clifford, "Traveling Cultures," in *Cultural Studies,* ed. Cary Nelson, Lawrence Grossberg, and Paula Treichler (New York and London: Routledge, 1992).

64. Cache, *Earth Moves,* 70.

65. Deleuze, *The Fold,* 30.

66. Cache, *Earth Moves,* 70.

67. Deleuze, *The Fold,* 30.

68. Max Beckman, artist in Weimar Germany, is known to have referred to boredom as the most exhausting thing.

69. Bersani, *Homos,* 178.

70. William Haver, "Queer Research; or, How to Practise Invention to the Brink of Intelligibility," In *The Eight Technologies of Otherness,* ed. Sue Golding (New York and London: Routledge, 1997), 281.

71. Miwon Kwon, "One Place after Another: Notes on Site Specificity," *October* 80 (Spring 1997): 85–110.

72. Haver, "Queer Research."

73. This nomenclature mimics the naming of dildos and other sex toys after porn stars, in which, for example, dildos supposedly are anatomical replicas (in length, girth, color, etc.) of the porn star's erect dick. Formally, Leiderstam's vases with folded openings resembling anuses might be regarded as prosthetic counterparts to dildos, which, along with their naming, effects an intercourse of shepherds and porn stars via sexual prosthetics and aesthetics.

74. My notion of an inconsolable or queer art history is inspired by Deborah Britzman's brilliant thinking towards an inconsolable pedagogy. Britzman, "Is There a Queer Pedagogy? Or, Stop Reading Straight," *Educational Theory* 45 (Spring 1995): 151–65.

75. Jacques Derrida, *Archive Fever: A Freudian Impression,* trans. Eric Prenowitz, Religion and Postmodernism, ser. ed. Mark C. Taylor (Chicago and London: University of Chicago, 1996).

76. Walter Benjamin, "The Work of Art in the Age of Mechanical Reproduction," in *Illuminations,* ed. Hannah Arendt (New York: Schocken Books, 1969), 217–51; and Michel Foucault, *The Archaeology of Knowledge,* trans. A. M. Sheridan Smith (New York: Pantheon Books, 1972).

77. Cache, *Earth Moves,* 102.

78. Cindy Patton, *Fatal Advice: How Safe-Sex Education Went Wrong,* Series Q, ser. ed. Michèle Aina Barale, Jonathan Goldberg, Michael Moon, and Eve Kosofsky Sedgwick (Durham and London: Duke University Press, 1996).

79. Kendall Thomas, "Em Baixo Do Pano, Tudo Pode Acontecer," in *Dark O'Clock,* ed. Wayne Baerwaldt (Winnipeg, Can.: Plug In Editions, 1994).

80. This is from Barthes' "Soirées de Paris," a journal that he began to keep in 1979, and in which he recorded his nighttime cruising in the city. Barthes, *Incidents,* trans. Richard Howard (Berkeley: University of California Press, 1992), 59.

81. This is repeated a number of times throughout the book. Maurice Blanchot, *The One Who Was Standing Apart from Me,* trans. Lydia Davis (Barrytown, NY: Station Hill Press, 1993).

82. Ibid., 63.

83. Haver, "Really Bad Infinities."

84. Giorgio Agamben, *The Man Without Content,* trans. Georgia Albert, Meridian: Crossing Aesthetics, ser. ed. Werner Hamacher and David E. Wellbery (Stanford: Stanford University Press, 1999).

85. Ibid.; see especially chapter six, "A Self-Annihilating Nothing," for Agamben's reading of Hegel's aesthetics.

86. Blanchot, *The Writing of the Disaster,* 49.

87. Ibid.

88. William Haver, *The Body of This Death* (Stanford: Stanford University Press, 1996), 53.

89. Blanchot, *The Writing of the Disaster,* 89.

90. Maurice Blanchot, "The Sleep of Rimbaud," in *The Work of Fire* (Stanford: Stanford University Press, 1995), 153–61.

91. Blanchot, *The Writing of the Disaster,* 89.

92. Agamben, *The Man Without Content,* 67.

CHAPTER FOUR

1. Douglas Crimp, *On the Museum's Ruins* (Cambridge and London: MIT Press, 1993).

2. Ibid., 5–6.

3. William Haver, "Queer Research; or, How to Practise Invention to the Brink of Intelligibility," in *The Eight Technologies of Otherness,* ed. Sue Golding (New York and London: Routledge, 1997), 277–92. Deborah P. Britzman, *Lost Subjects, Contested Objects: Towards a Psychoanalytic Inquiry of Learning* (Albany: State University of New York Press, 1998).

4. One might find correspondence with Jacques Derrida's formulation as to the relations between reason, the university, and pedagogy. In a lecture at Cornell, Derrida notes the Kantian definition of reason as the faculty of principles, and goes on to suggest that to be without reason is to be without principles. It is this un-principled condition that I wish to render here as illicit: that which makes it difficult if not impossible to respond to the call of the principle of reason, to speak reasonably by securing a grounding in principles. Derrida, "The Principle of Reason: The University in the Eyes of Its Pupils," *diacritics* (Fall 1983): 2–20.

5. Roland Barthes, "Writers, Intellectuals, Teachers," in *Image, Music, Text,* ed. Stephen Heath (New York: Hill and Wang, 1977), 190–215.

6. Haver, "Queer Research," 286.

7. Judith Butler, *Bodies That Matter: On the Discursive Limits of "Sex"* (New York and London: Routledge, 1993), 7.

8. Ibid.

9. Ibid., 225.

10. Haver, "Queer Research," 285.

11. Barthes, "Writers, Intellectuals, Teachers," 192 (emphasis in original).

12. These forms of rationality correspond to the three domains of classical knowledge production investigated by Foucault in *The Order of Things* (New York: Vintage Books, 1973).

13. Haver, "Queer Research."

14. Ibid., 191.

15. Barthes, "Writers, Intellectuals, Teachers," 205–6.

16. Barthes argues that "in the realm of speech there is no innocence, no safety" (ibid.).

17. Haver, "Queer Research," 285.

18. Ibid., 286.

19. Deborah P. Britzman, "Is There a Queer Pedagogy? Or, Stop Reading Straight," *Educational Theory* 45 (Spring 1995): 164.

20. Ann Pellegrini, as quoted in Richard Goldstein, "It's Here! It's Queer! It's Too Hot for Yale! Gay Studies Spawns a Radical Theory of Desire," *Village Voice,* 29 July 1997, 39.

21. Douglas Crimp, also quoted in Goldstein, "It's Here! It's Queer!" 41.

22. Haver, "Queer Research," 289.

23. Katie King, "Producing Sex, Theory, and Culture: Gay/Straight Remappings in Contemporary Feminism," in *Conflicts in Feminism,* ed. Marianne Hirsch and Evelyn Fox Keller (New York: Routledge, 1990), 82–101.

24. Ibid., 88.

25. For a discussion of the complicated overlapping of these political terrains, see Michael Warner, "Something Queer About the Nation-State," in *After Political Correctness,* ed. Christopher Newfield and Ronald Strickland (Boulder, San Francisco, and Oxford: Westview Press, 1995), 361–71.

26. It is perhaps worth noting, without resorting to a notion of cycles of history, that these debates have never been resolved, but seem to simply lie dormant for awhile until an event, political or otherwise—such as gay Catholic conservative and former editor of the *New Republic* Andrew Sullivan's admission in the summer of 2001 that he engages in bare-backing (sex without a condom)—precipitates their re-emergence and yet another round of moral argument over the virtues and vices of sex as public discourse and practice. As Eva Pendleton amongst others has pointed out, "While the current controversy surrounding public sex venues is often eerily reminiscent of the debates over bathhouse closure that took place in the early 1980s, the continued rightward turn of gay and lesbian politics provides a specific historical context for today's debates." Dangerous Bedfellows (Ephen Glenn Colter et al.), ed. *Policing Public Sex* (Boston: South End Press, 1996), 376. See also Michael Warner, *The Trouble with Normal: Sex, Politics, and the Ethics of Queer Life* (New York: Free Press, 1999); and Samuel R. Delany, *Times Square Red, Times Square Blue,* Sexual Cultures: New Directions from the Center for Gay and Lesbian Studies, ser. ed. José Esteban Muñoz and Ann Pellegrini (New York and London: New York University Press, 1999).

27. Michael Warner, "Media Gays: A New Stone Wall," *Nation,* 14 July 1997, 15–19.

28. Ibid., 16.

29. King, "Producing Sex, Theory, and Culture," 83.

30. Pellegrini, as quoted in Goldstein, "It's Here! It's Queer!" 39.

31. Currently, the primary website devoted to anonymous public sex is cruisingforsex.com, created by individuals formerly associated with the production and management of *Steam.*

32. Butler, *Bodies That Matter,* 13.

33. A partial bibliography of queer space discourse would include the following: *Mapping Desire: Geographies of Sexualities,* ed. David Bell and Gill Valentine (New York and London: Routledge, 1995); Christopher Reed, "Imminent Domain: Queer Space in the Built Environment," *Art Journal* 55, no. 4 (Winter 1996): 64–69; Simon Ofield, "Consuming Queerspace: Deconstructing the Glass Brick Wall," *Architectural Design* 68, nos. 1–2 (1998); Sy Adler and Johanna Brenner, "Gender and Space: Lesbians and Gay Men in the City," *International Journal of Urban and Regional Research* 16 (1992); and G. Valentine, "(Hetero)sexing Space: Lesbian Perceptions and Experiences of Everyday Practices," *Environment and Planning D: Society and Space* 11 (1993).

34. Aaron Betsky, *Queer Space: Architecture and Same-Sex Desire* (New York: Morrow, 1997). See also Gordon Brent Ingram, Anne-Marie Bouthillette, Yolanda Retter, eds., *Queers in Space: Communities, Public Places, Sites of Resistance* (Seattle: Bay Press, 1997).

35. John Paul Ricco, "Jacking-off a Minor Architecture." *Steam* 1, no. 4 (1993): 236–42. Henry Urbach, "Spatial Rubbing," *Sites* 24 (1993): 90–95.

36. Betsky, *Queer Space*, 170.

37. For a brief history of political pamphleteering in the United States, see, Howard Zinn, "On Pamphleteering in America," in *Open Fire: The Open Magazine Pamphlet Series Anthology*, ed. Greg Ruggiero and Stuart Sahulka (New York: New Press, 1993), xi–xix.

38. King, "Producing Sex, Theory, and Culture," 90.

39. Members of the this unnamed group are identified in the publication as follows: "anaheed alani, sabrina craig, mel ferrand, debbie gould, jeanne kracher, hana layson, cheryl miller, dawne moon, ada norris, dana seitler, and various co-conspirators." This group would later become the gender-inclusive Queer to the Left, an activist group currently thriving in Chicago.

Agamben, Giorgio. *The Coming Community.* Translated by Michael Hardt. Theory Out of Bounds, no. 1, edited by Michael Hardt, Sandra Buckley, and Brian Massumi. Minneapolis and London: University of Minnesota Press, 1993.

———. *Homo Sacer: Sovereign Power and Bare Life.* Translated by Daniel Heller-Roazen. Meridian: Crossing Aesthetics, edited by Werner Hamacher and David E. Wellbery. Stanford: Stanford University Press, 1998.

———. *The Man Without Content.* Translated by Georgia Albert. Meridian: Crossing Aesthetics, edited by Werner Hamacher and David E. Wellbery. Stanford: Stanford University Press, 1999.

———. *Means without End: Notes on Politics.* Translated by Vincenzo Binetti and Cesare Casarino. Theory out of Bounds, no. 20, edited by Michael Hardt Sandra Buckley, and Brian Massumi. Minneapolis and London: University of Minnesota, 2000.

———. "*Pardes:* The Writing of Potentiality." In *Potentialities,* edited by Daniel Heller-Roazen, 205–19. Stanford: Stanford University Press, 1999.

———. *Remnants of Auschwitz: The Witness and the Archive.* Translated by Daniel Heller-Roazen. New York: Zone Books, 1999.

Badiou, Alain. "Gilles Deleuze, 'The Fold: Leibniz and the Baroque.'" In *Gilles Deleuze and the Theater of Philosophy,* edited by Constantin V. Boundas and Dorothea Olkowski, 51–69. New York and London: Routledge, 1994.

Barker, Stephen. *Nightswimming.* Santa Fe, NM: Twin Palms, 1999.

Barthes, Roland. *Incidents.* Translated by Richard Howard. Berkeley: University of California Press, 1992.

———. "Preface." In *Tricks,* vii–x. New York: Serpent's Tail, 1981.

———. "Writers, Intellectuals, Teachers." In *Image, Music, Text,* edited by Stephen Heath, 190–215. New York: Hill and Wang, 1977.

Benderson, Bruce. *Toward the New Degeneracy: An Essay.* New York, Paris, and Turin: Edgewise Press, 1997.

Benjamin, Walter. "The Work of Art in the Age of Mechanical Reproduction." In *Illuminations,* translated by Harry Zohn, edited by Hannah Arendt, 217–51. New York: Schocken Books, 1969.

Bersani, Leo. "A Conversation with Leo Bersani." Interview by Hal Foster Tim Dean, and Kaja Silverman. *October* 82 (1997): 3–16.

———. *Homos.* Cambridge and London: Harvard University Press, 1995.

Bersani, Leo, and Ulysse Dutoit. *Arts of Impoverishment.* Cambridge and London: Harvard University Press, 1993.

———. *Caravaggio's Secrets.* Cambridge and London: MIT Press, 1998.

Betsky, Aaron. *Queer Space: Architecture and Same-Sex Desire.* New York: Morrow, 1997.

Blanchot, Maurice. *Awaiting Oblivion.* Translated by John Gregg. French Modernist Library. Lincoln and London: University of Nebraska Press, 1997.

———. *The Infinite Conversation.* Translated by Susan Hanson. Theory and History of Literature, no. 82, edited by Wlad Godzich and Jochen Schulte-Sasse. Minneapolis and London: University of Minnesota Press, 1993.

———. *The Last Man.* Translated by Lydia Davis. Twentieth-Century Continental Fiction. New York: Columbia University Press, 1987.

————. *The One Who Was Standing Apart from Me.* Translated by Lydia Davis. Barrytown, NY: Station Hill Press, 1993.

————. "Refusal." In *Friendship,* 111–12. Stanford: Stanford University Press, 1997.

————. "The Sleep of Rimbaud." In *The Work of Fire,* 153–61. Stanford: Stanford University Press, 1995.

————. *The Space of Literature.* Translated by Ann Smock. Lincoln and London: University of Nebraska Press, 1982.

————. *The Unavowable Community.* Translated by Pierre Joris. Barrytown, NY: Station Hill Press, 1988.

————. *Vicious Circles.* Translated by Paul Auster. 1st ed. Barrytown, NY: Station Hill Press, 1985.

————. "Who?" In *Who Comes after the Subject?* edited by Peter Connor, Eduardo Cadava, and Jean-Luc Nancy, 58–60. New York and London: Routledge, 1991.

————. *The Writing of the Disaster.* Translated by Ann Smock. Lincoln and London: University of Nebraska Press, 1995.

Bloomer, Jennifer. *Architecture and the Text: The (S)crypts of Joyce and Piranesi.* Theoretical Perspectives in Architectural History and Criticism, edited by Mark Rakatansky. New Haven and London: Yale University Press, 1993.

————. "A Lay a Stone a Patch a Post a Pen the Ruddyrun: Minor Architectural Possibilities." In *Strategies in Architectural Thinking,* edited by Jeffrey Kipnis, John Whiteman, and Richard Burdett, 48–66. Cambridge and London: MIT Press, 1992.

Britzman, Deborah P. *Lost Subjects, Contested Objects: Towards a Psychoanalytic Inquiry of Learning.* Albany: State University of New York Press, 1998.

————. "Is There a Queer Pedagogy? Or, Stop Reading Straight." *Educational Theory* 45 (Spring 1995): 151–65.

Bruns, Gerald L. *Maurice Blanchot: The Refusal of Philosophy.* Baltimore and London: Johns Hopkins University Press, 1997.

Butler, Judith. *Bodies That Matter: On the Discursive Limits of "Sex."* New York and London: Routledge, 1993.

————. "Revisiting Bodies and Pleasures." *Theory, Culture & Society* 16, no. 2 (1999): 11–20.

Cache, Bernard. *Earth Moves: The Furnishing of Territories.* Translated by Anne Boymans. Writing Architecture. Cambridge: MIT Press, 1995.

Caillois, Roger. "Mimicry and Legendary Psychasthenia." *October* 31 (1984): 17–32. Originally published in 1935 in the surrealist journal *Minotaure.*

Celan, Paul. *Poems of Paul Celan.* Translated by Michael Hamburger. New York: Persea Books, 1989.

Cixous, Hélène. "Castration or Decapitation?" In *Out There: Marginalization and Contemporary Cultures,* edited by Martha Gever, Russell Ferguson, Trinh T. Minh-ha, and Cornel West, 345–56. New York: Museum of Contemporary Art; Cambridge: MIT Press, 1990.

Clifford, James. "Traveling Cultures." In *Cultural Studies,* edited by Cary Nelson, Lawrence Grossberg, and Paula Treichler. New York and London: Routledge, 1992.

Conley, Tom. "A Plea for Leibniz." In *The Fold: Leibniz and the Baroque,* ix–xx. Minneapolis and London: University of Minnesota Press, 1993.

Crimp, Douglas. "Mourning and Militancy." In *Out There: Marginalization and*

Contemporary Cultures, edited by Martha Gever, Russell Ferguson, Trinh T. Minh-ha, and Cornel West, 233–45. New York: Museum of Contemporary Art; Cambridge: MIT Press, 1990.

———. *On the Museum's Ruins.* Cambridge and London: MIT Press, 1993.

Critchley, Simon. "With Being-With? Notes on Jean-Luc Nancy's Rewriting of Being and Time." In *Ethics, Politics, Subjectivity,* 239–53. New York and London: Verso, 1999.

Dangerous Bedfellows (Ephen Glenn Colter et al.), ed. *Policing Public Sex.* Boston: South End Press, 1996.

Davis, Don. *The Milwaukee Murders: Nightmare in Apartment 213: The True Story.* New York: St. Martin's, 1991.

Delany, Samuel R. *The Mad Man.* New York: Masquerade Books, 1994.

———. *Times Square Red, Times Square Blue.* Sexual Cultures: New Directions from the Center for Gay and Lesbian Studies, edited by José Esteban Muñoz and Ann Pellegrini. New York and London: New York University Press, 1999.

Deleuze, Gilles. *The Fold: Leibniz and the Baroque.* Translated by Tom Conley. Minneapolis and London: University of Minnesota Press, 1993.

———. *Foucault.* Translated by Sean Hand. Minneapolis and London: University of Minnesota Press, 1988.

Deleuze, Gilles, and Felix Guattari. *Kafka: Toward a Minor Literature.* Translated by Dana Polan. Theory and History of Literature, no. 30, edited by Wlad Godzich and Jochen Schulte-Sasse. Minneapolis and London: University of Minnesota Press, 1986.

———. *A Thousand Plateaus: Capitalism and Schizophrenia.* Translated by Brian Massumi. Minneapolis and London: University of Minnesota, 1987.

———. *What Is Philosophy?* Translated by Hugh Tomlinson and Graham Burchell. European Perspectives, edited by Lawrence D. Kritzman. New York: Columbia University Press, 1994.

Derrida, Jacques. *Adieu to Emmanuel Levinas.* Translated by Pascale-Anne Brault and Michael Naas. Meridian: Crossing Aesthetics, edited by Werner Hamacher and David E. Wellbery. Stanford: Stanford University Press, 1999.

———. *Aporias.* Translated by Thomas Dutoit. Meridian: Crossing Aesthetics, edited by Werner Hamacher and David E. Wellbery. Stanford: Stanford University Press, 1993.

———. *Archive Fever: A Freudian Impression.* Translated by Eric Prenowitz. Religion and Postmodernism, edited by Mark C. Taylor. Chicago and London. University of Chicago Press, 1996.

———. "The Principle of Reason: The University in the Eyes of Its Pupils." *diacritics* (Fall 1983): 2–20.

Doty, Mark. *Heaven's Coast: A Memoir.* New York: HarperCollins, 1996.

Duras, Marguerite. *The Malady of Death.* Translated by Barbara Bray. New York: Grove Press, 1986.

Foucault, Michel. *The Archaeology of Knowledge.* Translated by A.M. Sheridan Smith. New York: Pantheon Books, 1972.

———. "Different Spaces." In *Aesthetics, Method, and Epistemology,* edited by James D. Faubion, 175–85. New York: New Press, 1998.

———. "Friendship as a Way of Life." In *Ethics: Subjectivity and Truth,* edited by Paul Rabinow, 328. New York: New Press, 1997.

———. "The Life of Infamous Men." In *Michel Foucault: Power, Truth, Strategy,*

edited by Meaghan Morris and Paul Foss, 76–91. Sydney: Feral Publications, 1979.

———. "Maurice Blanchot: The Thought from Outside." In *Foucault/Blanchot*, 109. New York and Cambridge, MA: Zone Books, 1987.

———. "On the Genealogy of Ethics: An Overview of Work in Progress." In *Ethics: Subjectivity and Truth*, edited by Paul Rabinow, 253–80. New York: New Press, 1997.

———. *The Order of Things*. New York: Vintage Books, 1973.

———. "Sexual Choice, Sexual Act." In *Ethics: Subjectivity and Truth*, edited by Paul Rabinow, 141–56. New York: New Press, 1997.

———. *This Is Not a Pipe*. Translated by James Harkness. Berkeley, Los Angeles, and London: University of California Press, 1983.

———. *The Use of Pleasure*. Vol. 2 of *The History of Sexuality*. Translated by Robert Hurley. New York: Random House, 1985.

Golding, Sue. "The Poetics of Foucault's Politics, or, Better Yet: The Ethical Demand of Ecstatic Fetish." *New Formations* 25 (Summer 1995): 40–47.

Goldstein, Richard. "It's Here! It's Queer! It's Too Hot for Yale! Gay Studies Spawns a Radical Theory of Desire." *Village Voice*, 29 July 1997, 38–41.

Grosz, Elizabeth. "Animal Sex." In *Space, Time, and Perversion: Essays on the Politics of Bodies*, 187–205. New York and London: Routledge, 1995.

———. "Architecture from the Outside." In *Space, Time, and Perversion*, 125–37.

———. "Experimental Desire: Rethinking Queer Subjectivity." In *Space, Time, and Perversion*, 207–27.

Guibert, Hervé. *To the Friend Who Did Not Save My Life*. Translated by Linda Coverdale. High Risk Books. New York: Serpent's Tail, 1994.

Halperin, David. "Forgetting Foucault: Acts, Identities, and the History of Sexuality." *Representations* 63 (Summer 1998): 93–120.

Haver, William. *The Body of This Death*. Stanford: Stanford University Press, 1996.

———. "Queer Research; or, How to Practise Invention to the Brink of Intelligibility." In *The Eight Technologies of Otherness*, edited by Sue Golding, 277–92. New York and London: Routledge, 1997.

———. "Really Bad Infinities: Queer's Honour and the Pornographic Life." *parallax* 13 (October–December 1999): 9–21.

Heidegger, Martin. ". . . Poetically Man Dwells . . ." In *Poetry, Language, Thought*, 213–29. New York: Harper and Row, 1971.

Hölderlin, Friedrich. *Poems and Fragments*. Translated by Michael Hamburger. Cambridge: Cambridge University Press, 1980.

Ingram, Gordon Brent, Anne-Marie Bouthillette, and Yolanda Retter, eds. *Queers in Space: Communities, Public Places, Sites of Resistance*. Seattle: Bay Press, 1997.

Jarman, Derek. *Blue*. Great Britain: Zeitgeist Films, 1993.

———. *Derek Jarman's Garden*. Woodstock, NY: Overlook Press, 1996.

King, Katie. "Producing Sex, Theory, and Culture: Gay/Straight Remappings in Contemporary Feminism." In *Conflicts in Feminism*, edited by Marianne Hirsch and Evelyn Fox Keller, 82–101. New York: Routledge, 1990.

Koolhaas, Rem, and Bruce Mau. "Typical Plan." In *S,M,L,XL*, edited by Jennifer Sigler, 334–50. New York: Monacelli Press, 1995.

Kwon, Miwon. "One Place after Another: Notes on Site Specificity." *October* 80 (Spring 1997): 85–110.

Lacoue-Labarthe, Philippe. *Poetry as Experience*. Translated by Andrea Tarnowski.

Meridian: Crossing Aesthetics, edited by Werner Hamacher and David E. Wellbery. Stanford: Stanford University Press, 1999.

Lawrence, Tim. "AIDS, the Problem of Representation, and Plurality in Derek Jarman's *Blue*." *Social Text* 15, nos. 3 and 4 (Fall/Winter 1997): 241–64.

Lingis, Alphonso. *The Community of Those Who Have Nothing in Common*. Bloomington: Indiana University Press, 1994.

Lord, Catherine. "Doug Ischar: Smoking Guns." *Art/Text* 57 (Summer 1997): 42–45.

May, Todd. "Difference and Unity in Gilles Deleuze." In *Gilles Deleuze and the Theater of Philosophy*, edited by Constantin V. Boundas and Dorothea Olkowski, 33–50. New York and London: Routledge, 1994.

Melville, Herman. *Bartleby the Scrivener: A Story of Wall Street*. 1853; New York: Simon and Schuster, 1997.

Meyer, James. "Tom Burr." *Frieze* 27 (March/April 1996): 82–83.

Miller, D. A. *Bringing Out Roland Barthes*. Berkeley, Los Angeles, and London: University of California Press, 1992.

Morrison, Paul. "End Pleasure." *GLQ* 1, no. 1 (1993): 53–78.

Nancy, Jean-Luc. *The Inoperative Community*. Translated by Peter Connor, Lisa Garbus, Michael Holland, and Simona Sawhney. Theory and History of Literature, no. 76, edited by Wlad Godzich and Jochen Schulte-Sasse. Minneapolis and London: University of Minnesota, 1991.

Patton, Cindy. *Fatal Advice: How Safe-Sex Education Went Wrong*. Series Q, edited by Michèle Aina Barale, Jonathan Goldberg, Michael Moon, and Eve Kosofsky Sedgwick. Durham and London: Duke University Press, 1996.

Phelan, Peggy. *Unmarked: The Politics of Performance*. New York and London: Routledge, 1993.

Phillips, Carl. *Cortège*. St. Paul, MN: Graywolf Press, 1995.

Rajchman, John. *Constructions*. Writing Architecture. Cambridge and London: MIT Press, 1998.

Ricco, John Paul. "Jacking-off a Minor Architecture." *Steam* 1, no. 4 (1993): 236–42.

Rugoff, Ralph. *Scene of the Crime*. Cambridge and London: MIT Press, 1997.

Seltzer, Mark. *Serial Killers: Death and Life in America's Wound Culture*. New York and London: Routledge, 1998.

Shaviro, Steven. *The Cinematic Body*. Theory Out of Bounds, no. 2, edited by Michael Hardt, Sandra Buckley, and Brian Massumi. Minneapolis and London: University of Minnesota Press, 1993.

Smock, Ann. "Translator's Introduction." In Blanchot, *The Space of Literature*, 1–15. Lincoln and London: University of Nebraska Press, 1982.

Stux, Lydia, ed., and Russell Denver Harold. *Imagine That: Letters from Russell*. With an epilogue by Lydia Stux. Chicago: Lambda Publications, 1999.

Thomas, Kendall. "Em Baixo Do Pano, Tudo Pode Acontecer." In *Dark O'Clock*, edited by Wayne Baerwaldt. Winnipeg, Can.: Plug In Editions, 1994.

Urbach, Henry. "Spatial Rubbing." *Sites* 24 (1993): 90–95.

Vidler, Anthony. "The Exhaustion of Space at the Scene of the Crime." In *Scene of the Crime*, edited by Ralph Rugoff, 130–41. Cambridge and London: MIT Press, 1997.

Warner, Michael. "Media Gays: A New Stone Wall." *Nation*, 14 July 1997, 15–19.

———. "Something Queer About the Nation-State." In *After Political Correctness*, edited by Christopher Newfield and Ronald Strickland, 361–71. Boulder, San Francisco, and Oxford: Westview Press, 1995.

————. *The Trouble with Normal: Sex, Politics, and the Ethics of Queer Life*. New York: Free Press, 1999.

Wojnarowicz, David. *Close to the Knives: A Memoir of Disintegration*. New York: Vintage Books, 1991.

Zinn, Howard. "On Pamphleteering in America." In *Open Fire: The Open Magazine Pamphlet Series Anthology*, edited by Greg Ruggiero and Stuart Sahulka, xi–xix. New York: New Press, 1993.

180